The war that won't die

Manchester University Press

The war that won't die

The Spanish Civil War in cinema

David Archibald

Manchester University Press

Manchester and New York

distributed in the United States exclusively by Palgrave Macmillan

Published by Manchester University Press
Oxford Road, Manchester M13 9NR, UK
and Room 400, 175 Fifth Avenue, New York, NY 10010, USA
www.manchesteruniversitypress.co.uk

Distributed in the United States exclusively by
Palgrave Macmillan, 175 Fifth Avenue, New York,
NY 10010, USA

Distributed in Canada exclusively by
UBC Press, University of British Columbia, 2029 West Mall,
Vancouver, BC, Canada V6T 1Z2

British Library Cataloguing-in-Publication Data
A catalogue record for this book is available from the British Library

Library of Congress Cataloging-in-Publication Data applied for

ISBN 978 0 7190 7808 8 hardback

First published 2012

Typeset in 10/12 Photina
by Servis Filmsetting Ltd, Stockport, Cheshire
Printed in Great Britain
by CPI Antony Rowe Ltd, Chippenham, Wiltshire

Contents

List of illustrations

Acknowledgments

This book has been a long time in the making. Some of the thematic concerns explored in the following pages grew out of an interest in the relationship between the past and its cinematic representation which were first brought into focus when I studied as an undergraduate exchange student at Queen's University, Canada in the late 1990s. I'm indebted, therefore, to Susan Lord for planting the initial ideas when I was there. These ideas were developed through the focus on one specific event, the Spanish Civil War, and formed the basis for my PhD thesis, which I completed at the University of Glasgow in 2004. The Scottish Awards Agency for Scotland provided valuable funding towards this research, and the university's Departments of Theatre, Film and Television Studies and Hispanic Studies provided additional resources. I'm grateful to my supervisors, Mike Gonzalez and Dimitris Eleftheriotis, for their support and encouragement throughout the process. My external examiner, Peter William Evans, posed questions during the examination that I hope have been explored in more detail here. I am particularly grateful to Icíar Bollaín, Andy Durgan, Paul Laverty, Ken Loach, Carlos Saura, Guillermo del Toro and David Trueba for taking time to talk with me about their work. The staff at the Filmoteca Española in Madrid were always willing to accommodate my requests to access their catalogue of films; Trinidad del Río was particularly helpful in organising the screenings themselves. A very warm thanks to Blanca, David, Matxalen, Radija, Victoria and everyone else in Madrid who made my stay there in 2002 most enjoyable.

Some of this work has been presented at various conferences including 'Film and History' (Chicago, 2009), 'History in Words and Images' (Turku, 2002), 'Screen' (Glasgow, 2002, 2009), the Society

for Spanish and Portuguese Historical Studies (Athens, Georgia, 2002) and the Welsh Centre for International Affairs (Cardiff, 2008). In addition, some of the chapters build on work that has been previously published: 'No laughing matter? Comedy and the Spanish Civil War in cinema', in Hannu Salmi (ed.), *History and Humour*, 2011; 'The Spanish Civil War in 1990s Spanish cinema', in Antonio Lazaro-Reboll and Andrew Willis (eds), *Popular Spanish Cinema*, 2004; and 'The closing image: David Trueba's *Soldados de Salamina*', in *The Drouth: Scotland's Literary Quarterly*, 2006. I am also grateful to students at the universities of Glasgow and Turku who provided valuable feedback when I was teaching options on Film and History.

In the period since the submission of my thesis, Christine Geraghty, Karen Lury and Graeme Burnet have provided additional commentaries on drafts of new chapters, and Priyamvada Gopal offered invaluable words of encouragement and advice, in addition to pointing continually to ways in which both my prose and my argument could be sharpened. The editors at Manchester University Press have been supportive, and more than patient, as I negotiated the path from PhD to monograph while juggling with the commitments that the early years of full-time teaching bring. Thanks also to Alysia Maciejowska in Devon and to John Herron at Loughmelia Lodge in Donegal; they both sheltered me during an important part of the writing process. Finally, to my mum, Ann, and my son, Daniel, well, thanks for everything: this book is dedicated to them.

Introduction: film, history and the Spanish Civil War

> In creating the world's memory of the Spanish civil war, the pen, the brush and the camera wielded on behalf of the defeated have proved mightier than the sword and the power of those who won.
>
> Eric Hobsbawm (2007: 4)

The war that won't die

When a right-wing military coup was launched against Spain's democratically elected government in July 1936, a significant number of artists, filmmakers and writers rallied to support the country's government. On both sides of the divide it was a war waged by millions of largely anonymous, mostly impoverished Spaniards; yet the fact that writers such as John Dos Passos, Joris Ivens, George Orwell, André Malraux, Pablo Neruda and Stephen Spender travelled to Spain to support the Republic, joining numerous native artists who voiced opposition to the coup, helped establish the conflict's reputation internationally as an artists' or writers' war, a description reinforced by the execution of Federico García Lorca by Nationalist soldiers on 19 August 1936.[1] That the first British volunteer to die in the conflict was Felicia Browne, an artist and sculptress shot dead while returning to help a wounded colleague, has also fuelled the romanticism. (Hopkins, 1998: 130) That the civil war attracted many leading artists to commit themselves to, what was to some, the 'Last Great Cause'[2] ensured that the conflict has been represented in numerous seminal works of visual art, with Picasso's *Guernica*, Magritte's *Le Drapeau Noir/Black Flag* and Miró's eight small-scale etchings *Black and Red Series* among the most celebrated examples from the vast array of art crafted during the period. In addition, both sides produced remarkable propaganda

posters, and from the field of photography emerged the now legendary work of Robert Capa, most famously 'Death of a Militiaman'. In the world of theatre, output ranged from short agit-prop pieces like Jack Lindsay's *On Guard for Spain!* (1936), which was performed by workers' theatre groups throughout the English-speaking world, to more conventional dramatic responses such as Bertolt Brecht's *Die Gewehre der Frau Carrar/Señora Carrar's Rifles* (1937), an adaptation of John Millington Synge's 1904 play, *Riders to the Sea*. The arts, then, have played an important role in shaping popular understandings of the Spanish Civil War and this book examines the specific role cinema has played in how the event has been remembered. My focus is on fictional feature films produced within Spain and beyond its borders between the 1940s and the early years of the twenty-first century. In providing critical analyses of a diverse range of cinematic depictions of the period, the book draws on, and attempts to situate these analyses within, contemporary debates on Spanish Civil War historiography, but also the philosophy of history and the relationship between the past and its cinematic representation.

The Spanish Civil War: an overview

Before coming to the films themselves, an outline of the war itself is necessary. The Spanish Civil War began on 17 July 1936 when a right-wing rebellion organised from Spanish military garrisons in North Africa and the Canary Islands was launched against a left-leaning Republican government; it ended with the rebels proclaiming victory on 1 April 1939. Rather than examining the civil war in isolation, it is helpful to situate the conflict within a wider framework. The civil war was no aberration in an otherwise peaceful historical trajectory, but rather the outcome of an almost continuous series of revolts, strikes and uprisings in the early years of the twentieth century. According to Hugh Thomas, the outbreak of the civil war represented 'the culmination . . . of a hundred years of class war'. (2003: 246) Indeed, Franco himself highlighted the conflict's class nature when he stated, 'Our Crusade is the only struggle in which the rich who went to war came out richer than when they started.' (quoted in Preston, 2000: 64) Historians have identified other underlying factors: Anthony Beevor, for instance, argues that the civil war developed out of, as he puts it, 'three basic forces of conflict: right and left, centralist against regionalist, and authoritarian against libertar-

ian'. He continues, 'If the war is only unfolded along a single dimension of class struggle, events and motives become unnecessarily hard to understand.' (1999: 7) While it is important to take cognisance of all processes, an exploration of class relations is central to understanding the background, events of and outcome of the civil war.

Spain's defeat in the Spanish-American War in 1898 diminished its status as an important colonial power. The removal of colonialism's material benefits brought into relief Spanish capitalism's relatively undeveloped nature, at least compared with its European competitors. Although neutrality in the First World War enabled Spain to boost its industrial position, by the 1920s it remained a largely agricultural economy. It was also deeply divided: while the country's four-and-a-half million agricultural workers existed in near-starvation conditions, the wealthy landowners lived virtually tax-free. (Beevor, 1999: 17) In 1930 Primo de Rivera's right-wing dictatorship, which had ruled for seven years, collapsed and municipal elections were called for 12 April 1931. Pro-Republican parties achieved a decisive victory and King Alfonso XIII, who had occupied the throne since his proclamation at birth on 17 May 1886, fled the country.

The new Republican government, the Second Spanish Republic, attempted to introduce reforms, most notably relating to land redistribution, education, regional autonomy and women's enfranchisement. A fierce right-wing reaction ensued, exemplified by General José Sanjurjo's failed uprising, or *pronunciamento*, in August 1932. The slow pace and limited nature of reform also failed to satisfy the anarchist and socialist left which demanded deeper societal change. In early 1933 the one-and-a-half million strong anarcho-syndicalist trade union, Confederación Nacional del Trabajo/National Confederation of Labour (CNT), organised a series of localised peasant uprisings. One such uprising, at Casas Viejas in Cadiz, resulted in the military exemplarily executing the participating peasants. Although small in scale, the event led the anarchists to withdraw electoral support from the Republican government, a contributory, but far from solitary, factor in the electoral victory of a right-wing coalition of the Partido Republicano Radical/Radical Republican Party and the Confederatión Espanola de Derechas Autónomas/Spanish Confederation of the Autonomous Right (CEDA) on 19 November 1933.[3] On 5 October 1934 left-wing forces staged an uprising against what they regarded as the government's increasingly authoritarian actions and the possibility of a fascist takeover, but the uprising

was poorly organised and dissipated quickly. In Asturias, however, the combined efforts of the CNT and the socialist trade union, Unión General de Trabajadores/General Union of Workers (UGT), developed into a localised civil war, which troops led by General Franco suppressed brutally. When a Republican coalition, the Frente Popular/ Popular Front, emerged victorious in elections on 16 February 1936, the result provoked wide-scale opposition from the right, and the deeply divided country entered a period of fresh instability as battle-lines were drawn on either side.

When leftists assassinated the parliamentary opposition's leader, Jóse Calvo Sotelo, on 13 July, dissident generals exploited the incident to launch a pre-arranged *coup d'état* four days later. The rebel generals had significant support from the landlords and industrialists and the Church hierarchy blessed what it regarded as a crusade against a toxic mixture of communism and atheism. Given the conflict's class nature, it was unsurprising that workers and peasants formed the bulk and backbone of the opposition to the coup. Although within days the rebels occupied significant sections to the north of the country, in addition to Seville and Cordoba in the south, popular armed resistance prevented its immediate success throughout Spain, notably in the country's key industrial areas where working-class organisation was strongest. The resistance, however, did not stop at simply opposing the rebellion. In parts of Spain, primarily in Aragon and Catalonia in the north-east, the workers' organisations took factories into collective ownership and in many villages the peasants seized and collectivised the land.

Some voices on the Republican left, notably the political wing of the anarchist movement, the Federación Anarquista Ibérica/Iberian Anarchist Federatio (FAI) and the Partido Obrero de Unificación Marxista/Workers' Party of Marxist Unification (POUM), argued that the road to victory lay in waging a revolutionary war against both fascism and capitalism. A revolutionary social programme, they contended, was the most effective way in which the majority of workers and impoverished peasants could be mobilised behind the Republic's banner. One headline in the CNT newspaper, *Solidaridad Obrera*, captured their aspirations when it proclaimed, 'Only by making a social revolution will fascism be crushed.' (quoted in Fraser, 1988: 136) Yet the Republican government pursued an alternative political strategy, arguing that military victory was necessary before broader societal change could be effected. In order to achieve this, they argued that a

moderate political programme could most effectively unite the majority of the twenty-five million strong population against the threat of fascism. They also argued that this would encourage foreign governments, specifically Britain and France, who were opposed, at least in words, to Europe's developing fascist movement, to intervene on the Republican side. Gradually the revolutionary movement, which peaked in July 1936, was weakened, most notably during what has become known as 'The Civil War within the Civil War' or 'The May Days' when the Republican army forcibly disarmed sections of the revolutionary left in Barcelona early in May 1937.[4]

In contrast to Republican division, the Nationalists, partly as a result of their military progress, were successfully integrated under Franco's leadership, which was formalised on 28 September 1936 when the rebel generals elected him 'Head of the Government of the Spanish State'. By summer 1937 Nationalist forces controlled over half of Spain and their victory seemed increasingly assured. Following a series of failed counter-offensives in the latter half of 1937, at Brunette, Belchite and Teruel, Republican forces launched a major counter-offensive at the River Ebro in July 1938. Its eventual failure four months later led the Republican government to pursue a negotiated solution. The Nationalists, however, emboldened by their continued military success, and determined to drive home their advantage, sought their opponents' unconditional surrender as they advanced relentlessly through the country. (Thomas, 2003: 870)

Central to the Nationalists' success was the military support they received from European fascist regimes, first evident when German and Italian aircraft transported troops from North Africa to mainland Spain in July 1936. During the conflict the rebels also received an estimated US $981 million in aid; in addition, more than 10,000 German and up to 75,000 Italian troops fought on the rebel side. (Thomas, 2003: 936–9)[5] France, Britain and the United States signed the Non-Intervention Agreement and established the Non-Intervention Committee in August 1936. As this prohibited the sale of arms to the democratically elected government, it ensured that the Republic struggled to strengthen its inferior military capacity. Mexico and the Soviet Union provided limited support to the Republican side, although the latter demanded a significant price for this. Additionally, at the Moscow-based Communist International's behest, around 32,000 volunteers, mostly communists, socialists and trades unionists, from 53 countries around the world, though mainly from Europe, fought

for the Republic. (Durgan, 2007: 72–3) What became known as the 'International Brigades' played an important military role at the Defence of Madrid in November 1936, the Battle of Jarama in February 1937 and the Battle of Guadalajara the following month. Their overall significance was primarily symbolic, however, and they were officially withdrawn on 29 October 1938 in an attempt to appease the Non-Intervention Committee, although many individuals remained to fight.[6] Somewhere in the region of 5000 international combatants, mostly anarchists and socialists critical of the Soviet Union, also joined the Republican military effort. Again, however, their military impact was limited. (Beevor, 1999: 124) The rebels used their superior military might to sweep slowly but systematically through Spain and, after thirty-three months of fighting, the civil war culminated in the establishment of a military dictatorship headed by Franco.

Following Franco's acccession to power, and up until around 1941, the new government pursued a policy of '*limpieza*' or 'cleansing'. The Spanish right regarded any form of liberal thought, let alone the anarchist and socialist ideas that had become firmly established among the workers and peasants, as a virus requiring eradication. The manner in which the government viewed its opponents was exemplified by Franco's first Minister of the Interior, Ramón Serrano Súñer, who, when speaking to a German journalist in the aftermath of Barcelona's fall in January 1939, stated, 'The city is completely bolshevized. The task of decomposition absolute . . . In Barcelona the reds have stifled the Spanish spirit. The people . . . are morally and politically sick.' (Richards, 1996: 219) The regime's remedy was a campaign of terror and violence aimed at their opponents' atomisation and, where necessary, extirpation, a process that had begun at the start of the rebellion.[7] Meanwhile, small numbers of Republican fighters, or *maquis*, retreated to the countryside and continued their struggle. For over thirty years the Spanish authorities fought a protracted cat-and-mouse game with the *maquis* whose numbers dwindled as time progressed. Franco's death on 20 November 1975 signalled the dictatorship's end. Juan Carlos I was proclaimed King of Spain seven days later and elections took place on 15 June 1977. As part of the transition from dictatorship to democracy, there was an unwritten pact of forgetting, the *pacto del olvido*, in which the majority of the parties on both sides agreed, in effect, to actively forget the civil war, the consensus position being that suppressing discourse on the past was required to ensure political and social stability in the present.

This unofficial pact was accompanied by the passing of the 1977 Ley de Amnistía/Amnesty Law, which granted an amnesty to those who had perpetrated crimes for political reasons and was aimed at those responsible for atrocities committed during the civil war and under the dictatorship. Writing of the pact, Paul Preston comments:

> Since the return of democracy to Spain, commemoration of the Civil War has been muted. The silence was partly a consequence of the legacy of fear deliberately created during the post-war repression and by Franco's consistent pursuit of a policy of glorifying the victors and humiliating the vanquished. It was also a result of what has come to be called the *pacto del olvido* (the pact of forgetfulness). An inadvertent effect of Franco's post-war policies was to imbue the bulk of the Spanish people with a determination never to undergo again either the violence experienced during the war or the repression thereafter. (2000: 321)

Since the turn of the millennium, however, the pact, which was never strictly adhered to, notably by filmmakers, has broken down irrevocably. On 31 October 2007 the Spanish Congress of Deputies passed the Ley de Memoria Histórica/Law of Historical Memory, which established how the Spanish state would deal with the legacy of the civil war and the resulting dictatorship. Among other measures, the controversial legislation introduced by the then Socialist government declared illegitimate the trials that preceded the execution of scores of thousands of Republican supporters during the *limpieza*. It also provided state support for locating and excavating the mass graves of those executed. Like ghosts from the past, the civil war's dead were returning to haunt modern Spain.

Of course, this brief sketch cannot even begin to do justice to the civil war's complexities and one need not be a historian of the period in order to highlight omissions in the account. Readers interested in detailed studies are advised to consult Hugh Thomas's groundbreaking account, *The Spanish Civil War*, the first edition of which was published in 1961, in addition to more recent research. Key texts here are Antony Beevor's *The Spanish Civil War*, Helen Graham's *The Spanish Republic at War 1936–1939* and the numerous books by Paul Preston, the civil war's pre-eminent historian. Andy Durgan's *The Spanish Civil War* also provides an overview of research in this area. There are a plethora of English-language accounts, which are well worth exploring; indeed, Beevor (1999: 7) notes that the civil war 'has almost certainly provoked more books in more languages than

any other'.[8] Beevor suggests that simplifying the civil war only serves to make the events more complex. Fully cognisant of such risks, my intention in these opening pages is merely to provide sufficient historical detail to enable the reader to follow the thrust of my argument; further appropriate historical information is included in the following chapters to help illuminate my analysis.

This abridged account nevertheless highlights one of the issues that this book explores, that is, the relationship between the past and its narrativisation in either written or cinematic form. For even to entitle the conflict between 17 July 1936 and 1 April 1939 the 'Spanish Civil War' involves selecting and ordering certain events into a coherent story. There are, however, varying titles afforded to the conflict. What is now predominantly understood, in the West at least, as the Spanish Civil War was described contemporaneously as a 'CRUSADE' by the right while many on the revolutionary left called the period between 1931 and 1937 the 'Spanish Revolution'. The 'National Revolutionary War of the Spanish People' or the 'War of Fascist Intervention' were the titles ascribed to the conflict in Eastern Europe (at least before the collapse of the Soviet Union and its satellite states) and also, at times, by the Communist Party of Spain/ Partido Comunista de España (PCE). In more recent years, Paul Preston, while still employing the title 'Spanish Civil War' has described it as 'an episode in a greater European Civil War that ended in 1945'. (1996c: viii) In the preface to the revised edition of *The Spanish Civil War* (2003: xiv) Thomas argues 'Perceptions of the Spanish war differ from one period of ten years to the next. It now appears to have been Spain's contribution to the continent-wide breakdown which occurred between 1914 and 1945.' The latter part of Thomas's comment chimes with Oscar Wilde's assertion that 'The one duty we owe to history is to rewrite it.'

The re-writing of the history of the Spanish Civil War increased as a consequence of events outside Spain. In the wake of the demise of the Soviet Union, historians were able to access the vast, hitherto unseen Soviet archive relating to Spain. A collection of these documents was published as *Spain Betrayed: The Soviet Union in the Spanish Civil War* whose authors, Ronald Radosh, Mary R. Habeck and Grigory Sevostianov, argue that 'the Spanish Civil War remains to this day a highly charged issue. It is history, but to those who are writing it, as well as those who have a romantic or political attachment to the events, the issues are still vital and worth fighting about.' (2001: xxi) Until recently it was a commonly held opinion that the Soviet

Union and Mexico were the only countries to assist the Republic. *Spain Betrayed* calls this into question by alleging that Republican Spain was not assisted but betrayed by the Soviet Union. This was also alleged in *Arms For Spain: The Untold Story of The Spanish Civil War* in which Gerald Howson details how the Spanish Republic was swindled during arms deals with the Soviet Union. The title of Howson's book suggests that, far from the truth of the conflict being self-evident, there are episodes that remain to be told. He uncovers a scandal that involved the Soviet Union 'defrauding the Spanish government of millions of dollars, by secretly manipulating the exchange rates when setting the prices for the goods they were supplying'. (1998: 51)

Fresh evidence has also emerged for the viewpoint that Stalin's position was not born of international solidarity with the Spanish labour movement; rather, as James Hopkins writes,

> The Soviets became convinced that without sizeable military aid to the Republican government, the Popular Front would fall to the Spanish generals. If Franco could be defeated or if the demise of the Republic were delayed, a triple effect could be achieved: Russian influence in Western Europe would be greatly expanded; Spain could be used as a bargaining chip with Hitler; and Western anti-fascist opinion would be distracted from the Terror, which Stalin was about to unleash on the people. (1998: 153)

Stalin had long previously abandoned the object of exporting revolution beyond the borders of the Soviet Union, and his principal motivation was not to foster international revolution but to defend the domestic interests of the Soviet Union.

History and narrative

The diverse ways in which the conflict has been defined, and understood, highlights the relationship between the past and its narrative representation. This is particularly relevant as in recent years the usefulness of constructing *any* narratives about the past has been questioned increasingly as conventional history has come under something of a sustained critique.[9] Influenced by developments in the philosophy of language and literary criticism, the proponents of what has been termed 'the linguistic turn' argue for the necessity of understanding the centrality of language in the construction of historical meaning. One of its main advocates in the field of historiography,

Keith Jenkins, in arguing that the past cannot be accessed other than through textual form, asserts

> What textualism does is to allow all the various methodological approaches, be they Marxist, or empiricist, or phenomenological, or whatever, to continue just as before, but with the proviso that none of them can continue to think that they gain direct access to, or 'ground' their textuality in, a reality appropriated plain, that they have an epistemology. (1995: 32)

In highlighting historiography's discursive nature, Jenkins problematises, among other issues, historians' ability to access the past in its totality and to make truth claims about the past. This approach is epitomised by the work of Geoffrey Elton. Elton suggests that historiography does indeed amount to a search for truth: 'the truth we seek is the truth of the event and all that surrounds it, not the possibility that a truth abstracted from the event is being proclaimed and can be teased out by the techniques of the critic'. (1991: 30) Elton contends that history is a continuous accumulation of knowledge aimed at arriving at objective accounts that go beyond the individual historian's subjectivity. He argues, therefore, that 'historical study depends on discovering meaning without inventing it'. (1991: 30) On the contrary, echoing Friedrich Nietzsche, Jenkins asserts that all that can exist are conflicting perspectives on the past, with no single perspective able to claim a greater degree of validity than any other.[10]

In rejecting the textualist approach advocated by Jenkins and others, Terry Eagleton, while acknowledging that history may indeed be a discursive construct written in the present, suggests that it is not, as he puts it, 'merely an imaginary back-projection of it'. (1981: 51) Eagleton suggests that there are constraints on narrative accounts of the past because, although 'the past itself – by definition – no longer exists; its *effects* certainly do'. (1981: 51) In spite of Jenkins's assertions of the past's potential promiscuity, the historian is not the guest at an orgiastic free-for-all. Richard J. Evans also suggests that historical accounts do have referential limits when he writes:

> Most historical narratives consist of a mixture of revealed, reworked, constructed and deconstructed narratives from the historical past and from the historians' own mind. We start with a rough-hewn block of stone, and chisel away until we have a statue. The statue was not waiting there to be discovered, we made it ourselves, and it would have been perfectly possible for us to have made a different statue from the

one we finally created. On the other hand, we are constrained not only by the size and shape of the original stone, but also by the kind of stone it is; an incompetent sculptor not only runs the risk of producing an unconvincing sculpture that does not much resemble anything, but also of hammering or chiselling too hard, or the wrong way, and shattering the stone altogether. (2000: 147)

Evans's position stands in contrast to Jenkins's, but also to that advocated by Hayden White. One of the most influential historians exploring the relationship between the past and its cinematic representation, White argues that historical writing is determined, not by the content of the past itself, but by historians' emplotment choices when they sit down to write it. In highlighting what he sees as the connection between historical writing and the rhetorical tropes of fictional writing – Comedy, Irony, Romance and Tragedy – he writes, 'How a given historical situation is to be configured depends on the historian's subtlety in matching up a specific plot structure with the set of historical events that he wishes to endow with meaning of a particular kind.' (1978: 85) White argues that attempts to impute a definitive meaning to the past through the imposition of narrative order effectively deny the past's open-ended nature. In arguing that narrative closes down interpretations of the past monolithically, White is challenging the methodologies of nineteenth-century realist historiography. He is encouraging historians to break with what he regards as the tyranny of causal explanation and striving to liberate those living in the present from the burden of the past. History, conventionally understood, is not simply the study of what has happened in the past, but also the study of change over time; therefore, any understanding of the past flows from analysing the causal development of change over time. Yet White appears to question the possibility of arriving at any level of historical explanation when, in an echo of Fredric Jameson's assertion that 'history is what hurts' (1986: 102), he argues that 'History is not something that one understands, it is something one endures – if one is lucky.' (2007: 110) For White, if the past is characterised by anything, it is randomness, and he suggests that the historian does the past a disservice by attempting to forge causal accounts of past events. Instead, he argues, 'we require a history that will educate us to discontinuity more than ever before; for discontinuity, disruption and chaos is our lot.' (quoted in Jenkins, 1995: 145) White challenges the dominant perspective of continual process and 'progress' associated with an Enlightenment

view of the past. His position, in one sense, is closer to that postulated by Marxist historians who have highlighted the negative side of historical development. Theodor Adorno, for instance, asserts that 'No universal history leads from savagery to humanitarianism, but there is one leading from the slingshot to the megaton bomb . . . the One and All that keeps rolling on to this day – with occasional breathing spells – would teleologically be the absolute of suffering'. (quoted in Eagleton, 1996: 50) But White's perspective of a past characterised by 'discontinuity, disruption and chaos' can also be contrasted with Karl Marx's argument that, in pursuing their own interests, classes come into conflict across different social formations and in different historical periods. For Marx, this conflict, which flows from the organisation of production, acts as the motor-force of historical development.[11] In *The Manifesto of the Communist Party*, Marx and Engels argue, therefore, that 'The history of all hitherto existing society is the history of class struggles.' (1980: 35) Marx is not arguing that *everything* that has happened in the past is part of the class struggle, but that the shape of history with a capital 'H' is ultimately determined by the class struggle. Echoing Marx's 'history as class struggle' thesis, Eagleton suggests that the past can be characterised by a process of continuous exploitation, at least for the majority of the population: 'if history really were wholly random and discontinuous, how would we account for this strangely persistent continuity? Would it not loom up for us as the most extraordinary coincidence – that a human history which according to some is just the ceaseless chance twist of the kaleidoscope should again and again settle its pieces into scarcity and oppression?' (1996: 51) For historians influenced by Marx, then, the past does indeed possess discernible patterns and, moreover, there are referential limits on historical representations of that past.

In debates surrounding one area of historically unparalleled oppression, the extermination of six million Jews in Germany during the 1930s and 1940s, the textualist approach of Jenkins and White becomes embroiled in considerable controversy. In an edited collection of essays on representations of the Holocaust, White argues that 'We can confidently presume that the facts of the matter set limits on the *kinds* of stories that can be *properly* (in the sense of both veraciously and appropriately) told about them only if we believe that the events themselves possess a "story" kind of form and a "plot" kind of meaning.' (1992: 39) Given that White has elsewhere argued against the idea that the past has either a story kind of form or a plot kind of

meaning, he calls into question the possibility that there are limits to how historical events can be represented. It would, however, be a mistake to impose a single reading across White's considerable body of work. Indeed, in an earlier essay in 1973, 'Interpretation in History', he argues against those who 'have taken more radical views on the matter of interpretation in history, going so far as to argue that historical accounts are *nothing but* interpretations'. (1973: 287) And in later work he argues 'Obviously, considered as accounts of events already established as facts, "competing narratives" can be assessed, criticized, and ranked on the basis of their fidelity to the factual record, their comprehensiveness, and the coherence of whatever arguments they may contain.' (1992: 38) It is difficult to escape the conclusion, however, that that is exactly the implication in at least some of his work. Not surprisingly, White's position provoked a sharp response: Saul Friedlander, for instance, argues that debates around the Holocaust 'must challenge theoreticians of historical relativism to face up to the corollaries of positions otherwise too easily dealt with on an abstract level'. (1992: 2) Other critics have also rejected White's position. Perry Anderson (1992: 64), for instance, comments that 'certain kinds of evidence preclude certain sorts of emplotment – the Final Solution cannot *historically* be written as romance or as a comedy', a position also adopted by other writers within the Marxist tradition (Callinicos, 1997: 73), in addition to more traditional historians. (Evans, 2000: 124)

In analysing contested twentieth-century history events, some of the practical implications of the linguistic turn's seemingly abstract theoretical formulations emerge. Reflecting on his experience fighting for the Republic, George Orwell forecast the problems future historians of the period would face when he wrote:

> How will the history of the Spanish war be written? If Franco remains in power his nominees will write the history books . . . But suppose Fascism is finally defeated and some kind of democratic government restored in Spain in the fairly near future; even then, how is the history of the war to be written? What kind of records will Franco have left behind him? Suppose even that the records kept on the Government side are recoverable – even so, how is a true history of the war to be written? For, as I have pointed out already, the Government also dealt extensively in lies. From the anti-Fascist angle one could write a broadly truthful history of the war, but it would be a partisan history, unreliable on every minor point. Yet, after all, some kind of history will be written, and after

those who actually remember the war are dead, it will be universally accepted. So for all practical purposes the lie will have become truth. (1968: 257)

An analysis of the conflicting accounts of the civil war's most infamous event serves to illustrate Orwell's fears. On the afternoon of 26 April 1937 church bells signalled an impending aerial attack on Guernica, the Basque country's spiritual centre. In the hours that followed, aircraft from the German Luftwaffe's Condor Legion and the Italian Aviazione Legionaria/Legionary Air Force conducted a mass aerial bombing of the small market town. Smaller fighters followed up, strafing the civilian population with low-level machine-gun fire. As is well known, the horror of the first mass aerial bombardment of a civilian population is represented graphically in Pablo Picasso's *Guernica*. When the mural was first unveiled at the Paris International Exposition during the 1937 World's Fair, the story goes that a German army officer approached the exiled artist, pointed to the painting and asked, 'Did you do that?' 'No, you did it,' came Picasso's caustic reply. Responsibility for the bombing was initially contested and, following Franco's victory, a generation of Spanish schoolchildren was educated with an official state version of these events that denied Luftwaffe responsibility. The history that they were taught asserted, in 'no, you did it' fashion, that anarchists had firebombed the town: a lie had become the state-sanctioned truth. Only in 1970, when those responsible had died or faded from power, did the dictatorship admit that the town had been bombed from above. (Thomas, 2003: 605–11) The question arises then: was the official state narrative as valid as the one offered by the journalists who interviewed eyewitnesses, scoured the scorched earth, located fragments of German bombs and reported their findings to the outside world? The logic of Jenkins's position seems to invite a positive response. According to Jenkins, 'The past can be described as an utterly "promiscuous past", a past which will, as it were, go with anybody; a sort of loose past which we can all have; the sort of past that is, arguably not much use having in the first place.' (1995: 8) What then of the attempts of the Holocaust-denying historian David Irving who, following a visit to Guernica in 1967, published research on the event which sought to diminish the extent of the casualties?[12] In one sense the conflicting histories of the bombing of Guernica lend weight to Jenkins's assertion: all sorts of histories can be, and have been, told about the event,

and none can lay claim to revealing or narrating its *absolute* truth. Perhaps the best that an examination of the traces of the past can reveal is all that can be known about the event in the present, not the totality of the event itself. The question remains, however, as to whether there are empirical limitations on the narratives that can be *legitimately* constructed about the bombing of Guernica, the Spanish Civil War, or, for that matter, any historical period.

The example of Guernica indicates that narratives may well be emplotted; however, they come up against referential limits. Moreover, unless one gives up on the possibility of historical understanding, as White, at least at times, appears to desire, then surely not all emplotments will have the same explanatory powers? The past as chaos, as class struggle, as cyclical – narrative patterns, which, as I will show later, also emerge in cinema – are theoretical formulations that can be tested empirically, or in White's words, 'ranked on the basis of their fidelity to the factual record'. Narrative, then, is an integral tool in any attempt to arrive at an understanding of the past. While narrative may be linked to questions of human desire to control the past, it also presents an opportunity to work through why one process leads to one particular set of results rather than another. As Roland Barthes highlights, moreover, narratives are ubiquitous throughout human history:

> The narratives of this world are numberless . . . Able to be carried by articulated language, spoken or written, fixed or moving images, gestures, and the ordered mixture of all these substances; narrative is present in myth, legend fable, tale, novella, epic, history, tragedy, drama, comedy, mime, painting . . . stained glass windows, cinema, comics, news items, conversation. Moreover, under this almost infinite diversity of forms, narrative is present in every age, in every place, in every society; it begins with the very history of mankind and there nowhere has been a people without narrative. All classes, all human groups, have their narratives, enjoyment of which is very often shared by men with different, even opposing, cultural backgrounds. Caring nothing for the division between good and bad literature, narrative is international, transhistorical, transcultural: it is simply there, like life itself. (1993: 251)

Narrative, then, is vital for developing historical understanding. Indeed, even White's position that the past is marked by 'discontinuity, disruption and chaos' is itself a narrative. Narrative, substantiated by empirical evidence, cannot assert the absolute truth of the Holocaust or the bombing of Guernica, but it is the most effective tool

that can be deployed against those who wish to wilfully construct fictitious accounts of the past. Eric Hobsbawm asserts that 'More history than ever is today being revised or invented by people who do not want the real past, but only a past that suits their purpose. Today is the great age of historical mythology. The defence of history by its professionals is today more urgent in politics than ever.' (2002: 296) This necessity is illustrated by the political controversy surrounding the introduction of the Law of Historical Memory, which highlights the dialectical interaction between the past and the present. This book, then, is informed by debates pertaining to written history, but explores their impact on cinematic representations of the past, to which we now turn.

Film and history

When moving photographic images were first projected on to cinema screens at twenty-four frames per second they heralded an unprecedented visual experience, one that appeared to perfectly capture movement and action and, thereby, create the illusion of real life. As one of the early theorists of the moving image, André Bazin, suggests

> The guiding myth, then, inspiring the invention of cinema, is the accomplishment of that which dominated in a more or less vague fashion all the techniques of the mechanical reproduction of reality in the nineteenth century, from photography to phonograph, namely an integral realism, a recreation of the world in its own image, an image unburdened by the freedom of interpretation of the artist or the irreversibility of time. (1967: 17)

Filmmakers regularly exploited this apparent ability to recreate 'the world in its own image' and innumerable important historical films were produced in cinema's formative years, including *Birth of a Nation* (Griffiths, USA, 1915), *Oktyabr/October* (Eisenstein, USSR, 1927) and *La vida de Cristóbal Colón y su descubrimiento de América/The Life of Christopher Columbus and his Discovery of America* (Gérard Bourgeois, France/Spain, 1916). Today the cinematic appropriation of the past is widespread, apparent in countless Hollywood blockbusters and European art-house films. Of course, the relationship between cinema and reality and cinema and the past is more complicated than simple mimetic reproduction, and complicated further if we turn our attention to fictional cinema.

Academic film critics have too often ignored historical details in their analyses; conversely, historians have tended to neglect filmed representations of the past. With the increased proliferation of screen images in contemporary culture this is beginning to change, and cinema increasingly attracts historians' interest.[13] Perhaps the most influential writer on the relationship between film and history in recent years is the historian Robert A. Rosenstone who, subsequent to his involvement in feature film production, began to question the relationship between the past and its cinematic depiction.[14] Rosenstone highlights a number of points which, he argues, apply to mainstream cinematic representations of the past, summarised as follows: it constructs a story with a beginning, middle and, usually, an optimistic ending, regardless of the setting; it focuses on the actions of individuals (usually men) and tends to offer individual solutions to historical problems; it tends to offer up history as a closed, completed and simple past with little room for alternatives or questions; in its drive for drama it tends to concentrate on the emotional and personal implications of the past; it strives to give audiences the look of the past; and, finally, rather than separating different aspects of the past, mainstream film shows history as process by bringing many disparate elements together. We will test Rosenstone's position later; for now, it is important to recognise that although written history traditionally occupied a privileged space in relation to fidelity and accuracy, cinema, like literature, has increasingly been recognised as a valid way of representing the past.

In his study of the historical film, Rosenstone highlights two approaches that can be adopted. What he outlines as the 'explicit approach' suggests that films are 'reflections of the social and political concerns of the era in which they were made', which, he argues, can be read 'historically'. He finds this unsatisfactory, however, in that this 'provides no specific role for the film that wants to talk about historical issues. Nor does it distinguish such a film from any other kind of film.' He questions, moreover, why written works of history should not be treated with the same degree of scepticism. (1995: 48) Broadly speaking, this argument suggests that a Spanish film made about the civil war in the 1940s is likely to reveal more about Franco's post-war regime than about the conflict itself. In contrast, what he describes as the 'implicit approach' views the historical film as a written historical account projected on to a cinema screen. For Rosenstone, this approach involves subjecting the historical film to

the same judgements (the need for evidence, sources etc.) that are employed in historiographical practice. Rosenstone suggests that there are two problematic assumptions with this position: firstly, that written accounts are the only way to represent the past and, secondly, that these written accounts reflect 'reality'. (1995: 49) Rosenstone suggests that, rather than starting from the initial question of how historical films differ from written history, there are three questions which have to be posed first: 'What sort of historical world does each film construct and how does it construct that world? How can we make judgements about that construction? How and what does that historical construction mean to us?' (1995: 50) It is only after these three questions have been responded to that Rosenstone suggests we can ask how the on-screen world corresponds to written history. (1995: 50)

Rosenstone is struggling to break with the idea that written history is somehow superior to cinematic history, but also suggesting that cinema need not follow the rules of historiography. Although cinema is generally unburdened by the demands for objectivity that are placed on the historian's shoulders, it is notable nevertheless that films that depart from the established historical record regularly provoke controversy. It is not my intention here to critique films primarily on the basis of their fidelity, or otherwise, to the historical events that they purport to depict. Indeed, the most mundane discussions on film and the past involve debates over the inclusion, omission or slight departure from established historical evidence. What I am interested in exploring in the following chapters is both the diverse ways in which cinema can represent one event, the elasticity of the event and the efficacy of the representational techniques of varying film forms. In contrast to mainstream cinema, Rosenstone celebrates an experimental cinema which, in his words, 'Rather than opening a window directly onto the past . . . opens a window onto a different way of thinking about the past.' (1995: 63) This experimental cinematic practice – which for Rosenstone includes works such as *Sans Soleil* (Marker, France, 1983), *Shoah* (Lanzmann, France, 1985) and *Walker* (Cox, USA/Mexico/Spain, 1987) – consciously reveals the cinematic apparatus as a construction, in contrast to mainstream cinema, which, primarily, strives to mask its constructed nature. Similarly, White (1996: 18) champions the alternative cinematic style of what he titles '*post-modernist*, para-historical representation', suggesting that this is evident in films such as *The Night Porter* (Cavani, Italy, 1974), *The*

Return of Martin Guerre (Vigne, France, 1982) and *JFK* (Stone, USA/ France, 1991), and arguing that it is best placed to represent what he terms '"holocaustal" events', twentieth-century events such as the two world wars which, as he puts it, 'do not lend themselves to explanation in terms of the categories of traditional humanistic historiography'. (1996: 21) White does not suggest that these events, to which we could add the Spanish Civil War, are unrepresentable, but that they require non-realist representational techniques to adequately grasp their complexity. (1996: 21) In arguing that it is necessary to create a different way of thinking about the past on film, White calls for a cinematic practice in which 'Everything is presented as if it were of the same ontological order, both real and imaginary, with the result that the referential function of the images of events is etiolated.' (1996: 19) In this cinema, he claims that the outcome is '"History as you like it", representations of history in which anything goes.' (1996: 19) Rosenstone and White, then, argue for representational forms that parallel Modernist techniques of representation; forms that break free from attempts to capture totality and embrace objectivity, and that celebrate contingency.

Rosenstone's and White's position is certainly persuasive: self-reflexive cinema can open up a critical distance between spectator and screen, thereby allowing audiences to reflect on the constructed nature of what is projected. But they are less clear about the impact of films which reject this approach. Despite their perceived limitations, can mainstream or realist films invite, or provoke, a historical consciousness among audiences? Put another way, can audiences only think historically under the correct cinematic conditions? There are countless examples of mainstream or realist films which, through their content alone, do invite historical contextualisation. Let me step away from the Spanish Civil War to illustrate this point. *Michael Collins* (Jordan, UK/Ireland/USA, 1996), an epic historical drama set during the partition of Ireland in the early twentieth century, details the role of the eponymous president of the Irish Republican Brotherhood in signing the Anglo-Irish Treaty and his assassination at the hands of dissident Republicans. Released at a time when the IRA was on ceasefire, it was not difficult to discern parallels between the figure of Collins and that of Gerry Adams, the then-president of Sinn Fein, who, at the time, was working to prevent splits developing within Irish Republicanism. The film's content alone, therefore, is sufficient to allow historically informed viewers to historicise Irish politics without

the inclusion of self-reflexive cinematic devices. A similar process is also evident in *Katyn* (Wajda, Poland, 2007), a realist rendering of the events surrounding the 1940 Katyn massacre in which the Red Army executed thousands of Polish officers and *intelligentsia* and subsequently claimed that German soldiers had carried out the massacre the following year. In one touching scene, a woman attempts to place a gravestone inscribed with the date '1940' above her partner's grave. The gravestone's historical record must correspond with the official Russian narrative, however, and so the authorities prevent her from laying the stone. While not calling into question the ideological positioning of its own narrative, *Katyn* nevertheless highlights the way in which representations of the past occupy a continuous site of struggle, in this case between individual experience and official state accounts. As both these examples demonstrate, then, self-reflexive cinema does not have a monopoly on enabling audiences to think historically. A film form which positively foregrounds the nature of historical representation *is* more likely to heighten the relationship between the past and its cinematic depiction in the present; however, there is no straight binary between realist and experimental modes of representation in their ability to provoke reflection on the past and its cinematic recreation. Questions of film form and representation are returned to in the following chapters, testing Rosenstone's and White's ideas against a specific body of films, but first let us turn to the Spanish Civil War in cinema.

Cinema and the Spanish Civil War

Before I get to the films that I will be discussing in greater detail, an overview of cinematic depictions of the civil war will provide a useful backdrop.[15] The civil war was one of the first major international conflicts since the arrival of cinematic sound in 1929 and film became a widely utilised weapon in the propaganda war.[16] Newsreel footage and documentaries were produced regularly but a small number of fictional features were also released.[17] On the pro-Republican side a range of films was released throughout the territory under their control. For instance, following the collectivisation of cinema production in Catalonia, part of the social revolution in the area, the Sindicato Único de la Industria de Espectáculos Públicos/ Entertainment Industry Trade Union (SIE) produced a number of propagandist films including *Aurora de Esperanza/Dawn of Hope* (Sau,

1937), which follows a young worker whose everyday experiences lead him to enlist in the CNT.[18] Filmmakers from outside Spain also made notable contributions including *The Spanish Earth* (Ivens, USA, 1937), *L'Espoir/Man's Hope* (Malraux/Peskin, Spain/France, 1939–45), an adaptation of the last chapter of André Malraux's celebrated novel, and *Ispaniya/Spain* (Shub, USSR, 1939), a documentary highlighting Soviet support for the Republic.[19] *Las Hurdes/Land without Bread* (Buñuel, Spain, 1933), Luis Buñuel's enigmatic ethnographic documentary account of the lives of the rural population of Las Hurdes, was also re-released with additional intertitles championing the Republican cause.[20] In Nationalist-controlled Spain, the Departamento Nacional de Cinematografía was established in 1938; however, the fact that the main film production centres were in Republican territory – in Barcelona, Madrid and Valencia – limited Nationalist indigenous output.[21] Instead, the main contribution in Nationalist Spain came from Hispano-Film Produktion, a private German-Spanish company that made traditional pro-Spanish films such as *El barbero de Sevilla/The Barber of Seville* (Perojo, Germany/Spain, 1938) and *Suspiros de España/Sighs of Spain* (Perojo, Germany/Spain, 1939).

In the years immediately following Franco's victory the conflict was exclusively represented as a just and righteous crusade against atheism, communism and freemasonry. This is evident in the early output of the state-run cinema news service Noticiarios y Documentales Cinematograficos (NoDo),[22] but also in a number of films produced in the immediate post-war period. *Raza/Race* (Sáenz de Heredia, Spain, 1941), for instance, scripted by the dictator himself, glorifies Spain's past through a melodramatic account of the family of a gallant military figure – a thinly disguised Franco.[23] Militaristic glorification is also prominent in *Sin novedad en el Alcázar* (Genina, Italy/Spain, 1940), a reconstruction of the infamous siege of Alcázar when Republican forces besieged Nationalist troops for two months in the summer of 1936.[24] *¡A mí la legión!* (Orduña, Spain, 1942), which takes its title from the unofficial battle cry of the Spanish Foreign Legion and stars Alfredo Mayo as a young and valiant legionnaire during the conflict, also follows this trend. One of the leading Spanish actors of his generation, Mayo also features in *Raza* and *El santuario no se rinde* (Ruiz Castillo, Spain, 1949) in which he reprises his role as a Nationalist soldier, this time one caught up in the conflict.[25] Marsha Kinder points out, however, that after the initial burst of civil war

films in the 1940s and 1950s, the number of cinematic depictions of the conflict decreased because, as she suggests, 'it was perceived as a threat to the monolithic unity imposed by Franco and to his ongoing process of defascistization'. (1993: 38) The 1950s also witnessed a change in register and a series of films emerged which attempted to take a conciliatory approach. *La fiel infanteria/The Loyal Infantry* (Pedrom Lazaga, Spain, 1959) and *Tierra de todos/Land of All* (Antonio Isasi Isasmendi, Spain, 1961) aimed, as Paloma Aguilar puts it, 'to overcome the divisions that had taken place among Spanish families and emphasise the humanitarian and Christian values of reconciliation'. (2008: 134) The twenty-fifth anniversary of the dictatorship, officially referred to as '25 Años de Paz/25 years of peace', was marked by the release of the documentary *Franco ese hombre/That Man Franco* (Sáenz de Heredia, Spain, 1964), which charted Franco's career, including his civil war years. Rafael de España suggests (1986: 229) that 'Once the twenty-fifth anniversary was over films about the war almost disappeared from Spanish screens.' Yet films such as *Posición avanzada/Advanced Position* (Lazaga, Spain, 1965) and *Golpe de mano/Surprise Attack* (De la Loma, Spain, 1968) ensured that the civil war remained on screen, although as with previous films, always refracted through the lives of Nationalist soldiers.

Immediately following the Nationalist victory there was no space for oppositional filmmakers' views and it was only in the dictatorship's latter years that alternative views began to emerge. Franco's death and the abolition of censorship, however, enabled a cinematic re-examination of the conflict. Very occasionally films were released which were sympathetic to the Nationalist soldiers – for instance, *¡Biba la banda!* (Palacios, Spain, 1987). However, the overwhelming majority of films represented the conflict from a Republican perspective. Barry Jordan and Rikki Morgan-Tamosunas argue that during the transition from dictatorship to democracy, 'Spanish cinema was seriously concerned with recuperating a historical past and a popular memory that had been denied, distorted or suppressed under the Franco dictatorship.' (1998: 11) This process is evident in politicised documentaries such as *La vieja memoria/The Old Memory* (Camino, Spain, 1977) and *¿Por qué perdimos la guerra?/Why Did We Lose the War?* (Santillán, Spain, 1978). A more indirect approach is adopted in *Raza, el espíritu de Franco/Race, The Spirit of Franco* (Herralde, Spain, 1977), which includes interviews with Alfredo Mayo about his involvement in Francoist cinema and deconstructs the glorious

past that Franco had depicted for himself in *Raza*. The initial move to debate the civil war's central political concerns in documentary cinema was not, however, matched in feature film production. Writing in 1998, Antonio Monegal argues that at this time the film industry was complicit in the attempt to ease the transition from dictatorship to democracy at the expense of examining the more painful aspects of the civil war. He notes that, even after Franco's death, the civil war has rarely been the 'subject of a film that represented the war *as such*' (1998: 203) Monegal argues that, although there are numerous films which utilise a civil war or post-civil war setting, the event was continually represented in the private sphere. (1998: 203–4) Monegal cites as an example *Dragon Rapide* (Camino, Spain, 1986), which takes its title from the aircraft that transported Franco to mainland Spain in July 1936, and critiques it on the basis that its representation of the civil war 'is treated more in terms of individual dilemmas and family environment than of the forces in play'. (1998: 212) The manner in which the civil war is refracted through familial conflict is evident in a number of other films of the period including *Retrato de Familia/ Family Portrait* (Giménez Rico, Spain, 1976), *Las largas vacaciones del 36/The Long Vacation of 1936* (Camino, Spain, 1976) and *Las bicicletas son para el verano/Bicycles are for Summer* (Chávarri, Spain, 1984).[26] The focus on those embroiled in a conflict beyond their full comprehension is the focus of *Soldados/Soldiers* (Ungría, Spain, 1978), which follows a group of non-political Republican soldiers. *Soldados* exemplifies Roman Gubern's observation that in many of these films the dominant theme was that everyone had lost the war. (1991: 104) Jordan and Morgan-Tamosunas note that of 300 historical films released between the 1970s and 1998, the majority were set in the period between 1931 and 1975. (1998: 16) Yet although there was a turn to the past in this period, there has also been a turning away from the past's political complexities. Commenting on two films set during the civil war or in its immediate aftermath, *La lengua de las mariposas/Butterfly's Tongue* (Cuerda, Spain, 1999) and *El portero/ The Goalkeeper* (Suárez, Spain, 2000), for instance, Paul Julian Smith notes that the treatment of the subject has often been trivialised. (2007: 6) Yet, despite producing films of varying levels of insight and political engagement, the civil war continues to attract filmmakers' attention. Other more recent notable additions to the corpus of civil war films include *La hora de los valientes/A Time for Defiance* (Mercero, Spain, 1998), set partly in Madrid's Prado Museum, *El viaje de Carol/*

Carol's Journey (Uribe, Spain, 2002), an account of a young girl's journey from New York to war-torn Spain in spring 1938, and *Las 13 Rosas/13 Roses* (Martínez Lázaro, Spain, 2007), in which thirteen young left-wing activists are executed in the civil war's aftermath. The release of *Caracremada* (Galter, Spain, 2010), an account of an anarchist guerrilla who, following the CNT's instructions in 1951 to disband its resistance, retreats to the woods to continue the struggle, is indicative of a continuing trend.

Outside Spain the civil war has, understandably, not attracted similar levels of interest. There are numerous documentaries, although space precludes a detailed listing, but also a number of fictional features. Aside from the films under discussion below, perhaps the most significant include a number of US films: *The Angel Wore Red* (Johnson, Italy/USA, 1960), which recounts the tale of a priest who travels to fight in Spain, is unsympathetic to the Republic; *Behold a Pale Horse* (Zinneman, USA, 1964) is based on the exploits of real-life figure, Francesc Sabaté Llopart, popularly known as El Quico, an anarchist *maquis*, as he is pursued by a Spanish police chief; *Disappearance of Garcia Lorca* (Zuringa, Spain/France/USA/Puerto Rico, 1996) explores the Spanish poet's execution; and more recently *There be Dragons* (Joffe, USA/Argentina, 2011) deals with the origins of Opus Dei during the civil war's early years. There is also the rare example of United States television being attracted to the subject with *Hemingway & Gellhorn* (HBO, 2012), which is based on the lives of the two great American writers.

Two important films were released in France: *La guerre est finie/War is Over* (Resnais, France, 1966) centres on the life of Diego, a veteran communist working in the underground, while *Fiesta* (Boutron, France, 1995) is a rather unsympathetic portrayal of Nationalist soldiers.[27] The conflict's increasing commercial appeal is exemplified by the co-production *Head in the Clouds* (Duigan, UK/Canada, 2004), starring Charlize Theron and Penelope Cruz, in which the civil war is only one historical backdrop to a tale of pre-Second World War romance. This is a far from exhaustive list, but it highlights the breadth of cinematic representations of the conflict which forms a backdrop to the discussion which follows.

The selection of films under discussion charts the way that the Spanish Civil War has been re-visited, or re-pictured, since the end of the conflict by those sympathetic to the Republican cause – by those who, to paraphrase Hobsbawm, wielded the camera on behalf

of the defeated. As previously outlined, it is widely accepted that cinema's strength lies in its ability to recreate what the past may well have looked like, although as we will see, cinema has the capacity to recreate the look of the same event in widely differing aesthetic styles. Chapter one focuses on *For Whom the Bell Tolls* (Wood, USA, 1943), an adaptation of Ernest Hemingway's best-selling novel, but also touches on *Blockade* (Dieterle, USA, 1938) and *The Spanish Earth*. The chapter examines how Hollywood appropriated Hemingway's novel as part of a broader move to construct cinematic depictions of the Spanish Civil War suitable to wartime America's needs. Chapter two explores the East German film *Fünf Patronenhülsen/Five Cartridges* (Beyer, GDR, 1960), charting the way that the film corresponded with the then-ruling Socialist Unity Party's desire to construct an anti-fascist national heritage, one which valorised the International Brigades as part of the attempt to legitimise the existence of the East German state and its communist leadership, many of whom had fought for the Republic. Chapter three turns west, to Paris, the exiled residence of Fernando Arrabal, and to two films that he directed, *¡Viva La Muerte!/Long Live Death!* (Arrabal, France/Tunisia, 1971) and *L'arbre de Guernica/The Tree of Guernica* (Arrabal, France/Italy, 1975). A former member of the Paris Surrealist Group and co-founder of the experimental theatre group Panique, Arrabal drew on his childhood experiences in Spanish-controlled North Africa during the 1930s to create two searing, surrealist-inspired films melding autobiography and history.

In contrast, chapter four examines how oppositional filmmakers within the country presented alternative views to the official state narrative during the dictatorship's latter years. The chapter focuses on the work of Carlos Saura, particularly *La caza/The Hunt* (Saura, Spain, 1966) and *El jardín de las delicias/Garden of Delights* (Saura, Spain, 1970). The chapter examines how filmmakers, unable to deal directly with their subject matter due to censorial constraints, employed metaphorical and allegorical filmmaking to comment obliquely on the conflict. The films under examination in the final five chapters were all released after Franco's death and indicate the breadth of filmmaking that has emerged on the subject in more recent times. Chapter five examines the Basque-set historical drama *Vacas/Cows* (Medem, Spain, 1992), which places the civil war within the context of the Basque country's violent past and highlights the importance of understanding the conflict's nationalist dimension. The chapter also engages with

the cyclical view of history that the film presents, contrasting it with the historiographical perspectives outlined above. Thomas (2003: 919) argues that the conflict was 'essentially a tragedy'; chapter six, then, analyses whether it is possible to narrativise the civil war as a comedy through an exploration of four Spanish productions from the 1980s and 1990s that utilise comic elements: ¡Ay Carmela! (Saura, Spain, 1990), Belle Époque (Fernando Trueba, Spain, 1992), La vaquilla (Berlanga, Spain, 1985) and Libertarias/Libertarians (Aranda, Spain, 1996). Shifting from comedy to horror, chapter seven deals with how the civil war is represented by the Mexican-born filmmaker, Guillermo del Toro, concentrating particularly on El espinazo del Diablo/The Devil's Backbone (del Toro, Spain/Mexico, 2001), a ghost story set in the civil war's closing months, and the relationship between the figure of the ghost and the past. Although by 1995 the civil war had been the subject of numerous Spanish films, as Richard Porton points out 'even the free-wheeling post-Franco Spanish cinema has been extremely reluctant to tackle some of the thornier issues of the Civil War period'. (1996: 34) Chapter eight, then, explores how the 'thorny' issue of inter-Republican conflict is represented in Land and Freedom/Tierra y Libertad (Loach, UK/Spain/Germany/Italy, 1995), an overtly political cinematic engagement with the period that resurrects the conflict's revolutionary dimension. This chapter also explores the capacity of non-self-reflexive cinema to foster a historical consciousness in audiences. In chapter nine the focus is on Soldados de Salamina/Soldiers of Salamina (David Trueba, Spain, 2002) an adaptation of Javier Cercas's best-selling novel, which in both content and form call into question the possibility of accessing the past along the lines suggested by Jenkins, Rosenstone and White. In returning to material first discussed in the introduction, chapter nine also functions, in part, as a theoretical conclusion to the book. The conclusion itself gathers together the various threads that have been explored throughout the book and argues that, while the memory and meaning of the Spanish Civil War remain hotly contested, the civil war setting will be one to which filmmakers increasingly turn.

Notes

1 For a comprehensive, if slightly dated, account of further reading on the Spanish Civil War as a literary phenomenon see Peter Monteath, *The Spanish Civil War in Literature, Film and Art: An International Bibliography*

of Secondary Literature (1994a). For an analysis by the same author see (1994b). For poetry, see Valentine Cunningham (ed.), *The Penguin Book of Spanish Civil War Verse* (1980).

2 See, for instance, Weintraub (1968).

3 See Thomas (2003: 99–104) for more information on Casas Viejas and the 1933 elections.

4 George Orwell's *Homage to Catalonia* provides a vivid eyewitness account of these events. For a recent analysis, and one which is more sympathetic to the mainstream Republican position, see Helen Graham (2002), chapter five.

5 For an overview of the conflict's international dimensions see Michael Alpert (1994).

6 The Republican government offered to withdraw the International Brigades in return for the withdrawal of German and Italian military support.

7 For more information on Franco's repression see Michael Richards (1996) and (2006).

8 Anarchist accounts of the event have been marginalised, but see Stuart Christie, *We, The Anarchists!: A Study of the Iberian Anarchist Federation (FAI) 1927–1937* (2000), Robert Alexander's two-volume *The Anarchists in the Spanish Civil War* (1999) and José Peirats, *The CNT in The Spanish Revolution* (2001).

9 It is not the first time that the ability to access knowledge about the world has been under assault. Sextus Empiricus, for example, a philosopher of the late second and early third century AD, developed a mode of thought named after the philosopher Pyrrho of Elis. This philosophy came to be known as Pyrrhonism, an extreme form of scepticism that asserted that it was necessary to suspend judgement on whether it is possible to know true reality. Pyrrhonism does not suggest that reality can be known, or not known, but that it is not possible to assert a definite response to the question. It is a philosophical approach that has reappeared occasionally over the years; for instance, during the sixteenth century Pyrrhonists attacked history as both useless and inaccurate, suggesting that the laws of literary composition governed it. For further information see Alan Bailey (2002).

10 For Nietzsche, the past represents a chaotic mass of events that is only attributed meaning by those writing in the present; thus he argues 'you can explain the past only by what is most powerful in the present'. (quoted in Hutcheon, 1988: 98)

11 In arriving at what he described as the 'materialist conception of history', Marx was indebted to G. W. F. Hegel's work on contradiction and negation.

12 The German-language book is available at www.fpp.co.uk/books/Guernica/index.html.

13 In *The Spanish Civil War: Access To History in Depth*, for instance, an English-language textbook for higher education students, Patricia Knight recommends that readers view *Land and Freedom/Tierra y Libertad* (1998: 130).

14 Rosenstone worked as a historical adviser on both *The Good Fight: The Abraham Lincoln Brigade in the Spanish Civil War* (Buckner, Dore and Sills, USA, 1984), a documentary focusing on members of the International Brigades who travelled from the USA to fight in Spain, and the Russian Revolution drama about the life of the US writer and revolutionary socialist, John Reed, *Reds* (Beatty, USA, 1981).

15 Throughout this book I refer mostly to the English titles of foreign-langauage films. There are some films, however, such as *Vacas* and *Soldados de Salamina*, which are mostly known internationally by their original titles and in these cases the originals have been used.

16 Alfonso del Amo García (1996) provides an extensive catalogue of over 1000 films featuring the Spanish Civil War. Rafael de España (1986) provides an overview of Spanish feature-length films set during the conflict. A continuously updated Spanish-language website of civil war films is available at www.uhu.es/cine.educacion/cineyeducacion/historia_guer racivil.htm. In an interesting aside, one of the cinematic apparatus's more practical uses occurred during the bombing of Madrid when, owing to inadequate anti-aircraft defences, cinema projectors were deployed as searchlights to spot Nationalist aircraft. (Fraser, 1988: 175)

17 For an analysis of the British newsreel footage see Anthony Aldgate (1979).

18 See Diez (2009) and Porton (1999: 76–96) for information on anarchist cinema during the civil war.

19 For further reading on Malraux and L'Espoir see Michalczyk (1977) and Michalczyk and Villani (1992).

20 For an analysis of the Spanish Civil War in documentary cinema, specifically *The Spanish Civil War* (Granada TV, 1983), *Mourir à Madrid/To Die in Madrid* (Rossif, France, 1963), *The Good Fight: The Abraham Lincoln Brigade in the Spanish Civil War* and *El Perro Negro: Stories From the Spanish Civil War* (Forgács, Netherlands/France/ Finland/Spain, 2006), see Rosenstone (2006: 70–88).

21 An overview of filmmaking on both sides during the civil war is provided by Triana-Toribio (2003: 31–7).

22 Noticiarios y Documentales Cinematograficos (NoDo) were produced between 1943 and 1975. For more information on these documentary films see Ellwood (1995) and Aguilar (2008: 49–54).

23 The 1941 version concludes with a montage of fascist salutes; however, these were edited out of the re-released 1949 version, in accordance with Spain's desire to establish more cordial links with the USA.

24 The events of the siege are still glorified by the Spanish army at the military museum in Toledo where the official brochure states: 'The 70-day defence of the Alcázar, under the command of Colonel Moscardó, became world famous and has become a page of Spanish history of epic grandeur, serving as a sublime example of heroism and of sacrifices made for the highest ideals' (brochure distributed on a visit to the museum, October 2002). The museum remains as a monument to the Nationalist forces and displays the supposedly untouched remains of the room where Colonel Moscardó conducted a telephone conversation with his son who had been captured by Republican soldiers and was due to be executed. His speech advising him to prepare to meet his maker is displayed on a wall. It is inconceivable that a display like this glorifying a similar wartime episode could exist in either Germany or Italy, and the display is testimony to the complex way in which the country memorialises its past.

25 Ruiz Castillo also directed a number of short documentaries during the war including *Guerra en el campo* (Spain, 1936) and *Un año de guerra* (Spain, 1937).

26 In *Cain on Screen: Contemporary Spanish Cinema*, an extensive study of Spanish Civil War films, Thomas G. Deveny uses the theoretical framework of *Cainismo*, which he describes as 'a fraternal antagonism within Spanish society', to analyse a number of civil war films. (1993: 5) Flowing from an analysis of the nation state as a collective unit with its population sharing a communal interest, the theoretical model of *Cainismo* unsuccessfully attempts to transcend barriers of class, gender and national identity, leaving it unable to deal with the complexities of the films it strives to analyse.

27 Resnais also directed a short experimental film, *Guernica* (France, 1955).

Hollywood and the Spanish Civil War: *For Whom the Bell Tolls*

> Now it is necessary that we see the democratic-fascist battle as a whole and recognize that what the Loyalists were fighting for is essentially the same thing that we are. To focus too much attention on the chinks in our allies' armour is just what our enemies might wish. Perhaps it is realistic, but it is also going to be confusing to American audiences.
>
> US Office of War Information *For Whom the Bell Tolls* script review, 14 October 1942 (quoted in Koppes and Black, 2000: 71)

At the height of the 2008 United States presidential campaign, the Democratic and Republican Party candidates, Barack Obama and John McCain, both listed *For Whom the Bell Tolls* among their favourite novels, their literary tastes highlighting the enduring appeal of Ernest Hemingway's Spanish Civil War epic, at least in the US. (Keller, 2008) The novel was first published in 1940, and Paramount Pictures released a cinema adaptation in 1943. An analysis of the film and its transition from page to screen forms the main part of this chapter.[1] As background to this analysis, and in order to highlight the changing nature of US cinematic depictions of the conflict during this period, I briefly examine two US films set during the civil war that were produced and released while the conflict was still underway, *Blockade* (Dieterle, USA, 1938), and *The Spanish Earth* (Ivens, USA, 1937). Guy Westwell notes that during the civil war 'The American government's isolationist stance, and the continued difficulty of reconciling the ethnic allegiances and political beliefs of Hollywood's varied audiences, resulted in an avoidance of divisive war themes.' (2006: 26–7) When the US entered the Second World War following the bombing of Pearl Harbor on 7 December 1941, however, Hollywood's representation of the conflict became pro-Republican. This is evident in *For Whom the Bell Tolls* and in a further four films – *Casablanca* (Curtiz,

USA, 1942), *The Fallen Sparrow* (Richard Wallace, USA, 1943), *Watch on the Rhine* (Shumlin, USA, 1943) and *Confidential Agent* (Shumlin, USA, 1945) – all of which represent US citizens as central agents in the anti-fascist struggle during the Spanish Civil War. The shifting manner of US cinematic representations of the conflict provides an example of what Hayden White describes as 'willing backwards', a process in which the past is re-narrativised in the interests of those in the present. This analysis of *For Whom the Bell Tolls* will indicate, then, the way in which Hollywood attempted to, metaphorically, rewind the spool of history to appropriate and represent the Spanish Civil War in a manner befitting the needs of wartime USA.[2] The chapter also explores the way in which *For Whom the Bell Tolls* fits with Rosenstone's assertions with regard to the mainstream historical film as discussed in the introduction.

Blockade and *The Spanish Earth*

The Spanish Earth was commissioned by Contemporary Historians Inc., an organisation established by prominent, US-based, left-wing writers and artists, which invited the celebrated documentarian, Joris Ivens, to travel to Spain to make a film that could raise awareness of the civil war among a largely uninformed American public.[3] In January 1937 the US Congress had passed the Embargo Act prohibiting the export of arms to either side; however, as Germany and Italy were supporting the Nationalists, this seemingly neutral position effectively aided Franco. In this context, *The Spanish Earth* was part of the campaign to build support for the Spanish government and to overturn the US government's non-intervention policy.[4] The film is set in and around the town of Fuentiduena, Madrid, and battlefronts along the key highway connecting Valencia and the besieged capital. The civil war's impact on civilian life is captured in actuality footage of the after-effects of air strikes – strikingly encapsulated in a shot of two young boys lying lifeless on the floor – and is contrasted with the dramatic reconstruction of village life. While the bombing sequences represent the Spanish people as almost anonymous victims of war, the narrative reconstruction of peasant life, personified by the focus on one villager, Julian, and his family, represents the peasants as positive historical agents. Ernest Hemingway's narration displays a clear sympathy for the villagers' daily struggle: 'this Spanish Earth is dry and hard and the faces of the men who work that earth are dry and hard

from the sun'.[5] Although overly dramatic in the battle sequences, for instance when Hemingway asserts that 'men cannot act before the camera in the presence of death', the narration adds a sincere and sympathetic, personal and poetic tone in its description of peasant life. The connection of the peasants' struggle with the needs of the land is continued throughout and the film concludes with a sequence of water cascading over the arid earth.

Although *The Spanish Earth* is overtly supportive of the Republican cause, the identity of the opposition is extremely vague. There is no attempt to explain the civil war's complex political background, with Hemingway describing the 'enemy' simply as 'they'. The film, moreover, oversimplifies the political issues at stake by suggesting that the passivity of village life is under threat from alien fascist aggression, even if fascism itself is mentioned only once, and then by a speaker at a rally. There is no mention of Franco and no mention of wider social demands beyond the peasants' desire for land. The filmmakers also minimise communist involvement: La Pasionaria, Dolores Ibárruri, a leading communist member of the Spanish parliament, is referred to as 'the wife of a poor miner in Asturias' and General Lister, another prominent communist who had studied at the Freunze military academy in the Soviet Union, is casually described as having risen 'from a simple soldier to the command of a division'.[6] It is not surprising, then, that following one screening a *New York Times* columnist could write 'the Spanish people are fighting, not for broad principles of Muscovite Marxism, but for the right to the productivity of a land denied them through years of absentee landlordship'. (quoted in Waugh, 1998: 152) Despite its deliberately vague politics, *The Spanish Earth* remains a haunting cinematic account of the experience of those struggling against fascism, the rough nature of the black-and-white cinematography bringing an immediacy that authenticates the on-screen reality.

The desire to broaden the film's appeal and impact results in a representation of the conflict that sidesteps any problematic political concerns; moreover, it presents the conflict as one not directly involving US citizens. A similar process is evident in *Blockade*. Although the opening intertitles state 'Spain: the Spring of 1936', there is no subsequent mention of any events of the period, leaving nothing much more than a love story set against a standard spy plot.[7] This partly flows from the strategy adopted by the filmmakers – to select a familiar cinematic genre and use conventional Hollywood strategies to reach a

wide audience – but also from its production context. Joe Breen, head of the Production Code Authority, the industry's self-regulating body, sternly advised producer Walter Wanger:

> you will of course be careful not to identify at any time the uniforms of the soldiers shown throughout the story. You will also have in mind that your picture is certain to run into considerable difficulty in Europe and South America, if there is any indication in the telling of the story that you are 'taking sides' in the present unfortunate Spanish Civil War. It is imperative that you do not, at any time, identify any of the warring factions. (quoted in Schindler, 1996: 197)

Most of the overt political content emerges in the closing sequence when, as the camera tracks into a close-up of one of the villagers, Marco (Henry Fonda), who has been attempting to break the blockade, he directly addresses the audience:

> Where can you find peace? The whole country's a battleground. There is no peace. There is no safety for women and children. Schools and hospitals are targets. And this isn't war, not between soldiers. It's not war, it's murder. It makes no sense. The world can stop it. Where is the conscience of the world? Where is the conscience of the world?

The impassioned appeal remains surprisingly powerful, yet the attempt to win over the US government proved to be futile. When the Western powers signed the Munich Treaty in September 1938, the policy of appeasement sounded the death-knell of any faint hope of the US government breaking with non-intervention.[8] Nevertheless, the attempt to appeal to US public opinion and the US government led the filmmakers to represent the war as an abstract Manichean conflict pitching good against evil, which all right-minded US citizens should be morally obliged to support, but one, again, which did not involve US citizens directly.[9] The production context also encouraged filmmakers to avoid, as Breen puts it, 'taking sides'. This changed significantly, however, when the US entered the Second World War, as an analysis of *For Whom the Bell Tolls* reveals.

Hemingway in Spain

Having first visited Spain in 1923, Hemingway returned in 1937 to cover the civil war as a correspondent for the North American Newspaper Alliance. An active supporter of the Republican

government, in addition to narrating *The Spanish Earth* Hemingway collaborated with the Spanish novelist, Prudencio de Pereda, on the short propaganda film *Spain in Flames* (de Pereda, Spain, 1938). He began writing *For Whom the Bell Tolls* in Cuba in March 1939 and it was published in 1940 to a warm critical response.[10] The novel is set in 1937, in the area around Segovia, and the civil war provides the historical and political backdrop for a romantic relationship between Jordan, a US International Brigade member, and Maria, a Spanish peasant. The novel presents a sympathetic portrayal of the Republican cause; however, its political content was sufficiently vague as not to impede its success. Kenneth Kinnamon, for instance, argues that it 'transcends partisanship in its artistic integrity' (1996: 165) and Gene D. Phillips notes that 'The majority of critics who did not have a political axe to grind agreed that Hemingway's book was both good and true.' (1980: 40–1) Hemingway locates his narrative within established historical events, specifically the failed Republican offensive in La Granja and Segovia towards the end of May 1937, but he also, as Allen Josephs notes, 'invented a great deal – the bridge, the cave, the guerrillas themselves had no historical counterparts in that sector'. (Josephs, 1996: 239)[11] Hemingway also modelled certain characters on real figures; the Russian Republican officer, General Golz, for instance, is based on the Polish general Karol Swierezenski. (Kinnamon, 1996: 165) The *roman à clef* elements, combined with the references to established historical events, led some critics to suggest that it was an accurate, if incomplete, portrayal of the period. For instance, Josephs writes that it provides 'an accurate rendition of that part of the war that Hemingway actually experienced, in and around Madrid'. (1996: 236) If the novel was regarded as faithful to the events of the civil war, the film's release provoked critics to question how authentic the cinematic version would be. Thus Phillips suggests that 'The question now was how much of that truth and goodness would find its way into the projected film version of the novel.' (1980: 40–1) These quotes highlight the fact that many critics of the time regarded fidelity to the original as important. My main concern here, however, lies not in exploring the film's faithfulness or otherwise to the novel, but in analysing what happens to the novel's political content and its representation of the civil war when it moves from page to screen.

For Whom the Bell Tolls on screen

The film, shot in Technicolor, opens with the dramatic orchestral sweep of Victor Young's score. A giant bell tolls as an intertitle appears on screen with a quote from John Donne: 'Any man's death diminishes me, because I am involved in mankind, and therefore never send to know for whom the bell tolls; it tolls for thee.' A subsequent intertitle locates the action in Spain in 1937. The opening sequence plunges immediately into highly dramatic action as two men successfully blow up a train, but in their attempted escape, Kashkin (Feodor Chaliapin), presumably Russian, is shot and wounded.[12] He appeals to the other, Robert Jordan (Gary Cooper), to fulfil his promise and kill him before enemy soldiers arrive. Jordan, who we later learn is a Spanish-language teacher from the United States, does so. Back at Republican headquarters, General Golz (Leo Bulgakov) instructs Jordan, a munitions expert, to blow up a bridge in enemy territory to coincide with a Republican offensive. In this operation he is aided by a small band of Spanish guerrillas led by Pablo (Akim Tamiroff) and his 'woman' Pilar (Katina Paxinou). Also in the group is nineteen-year-old Maria (Ingrid Bergman), who is recovering from her parents' murder and her subsequent gang rape by Nationalist soldiers. Maria falls for Jordan and the couple's love story forms the narrative's central focus. The film follows the group as they prepare for the attack on the bridge over the ensuing three days. Whereas the novel is narrated in flashback, the film's narrative is predominantly linear. There is a limited use of flashback, for instance when Pilar recounts stories of violence at the outset of the civil war; however, the film begins with the end of Jordan's penultimate mission and concludes with his final mission.

The sense of foreboding present in the opening sequence is developed throughout the film: when Pilar reads Jordan's palm and 'sees' his death, when the Spanish peasant Anselmo (Vladimir Sokoloff) is disinclined to shoot a man from his own village, and when Pablo expresses reluctance to join the attack. The darkness of the wartime situation is represented by lighting a number of sequences in a way that places the characters in silhouette; for instance in the opening train-blowing sequence and in the early exchange between Jordan and Golz. The film concludes after the bridge has been successfully destroyed, but not without consequences: two group members are killed and Jordan is wounded. The Nationalists, moreover, have

learned of the Republican plans and the offensive appears doomed. As the remaining group members attempt their escape, Jordan, facing certain capture or death, stays behind to face the arriving Nationalist soldiers. As the enemy approaches, he turns his machine gun to face the camera and releases a barrage of fire directly at the audience. The film fades to another shot of the giant bell featured in the opening sequence, and it once again tolls as the final credits appear on screen.

The role of the US individual in history

As I noted in the introduction, Rosenstone points out that one central feature of Hollywood historical films is that the events they depict are structured around the impact of history on an individual, or, at most, a small group of individuals. This practice, which finds parallels in literature, specifically the nineteenth-century realist novel, has implications for our understanding of the past. Mike Wayne, for instance, highlights some of the problems in this approach when he states that 'An account of historical change which starts from and ends with the individual is problematic because it is unable to show how the individual is formed within a broader set of social relationships and how they develop in conjunction with those relationships.' (2001: 60) In Hollywood cinema, complicated political processes tend to become represented through the personal narratives of specific, often heroic, men and women embroiled in events that operate only as a backdrop to their personal struggles, thereby rendering the past as the subjectivised experience of individuals, not classes, nations or other social formations.

As is clear from the opening and closing sequences, Jordan is the film's central character, thereby presenting a US citizen as the main protagonist in a primarily Spanish affair. The exchange between Jordan and Golz establishes these characters, and, by extension, the USA and the Soviet Union, as key figures in the conflict. Of course, this stems primarily from the literary source material which, as the US screenwriter Alvah Bessie asserts in the documentary *Hollywood contra Franco/A War in Hollywood* (Porta, Spain, 2008), creates 'a novel about Spain without the Spanish people'.[13] It is not restricted to the source material, however, as non-Spanish actors are cast in key roles.[14] In one sense, this mirrors the civil war's international complexities – it was indeed a conflict in which external forces played decisive roles – but it effectively reduces Spaniards to the status of sup-

porting players in their own struggle. Furthermore, in contrast to the clear-headed and intelligent foreign strategists running the civil war at the highest levels, the Spanish Republicans, mostly peasants such as Anselmo, are humble, compliant characters requiring constant guidance. Jordan's authority and leadership, meanwhile, goes largely unquestioned, with only Pablo mocking Jordan's status as a 'false professor' because of his lack of facial hair, and refusing to cooperate with his plans. This opposition is undermined, however, by Pablo's own dubious character traits, exemplified by his alcoholism and the repeated references to his violent past. The audience is presented with a largely ignorant, if generally noble, band of Spanish peasants, eager to be led by an educated US outsider, 'Inglés' as they call him. Jordan's status as a Spanish teacher in a US college further positions him in a hierarchically superior position and he adopts the role of group leader, for instance in instructing Anselmo and the gypsy, Rafael (Mikhail Rasumny), in the simple task of recording the movement of vehicles and soldiers across the bridge. Jordan's supposed moral superiority is also highlighted when the group quarrels over how to respond to Pablo's initial treachery. The Spaniards, including Pilar, want him killed while Rafael suggests that they 'sell him to the Nationalists' or 'blind him'. Jordan, although keen to remove Pablo, introduces some old-fashioned Hollywood Western morality to the situation by refusing to 'kill a man in cold blood'. In contrast to Jordan's unquestionable morality, Rafael states that Pablo had 'killed more people than the cholera', referring to the deaths of a numbers of landowners at the start of the civil war, shown in the flashback sequences. It is this violence that has both corrupted Pablo and turned him to alcohol; his degeneration is further evidenced when he shoots three men in the gorge who have come to assist their escape, commenting, 'I look after my own people.' He appears, however, to be more interested in their horses than in the men. In the novel Anselmo says to Pablo, 'Until thou hadst horses thou wert with us. Now thou art another capitalist more.' (Hemingway, 1976: 22) To which Jordan adds, 'The old man was right. The horses made him rich and as soon as he was rich he wanted to enjoy life.' (1976: 22) Pablo's desire for personal aggrandisement is less apparent in the cinematic adaptation, but is still evident when he expresses his reluctance to attack the bridge because, as he states, 'It brings no profit'.

As with its literary antecedent, the film is littered with archaisms and literal translations that mimic Spanish grammatical conventions

in an attempt to create a sense of 'Spanish' dialogue; for instance, when Jordan first greets Maria he says 'How are you called?' and Jordan and Anselmo exchange an 'until soon', a literal translation of 'hasta luego'. Although she uses Spanish to a limited degree – the occasional 'hola' or 'salud' – Maria's accent creates no barrier between her and a US audience. In contrast, Pablo's gruff, thick accent and 'Spanish' language increasingly differentiate him from Jordan, most noticeably when he repeatedly states 'I don't provoke' when the group attempts to create a situation whereby they can kill him. The action may have been filmed in North Carolina's High Sierra mountains (substituting for Spain's Guadarrama mountains) but the language effectively works to locate the action in a foreign, non-English-speaking locale. Jordan's status as a US citizen obviously fits with the narrative requirements of a film aimed at a US audience, ensuring a higher level of narrative identification both with the central protagonist's pursuit of Maria and the destruction of the bridge.

Love on the battlefield

Rosenstone highlights the mainstream historical film's interest in the emotional and personal implications of the past, a process evidenced by the focus in *For Whom the Bell Tolls* on the relationship between Jordan and Maria. Maria is contrasted with Pilar, who Pablo describes as having 'the head of a bull and the heart of a hawk', and who is further characterised and differentiated by her Greek accent and dark hair, make-up and skin. Pilar stands poles apart from Maria, who in the novel is described in the following terms: 'Her teeth were white in her brown face and her skin and her eyes were the same golden tawny brown.' (27) But in the film, her brown face and eyes are replaced with pale, white skin and sharp blue eyes, ideal companions for her brilliant-white teeth. Rather than an impoverished and war-ravaged peasant, in one sense Maria epitomises the Hollywood stereotype: beautiful, blond, white-skinned, somewhat naive and, crucially, chaste. Yet this is problematised by the casting of Ingrid Bergman in the role. The Swedish-born actor had achieved widespread recognition for her role as Ilsa Lund in *Casablanca*, in which her Norwegian character has a relationship with both the disillusioned American anti-fascist Rick (Humphrey Bogart) and Victor Laszlo (Paul Henreid), a Czech Resistance leader fleeing from the Nazis. The casting of

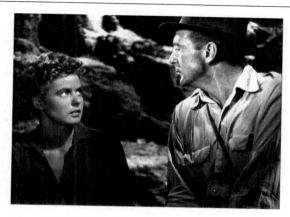

1.1 *For Whom the Bell Tolls* War and romance: Jordan and Maria stare longingly into each other's eyes.

Bergman provides an intertextual reference that allows Maria to fulfil the role of exotic European other.

The two women also display divergent approaches to politics. From the outset Pilar's position is direct and unequivocal: 'I am for the bridge and the Republic.' In contrast, Maria, despite her traumatic wartime experiences, is primarily concerned with Jordan. Although she states that at the time of her parents' murder she wanted to cry out 'Long live the Republic!', Maria is characterised primarily not by her politics but by her passivity. Thus, while Pilar carries a gun in the attack on the bridge and is also skilled in the throwing of hand grenades, Maria remains quietly behind to tend the horses. Highlighting her position in the group hierarchy – at one point she states forcefully 'Here I command!' – Pilar is often shot from below, most notably when she first appears, standing on a ledge above the entire group. In a subsequent shot with Jordan outside the cave, she is positioned so that he is forced to look up to her; literally and metaphorically she stands head and shoulders above him. In contrast, Maria is always positioned below the male figures and is repeatedly framed half a head shorter than Jordan. The difference between the two women characters is exemplified by reference to their sensuality. Pilar, somewhat comically, if not intentionally, states, 'I was born ugly' and when she goes to kiss one of the Spanish fighters he draws back quickly. In contrast, Maria, who is often shot in soft focus, is presented as naive, highlighted when she innocently tells Jordan 'I don't know how to

kiss or I would kiss you', before she asks him 'Where do the noses go?' The romantic relationship between Jordan and Maria is far from a relationship of equals. After Maria relates her parents' death to Jordan, she recounts to him her experience when Nationalist soldiers cut off her braids and used them to gag her; however, Jordan responds by placing his patriarchal, censorial hand over her mouth and says 'I don't want to hear it.' Later, as the couple spend their first and last night together, Maria again attempts to recount her traumatic experience. She states that after they had cut her hair she was taken to the office of her father, 'where they laid me on the couch. It was here the worst things were done.' But Jordan insists on Maria's silence: 'Don't talk about it any more. No one touched you.' Maria's trauma can be hinted at, even spoken of, but, ultimately, Jordan must be allowed the opportunity to deny it, thereby keeping intact her virginal status, at least in his mind, even if it will only last the few remaining hours until their relationship is consummated.

The contrasting endings of the film and the novel attest to the way in which Hollywood concentrates on the emotional at the expense of the political. Jordan's final words in the novel are 'Think about Montana. *I can't*. Think about Madrid. *I can't*. Think about a cold drink of water. *All right*. That's what it will be like. Like a cool drink of water.' (412). In contrast, Jordan's last words in the film are 'Don't pass out. Think about America. I can't. Think about Madrid. I can't. Think about Maria. I can do that all right', which then runs into an interior monologue in which Jordan states 'They can't stop us ever. She's going on with me', thereby shifting focus from political struggle to romantic engagement.

Politics

On one level the film is an individualised, romanticised narrative that can be watched easily without worrying about historical or political specificity. Although set in Spain during a civil war there is little attempt to explain the details of the conflict; indeed in some ways this could be any war. Hemingway's novel portrays the civil war as, generally, an uncomplicated struggle between good Republicans and evil fascists. But most of the novel's political content has been excised from the screenplay, with many direct political references removed. In a contemporaneous *Time* article, the director, Sam Wood, states that 'It is a love story against a brutal background. It would be the

same love story if they were on the other side.' (quoted in Phillips, 1980: 43) It is likely, however, that this was an attempt to focus on the romantic interest in an effort to fuel box-office demand. Phillips suggests that the reason for the de-politicised script was that 'Wood and the studio bosses wanted to soft-pedal the political implications of the story in order to avoid running the risk of having the film boy-cotted by the Spanish government or by Spanish groups in the United States.' (1980: 43) If this was the intention, it was unsuccessful, as the film was banned in Spain until 1978; it seems unlikely, however, that this was the primary motivation. There is a general assumption that strident political filmmaking leads to box-office failure, therefore overt politics are largely absent from Hollywood cinema. The film does contain, however, a number of components that would be regarded as essential for a reasonable box-office return: a famous and celebrated literary source, the use of famous stars, a strong love interest and highly charged dramatic action. Commercial concerns seem a more likely reason why the screenplay is vaguer about politics than the novel. Political moments remain: Maria mentions both Republicans and Nationalists and there is a clear reference to wider social forces at play when Pilar recollects that Pablo defended his town 'the day the revolution began'. Moreover, when Fernando asks Jordan 'Why have you come so far to fight for our Republic?' Jordan responds, 'A man fights for what he believes in'. He continues

> It's not only Spain fighting here is it? It's Germany and Italy on one side and Russia on the other and the Spanish people right in the middle of it all. The Nazis and fascists are just as much against democracy as they are against the communists and they are using your country as a proving ground for their new war machinery; their tanks and dive-bombers and stuff like that so that they can jump the gun on the democracies and knock off England and France and my country before they get armed and ready to fight.

In an effort to develop sympathy for the Republican cause among an American audience, the novel links the Spanish peasants' desire for agrarian reform with homesteading in the US and there are constant references to Jordan's grandfather's homesteading project. In the transition to the screen, however, these references are all removed. However, in the film, when Fernando asks if he was always a Republican, Jordan conflates the Spanish and US political situations when he states that his father had always voted Republican. Thus

two entirely different political traditions, albeit sharing one name, become incongruously fused in a somewhat muddled attempt to 'Americanise' the conflict.

A number of the novel's overt political points are omitted from the adaptation, indicative of the manner in which Hollywood tends to simplify politics and in keeping with the desire of the US Office of War Information (OWI) not to focus on 'chinks in our allies' armour'. One major omission is Hemingway's attitude towards the anarchists. In the novel, Pilar describes the anarchists during the revolutionary events in openly derogatory terms: 'It would have been better for the town if they had thrown over twenty or thirty of the drunkards, especially those of the red-and-black scarves, and if we ever have another revolution I believe they should be destroyed at the start.' (117–18)[15] This is further developed in a report of the killing of the anarchist leader, Buenaventura Durutti, when Hemingway writes that 'Durutti was good and his own people shot him there at the Puente de los Franceses. Shot him because he wanted them to attack. Shot him in the glorious discipline of indiscipline. The cowardly swine.' (326)[16] This negative appraisal of the anarchists' contribution to the war effort is also apparent as one of the guerrillas, Andres, attempts to cross enemy lines to warn of the attack, his journey being interrupted by 'the crazies; the ones with the black-and-red scarves'. (330) His failure is described by Gomez, who tells Marty, 'Once tonight we have been impeded by the ignorance of the anarchists. Then by the sloth of a bureaucratic fascist. Now by the oversuspicion of a Communist.' (367) The political complexities of this situation, however, are lost completely in the adaptation, with Andres's failure to arrive in time put down to suspicion and incompetence.

One small scene indicates how the political details are omitted in the transition from page to screen: when Jordan first meets Pablo in the film he shows him his papers from SIM (Servicio de Investigación Militar/Service of Military Investigation), an organisation heavily influenced by the communists.[17] In the novel, Jordan asserts that he is not a communist but an anti-fascist (64); however, the narrator asserts that Jordan's sympathies lay with the communists when he says that 'He was under Communist discipline for the duration of the war. Here in Spain the Communists offered the best discipline and the soundest and the sanest for the duration of the war. He accepted their discipline for the duration of the war because, in the conduct of the war, they were the only party whose programme and discipline he

could respect.' (149) Echoing the communist position, Jordan himself argues that 'The first thing was to win the war. If we did not win the war everything was lost.' (125) Although this detail is elided from the film, it was regarded as important politically, evidenced by an FBI report in July 1943 that scrutinised the film's content and catalogued the names of all the people who worked on it. (Horne, 2002: 57) The US military also displayed a keen interest, as is apparent from the quote contained in the OWI report at the start of this chapter. The quote refers to Republican attacks on landowners carried out by Pablo and others in the flashback sequence. The OWI regarded these sequences as presenting possible weaknesses in the Republican cause and, therefore, problematising the democracy versus fascism, good versus bad dichotomy, which they were eager to portray. In their study of Hollywood during the Second World War, Koppes and Black point out that the OWI director, Elmer Davis, asserted that 'The easiest way to inject a propaganda idea into most people's minds is to let it go in through the medium of an entertainment picture when they do not realize that they are being propagandized.' (2000: 64)[18] That these sequences remain in the film is testimony to Paramount Pictures' refusal to respond to every beck and call of the OWI; nevertheless, despite the inclusion of these 'problematic' sequences, the overall content fits well with those overseeing Hollywood's contribution to the US war effort.

Death in the afternoon

Rosenstone suggests that Hollywood tends to offer up the past as a closed and completed process. However, the conclusion of *For Whom the Bell Tolls* is open-ended. In the closing sequence, as Nationalist troops approach the injured Jordan, his death appears inevitable. He trains his machine gun on the approaching enemy before the camera tracks across to face him directly and he fires directly at the audience, suggesting that it is the audience who are under direct attack. It is an unconventional fourth-wall-breaking conclusion, which is at odds with the narrative conventions of the rest of the film and of most Hollywood output of the period. In *Death in the Afternoon* Hemingway writes, 'If two people love each other there can be no happy end to it', and there is no happy ending to the love affair between Jordan and Maria. Jordan is sacrificed, but the narrative's open-endedness leaves victory as a possibility, with hope residing in those that have managed

1.2 *For Whom the Bell Tolls* Jordan fires his machine gun directly at the camera, suggesting that it is the US audience themselves who are now under attack.

to escape. The opening quote from Donne suggests that Jordan's death, in a gorge in faraway Spain, is of universal concern: the bell tolls for Jordan but in 1943 it could also toll for US citizens fighting in Europe and the Far East and therefore operated as a wider call to arms. The concluding scene, therefore, reinforces US centrality in the ongoing fight against fascism, highlighting how the Spanish Civil War was narrativised to suit the wartime needs of the US.

Rewinding the spool of history

This process also emerges in *Casablanca* in which the central character, Rick, is the American owner of a bar in the eponymous Moroccan city who had previously worked as a gun-runner in Ethiopia during fascist Italy's occupation of the country. But there is also a reference to his record of anti-fascist activity in Spain, thus tracing his anti-fascist credentials (or, more importantly, the US hero's credentials) back to before the outbreak of the Second World War. Eric Hobsbawm makes a rather grand claim for the film when he writes, 'If we leave aside the basic love affair, this is a film about the relations of the Spanish civil war and the wider politics of that strange but decisive period in 20th-century history . . . In short, *Casablanca* is about the mobilisation of anti-fascism in the 1930s.' (Hobsbawm, 2007: 4) Audiences might not be so willing to put to one side one of cinema's most enduring

romances, yet Hobsbawm's wider political point is correct. Indeed, the OWI Bureau of Motion Pictures report on *Casablanca* lists seven 'excellent points' about the film; number six is worth quoting in full:

> Some of the scope of our present conflict is brought out. It is established that Rick, the American café owner, fought for the loyalists in the Spanish Civil War, and for democracy as far back as 1935 and 1936, when he smuggled guns for the Ethiopians. Points like this aid audiences in understanding that our war did not commence with Pearl Harbor, but that the roots of aggression reach far back. (quoted in Mintz and Roberts, 2010: 143)

These wider political issues are also evident in *The Fallen Sparrow* in which John McKittrick (John Garfield), an American who had fought for the Spanish Republic, is captured and tortured by the Nazis in an attempt to recover information. Similar themes also emerge in two films directed by Herman Shumlin, *Watch on the Rhine* and *Confidential Agent* in which the central characters have also fought for the Republican side in Spain, Together with *For Whom the Bell Tolls*, these four films highlight a pattern in which, as part of the US war effort, Hollywood reconnects the fight against fascist Germany with the fight against fascist Spain by rewinding the spool of history and placing US citizens at the heart of the struggle.[19] In this they provide an example of what Hayden White describes as 'willing backwards', which, he contends, 'occurs when we rearrange accounts of events in the past that have been emplotted in a given way, in order to endow them with a different meaning or to draw from the new emplotment reasons for acting differently in the future from the ways we have become accustomed to acting in the present'. (White, 1987: 150) The films also displace the protagonists in the real civil war and place US citizens as key agents in a foreign war. As with *Blockade* and *The Spanish Earth* from the late 1930s and *Casablanca*, *The Fallen Sparrow*, *Watch on the Rhine* and *Confidential Agent* from the early 1940s, *For Whom the Bell Tolls* contributed to the fact that the democracy versus fascism dichotomy is the dominant way in which the civil war has been represented in US cinema. As the analysis of *Five Cartridges* in the following chapter will show, however, the civil war was represented in a rather different light on the other side of the Iron Curtain.

Notes

1 There are a numerous versions of *For Whom the Bell Tolls* available on VHS and DVD. Originally released at 170 minutes, most television transmissions now come in at around 120 minutes and exclude the flashback sequences and most direct references to the civil war itself. This analysis is based on viewing a 166-minute-long US version that includes the flashbacks. More information about the various cuts to the film at various showings is available at http://www.tcm.com/tcmdb/title/75353/For-Whom-the-Bell-Tolls/notes.html (accessed 22 November 2011).

2 The film's critical and commercial success is testimony to the manner in which it chimed with US military needs: it was one of the US's top-grossing films in 1943 and received nine Academy Award nominations, although only Katina Paxinou was successful, winning the Best Supporting Actress Oscar for her portrayal of Pilar.

3 In an opinion poll published in 1937, 67% of US citizens stated that they were neutral in the conflict. (Campbell, 1982: 170)

4 The group's second and more immediate objective was to raise money for medical relief for the Republican cause; Ivens comments that their task was 'to make a good film for exhibition in the United States in order to collect money to send ambulances to Spain'. (Alexander, 1981: 152)

5 There is also an alternative version in which Orson Welles provides the voice-over.

6 Rosenstone (2006: 82–3) outlines a parallel downplaying of politics, particularly the lack of references to communism, in *The Good Fight: The Abraham Lincoln Brigade in the Spanish Civil War*.

7 The scriptwriter, John Howard Lawson, a Communist Party of the United States organiser in Hollywood, makes his position clear when he states that 'the people of Spain were fighting for democracy and freedom . . . the blockade cut off food, medical supplies, and arms from the legal government. I had no other message, and there was none which so urgently needed to be said.' (quoted in Carr, 1984: 76)

8 Hollywood did not display a consistently supportive political position during the civil war; in fact *Last Train From Madrid* (Hogan, USA, 1937) invites an audience response more sympathetic to the Nationalists than to the Republic.

9 Despite attempting to take a moderate political stance, the film faced a fierce boycott campaign organised by the religious right. See Smith (1996) for more information.

10 The awarding jury recommended the novel for the 1941 Pulitzer Prize, but the *ex officio* head of the board, Nicholas Murray Butler, overruled the decision and no award was presented that year.

11 There is also evidence that Hemingway may have participated in the

blowing-up of a bridge north of Turuel, an episode that would have provided the author with rich source material for the novel. (Josephs, 1996: 226)

12 In the novel, Kashkin, a Russian explosives expert who works with Pablo's band before Jordan's arrival, is already dead when the narrative begins.

13 Alvah Bessie fought with the International Brigades. A member of 'The Hollywood Ten', in 1950 he was sent to prison for ten months by the House UnAmerican Activities Committee for refusing to confirm or deny that he was a member of the Communist Party. He wrote the script for *Spain otra vez/Spain Again* (Camino, Spain, 1968), which features a US member of the International Brigade returning to Spain.

14 Cooper is American, Bergman is Swedish, Paxinou is Greek and Tamiroff was born in Georgia in the former Russian Empire.

15 Red and black were the colours of the anarchist flag and of the neckerchiefs worn by anarchist militia members.

16 The anarchists may have had their faults, but shooting their own leaders in the back does not appear to have been one of them.

17 The SIM was formed in the latter part of the civil war, thus placing it out of the timeframe of the events of the film. (Thomas, 2003: 756–7)

18 The way that Hollywood turned its attention to producing films that suited the US war effort in the Second World War is also evidenced by a remarkable series of films supportive of their wartime ally, the Soviet Union, the most notable being *Mission to Moscow* (Curtiz, USA, 1943).

19 It should be noted that the process is also evident in *Arise, My Love* (Leissen, USA, 1940), which bridges the gap between the end of the Spanish Civil War and US entry into the Second World War.

The Spanish Civil War in East German cinema: *Fünf Patronenhülsen/Five Cartridges*

> The Spanish Civil War provided material for the great myth of East Germany from its earliest days. From the ranks of the International Brigades came trusted and proven ideologues, and from the stories of its heroics came models of socialist sacrifice. In the cult of antifascism, victims of both National Socialism/fascism and Stalinism were linked together and became posthumous victors. They were raised to the rank of immortality, but the symbolic use of their names diverged completely from the historical persons: they became a type, a collective identity.
>
> Arnold Krammer (2004: 560)[1]

The strong connection between the Spanish Civil War and the Deutsche Demokratische Republik (GDR), or what is commonly referred to in the west as East Germany, might not be an obvious one. Yet, for numerous political and historical reasons outlined below, the civil war played an important part in the short-lived communist country's political and cultural life.[2] This chapter focuses on the way that this is manifested in *Fünf Patronenhülsen/Five Cartridges* (Beyer, GDR, 1960).[3] Set in Spain in 1938, the film follows seven members of the International Brigades who are tasked with providing cover for their retreating battalion as it prepares for a major Republican offensive. Finding themselves in enemy territory, five members of the group struggle to relay to their headquarters what they believe to be vital military information contained in five cartridge cases passed to them by their dying commissar. Through an analysis of *Five Cartridges*, this chapter outlines the way in which cinema was utilised to depict the events that took place in Spain between 1936 and 1939 in a manner that fitted with the East German state leadership's view of the conflict: not as a war between democracy and fascism as it was represented in the US films discussed in the preceding chapter, but as

the 'National Revolutionary War of the Spanish People' or the 'War of Fascist Intervention'. *Five Cartridges* was a significant success inside the GDR and the film's director, Frank Beyer, one of the country's leading filmmakers, proceeded to make a number of celebrated anti-fascist films including *Königskinder/And Your Love Too* (GDR, 1962) and *Nackt unter Wölfen/Naked Among Wolves* (GDR, 1963).[4] Beyer, however, fell foul of the state authorities later in his career when they responded furiously to his mild satire, *Spur der Steine/Traces of Stones* (GDR, 1966).[5] The chapter suggests that, although superficially *Five Cartridges* appears to be an uncritical homage to the International Brigades, closer inspection reveals that a tension arises from the complex characterisation of the International Brigade members. This tension undercuts the notion that it is simply state propaganda and suggests that the film can be read as a harbinger of Beyer's later problems with the GDR state. The main thrust of the chapter, however, will be to further demonstrate how the Spanish Civil War has been appropriated cinematically for political purposes.

The International Brigades: positive heroes

The GDR was established in October 1949 in the areas of Germany that had, since the end of the Second World War, been known as the Soviet Occupation Zone (SBZ).[6] Following the Russian Revolution in 1917, the fledgling Soviet government had been quick to understand the importance of cinema in propagating ideology. Lenin, for instance, had argued that 'of all the arts . . . cinema is the most important' (quoted in Eisenstein, 1988: 180), and the Soviet Union established the world's first national film school from which emerged numerous outstanding filmmakers, including Sergei Eisenstein, Vsevolod Pudovkin and Dziga Vertov. Their revolutionary filmmaking methods impacted greatly on an art form still in its formative years and their cinematic output was central to the attempt to cement communist ideology within the predominantly rural and illiterate population. The SBZ authorities attempted to emulate the success of their Soviet counterparts and in 1946 established the German Film Corporation or Deutsche Film-Aktiengesellschaft (DEFA) as the body responsible for film production.

Aware that the past provided a rich seam that could be mined in order to propagate myths that had political relevance for the present, the communist regime encouraged filmmakers to depict episodes from

Germany's radical past. Their focus was broad, covering events such as the 1524–26 peasants' uprising, the 1848 revolutions and the 1919 Spartacist uprising. (Krammer, 2004: 531). The Spanish Civil War, however, provided the most useful historical period as it fitted perfectly with the desire of the ruling Sozialistische Einheitspartei Deutschlands/Socialist Unity Party (SED) to construct an anti-fascist national heritage as part of the attempt to legitimise the existence of the East German state and, crucially, their leadership role within it. (McLellan, 2006: 289)[7] If one narrative of early twentieth-century German history could be traced from the rise of Hitler in the 1920s and 1930s through to German expansion, the Second Wold War and the ultimate defeat of the Nazis in 1945, another narrative could link the Spartacist uprising, workers' struggles during the volatile Weimar Republic (1919–33), anti-fascist opposition to Hitler in the 1930s (including what the communists perceived to be heroic anti-fascist resistance in Spain during the civil war) and ongoing underground struggle during the Second World War. In this red thread of struggle, the Spanish Civil War stood out as an exemplary period: whereas Nazi Germany's most notable contribution to the civil war was the Luftwaffe's atrocity at Guernica, which took place as the Allied powers sat on the sidelines, the communists could point to their leadership role in organising the International Brigades.[8]

As previously outlined, the International Brigades comprised approximately 32,000 communists, socialists and trade union activists from over fifty countries. Following their disbandment in October 1938, the 2000–3000 members of the German section, the Thälmann Brigade, faced death or imprisonment if they returned to their homeland, and many remained in Spain where they were integrated into the Republican Popular Army. After the civil war concluded, the majority of those who stayed in Spain were handed over to the French authorities who, in turn, passed them to the Nazis, and many subsequently perished in concentration camps at Mauthausen and Sachsenhausen. Significant numbers evaded capture, however, and when communist regimes were established throughout Eastern Europe in the late 1940s, many former International Brigade members gained prominent positions in their respective governments. In the GDR this process reached its apogee with hundreds of International Brigade members occupying positions at the highest levels of the East German state apparatus. (Krammer, 2004: 537)[9]

In an article entitled 'The Cult of the Spanish Civil War in East

Germany', Arnold Krammer notes the extent to which the SED valorised the International Brigades in various cultural forms including film, commemorative postage stamps, books, music and monuments. (2004: 549–52)[10] Artists, however, were not given a free hand in these artistic endeavours. For instance, Fritz Cremer was forced to alter the design of his International Brigades memorial statue to show the figure not as passive, possibly defeated, as had been the case in the artist's initial drafts, but as one stoically resolved to continue the struggle. (McLellan, 2004: 110–11). *Das Leben der Anderen/The Lives of Others* (von Donnersmarck, Germany, 2006) presents the GDR state's supervision over culture as one of almost total control. Yet GDR cultural policy was more complex than von Donnersmarck's Academy Award-winning film suggests. While in Nazi Germany the slightest expression of opposition was crushed ruthlessly, Joshua Feinstein notes that in the GDR, 'Literature, film, and other kinds of art provided opportunities to air, in an oblique fashion, issues that were otherwise taboo.' (2002: 8) Moreover, the state's approach to cultural production oscillated between periods of overt control and of relative artistic freedom, allowing space for commentary and critique, albeit within strictly monitored parameters. For instance, between the Film Conference staged by the Ministry of Culture in 1958 and the Eleventh Plenum of the SED Central Committee in 1965, Seàn Allan (1999: 11) notes that by returning to what he describes as the 'safe ground' of the anti-fascist genre, filmmakers were granted a degree of artistic freedom.[11] It was during this period that *Five Cartridges* emerged, which might help explain why, although on the surface it appears to match the SED's desire for representations of 'positive heroes' (Feinstein, 2002: 30–31), closer inspection reveals a greater degree of political complexity than the ruling authorities might have desired.

Five fingers make a fist

Five Cartridges opens with a montage of monochromatic shots of the Spanish sierra. Initially the camera is positioned at ground level, pointing upwards towards the surrounding hills and tree-tops before tilting down and panning left across a landscape carrying signifiers of trench warfare: hand-built stone walls, barbed wire and burst sandbags. As the camera continues to pan across the war-torn battle zone, shells explode in the middle of the screen as an off-screen male voice, the civil war veteran Ernst Busch, sings a rousing song celebrating the

International Brigades' role in battles at Madrid, Arganda and Jarama. The camera focuses on Commissar Wittig (Erwin Geschonneck), who we later learn is German, as he surveys the war zone through a pair of binoculars. As Busch continues singing, the remaining key protagonists are introduced through a series of close-up shots of their faces with accompanying titles outlining their nationality.[12] All sporting the Soviet star on their military headwear, they appear in the following order: Wasja (Ulrich Thein) – Soviet Union; José (Edwin Marian) – Spain; Willi (Ernst-George Schwill) – Germany; Pierre (Armin Mueller-Stahl) – France; Oleg (Manfred Krug) – Poland; and, finally, Dimitri (Gunter Naümann) – Bulgaria.[13] When Oleg lifts a water-flask from his belt but pours the contents into the cooling mechanism of a machine gun to prevent it from overheating rather than assuaging his evident thirst, his actions flag the theme of the need for self-sacrifice, but also forewarn of the importance of water to the men's future mission. Immediately following the song's closing words, Dimitri, positioned behind a Gatling gun, removes his helmet and releases a burst of gunfire at an anonymous off-screen foe. This is followed by a cut to the gun's base as five cartridge cases cascade on to the arid Spanish earth, a visual corollary of the film's title, which appears simultaneously in bold white letters over the action.

As was shown in the preceding chapter's analysis of *For Whom the Bell Tolls*, the individual is the key narrative agent of Western cinema. Eisenstein, however, had adopted a radically fresh approach in *Stachka/Strike* (USSR, 1925) in which it is the masses themselves who operate as a collective hero, a process also apparent, albeit to a lesser degree, in *Bronenosets Potyomkin/Battleship Potemkin* (Eisenstein, USSR, 1925) and *Oktyabr/October* (Eisenstein, USSR, 1927). *Five Cartridges*, scripted by former International Brigader Walter Gorrish, falls somewhere between the two approaches: there is a focus on individuals, apparent in the shots accompanying the credits; yet, in short order, the individuals come together to establish a group identity. In fitting with Krammer's epigraph at the start of this chapter, they become a collective 'hero' and throughout the film's eighty-seven minutes the audience is invited to identify with the men as a group as they attempt to complete their arduous mission.

The nature of their mission becomes clear in the scene immediately following the opening credits: in an underground bunker, Major Bolaños (Fritz Diez) instructs Wittig to raise five volunteers and, with the support of Wasja, a radio operator assigned to the group,

2.1 *Fünf Patronenhülsen/Five Cartridges* Five shells lie discarded on the arid earth, an analogue for the five communists who will attempt to carry them to their own lines.

cover the battalion's withdrawal. That the action is likely to be a suicide mission becomes apparent when Bolaños states, 'About the volunteers: take unmarried men.' As befitting the political necessity of placing Spaniards in prominent positions, José volunteers first, followed by Pierre, Dimitri, Oleg and Willi respectively; close-ups of their passports and that of their political leader, Wittig, highlight both the individuals' nationalities and the group's international character. That the first and last of the group are German – Wittig, a seasoned political fighter, and Willi, a younger new recruit – highlights the need to place German characters as central to the narrative. Notably, when the group is joined by Wasja and Wittig, the Soviet soldier and the commissar are shot as individual characters in separate frames, whereas the five volunteers are framed together in one shot, cinematically forging their group identity and their status as collective hero, a regularly repeated compositional technique. Through costume and dialogue, the group's political ideology is quickly established; it is further made explicit when Wittig invites Willi to leave the group on account of his age and the young man responds 'Impossible; I'm in the Communist Youth.' When he adds 'And I'm in José's domino league', it highlights the personal and fraternal bonds that unite the men in addition to political solidarity.

This solidarity is evidenced when, following a Nationalist attack in which Wasja receives an arm injury, the remaining group members

2.2 *Fünf Patronenhülsen/Five Cartridges* The soldiers are repeatedly framed
tightly together, a cinematographic representation of group solidarity.

postpone their attempt to cross enemy lines and participate in the
offensive while they search for their missing comrade. During their
search, two group members furtively observe Nationalist soldiers
marching a line of Spanish peasants up a hill to be hanged. Facing
imminent death, one peasant sings a song, which opens:

> España, the country that's dearest.
> España, the land that I love.
> Who's ready for battle on Spain's side
> For all the poor and the landless?

The reference to 'the poor and the landless' highlights the con-
flict's class character; however, in suggesting that they stand 'on
Spain's side', the song attempts to posit a country unified against
an anonymous, unspecified enemy. This scene's political content
fits comfortably with the communists' ideology, which, at the time,
did not describe the conflict as a civil war. Instead, they offered two
alternative narratives. First it was a 'National Revolutionary War of
the Spanish People' in which, as Josie McLellan notes, '"National"
referred to the Spanish people's fight for freedom and independence
against German and Italian intervention; "revolutionary" to their
struggle against the domestic forces of reaction and to protect and
extend their democratic rights.' (2004: 77) Alternatively, it was narr-
ativised as the 'War of Fascist Intervention.' (Krammer, 2004: 545)
Categorising the Spanish conflict as a war against fascism, which the

SED had designated as a specific form of finance capitalism, meant that the conflict's internal dimensions were marginalised or ignored, and the supposedly revolutionary role of the communists celebrated.

In *Five Cartridges* the fighters' revolutionary status is highlighted repeatedly. This is exemplified in the characterisation of Wittig, whom Willi identifies as a 'Spartacist fighter', thus tracing the commissar's political credentials to the glorious, but defeated, Spartacist uprising almost two decades earlier. It is Wittig's revolutionary example that inspires the group. For instance, in the scene following the Spanish peasants being led to their death, Wittig becomes separated from the group and is shot by Nationalist troops. As he lies, fatally wounded, a series of images of his comrades appear superimposed over a close-up of his face. On a sheet of paper headed 'Orders' he pens the words: 'Stay together, that way you will survive.'[14] It is notable that it is when he strays from the collective that he receives his injury. Reunited with the group, Wittig misleadingly tells the remaining five soldiers that before being shot he obtained a copy of fascist deployment plans for forcing the Ebro from a Nationalist officer, which the group must now relay to headquarters. It is a notable instance in which Wittig deliberately distorts the past in the interests of the present (saving the lives of the International Brigades) and the future (ensuring their involvement in future struggles). A more critical reading might suggest that it highlights the manner in which the personal and political mythologies of leading German International Brigaders – based in this case on Wittig's deliberately, if justifiably, distorted account – can be constructed. Wittig tears the 'orders' into five pieces and José places each piece in an empty cartridge case. Their task, therefore, takes on increased importance: inspired by their communist leader's exemplary self-sacrifice, it becomes crucial that they relay the orders to their own headquarters by crossing the deadly terrain. That the only available watering posts are being guarded by Nationalist soldiers brings together the two perils that they face; direct confrontation with a militarily and numerically stronger enemy and the danger of dying of thirst in the searing heat.

It is no coincidence that, with the absence of Wittig and Wasja, the group consists of five volunteers. The importance of the number five to the German communist movement is evident in John Heartfield's propaganda poster, which the German Communist Party used in the 1928 elections. In the artwork, an outstretched hand reaches skyward, its five digits grasping in the air, above the words '5 Finger

hat die hand. Mit 5 packst du den feind!/A Hand has Five Fingers: With Five Fingers You Can Catch the Enemy!' The number five also appears in the biopic, *Ernst Thälmann – Führer seiner Klasse/Thälmann – Leader of the Working Class* (Maetzig, GDR, 1955), in which Thälmann, the German communist who gave his name to the German International Brigades, addresses a demonstration and states: 'One finger can be broken, but five fingers make a fist'.[15] In *Five Cartridges*, then, the five volunteers are a cinematic representation of the five fingers of the clenched fist, the symbol of the international workers' movement.[16]

Film form

As with *For Whom the Bell Tolls*, *Five Cartridges* could be defined as realist cinema, but only in very general terms. In an article outlining the impact of international film styles on East German cinema, Barton Byg notes that elements of Western Expressionism are fused with socialist realism in a series of 1950s GDR films. In his brief analysis of *Five Cartridges* he identifies aesthetic similarities with the Western, citing *Stagecoach* (Ford, USA, 1937) and *The Searchers* (Ford, USA, 1956) as examples. (Byg, 1999: 29) Byg also notes that the film's central dramatic action, the struggle of 'lonely heroes against an inhuman landscape and an invisible enemy', is one of the Western's familiar features. (1999: 29)[17] Starting in the late 1960s the GDR, in common with other Eastern European countries, produced a number of *Indianerfilm* or 'Red Westerns', which expressed sympathy for the Native Americans rather than the white European settlers. In its similarities to the US genre par excellence, *Five Cartridges* can be seen as a foretaste of this trend. This is evidenced by the characters' positioning in the landscape: while the communists move on foot as they hide out high in the Spanish sierra, attempting to be at one with the landscape – characteristics normally associated with Native Americans in the Western – the Nationalist soldiers occupy flat open spaces and appear regularly on horseback, like a twentieth-century US cavalry troop. There are also aesthetic parallels between Beyer's film and the 1950s US war movie. For instance, the repeated use of close-ups of the worn and weary faces of the protagonists invites comparison with the films directed by Sam Fuller set in the Korean War, *Fixed Bayonets!* (USA, 1951) and *The Steel Helmet* (USA, 1951). Thus the film quite clearly appropriates elements of the generic conventions of the US war movie and the Western, both aesthetically and in narrative terms.

There are also a number of striking similarities with the plot of *For Whom the Bell Tolls* which suggest that the filmmakers may have drawn on the 1943 film and/or Hemingway's novel: both narratives follow a small band tasked with conducting a dangerous mission which coincides with a major troop deployment; both films include a group of Nationalist soldiers on horseback and the death of a Nationalist officer; and in both films a vital dramatic act takes place on a bridge. Of course there are many difference, not least the contrast between *For Whom the Bell Tolls'* use of Technicolor, which correlates with its epic, romantic quality, and the stark monochrome photography of *Five Cartridges*.

Although Socialist Realism was the dominant aesthetic in Eastern European cinema at the time of its production, *Five Cartridges* is not a straightforward realist representation of the civil war. Indeed personal trauma is on occasion represented expressionistically. This is evidenced by, for instance, the sequence in which Wasja, lying wounded and dying of thirst, suffers hallucinations depicted through a montage of flashbacks and/or dream shots of Soviet parades, glasses overflowing with alcohol and shots of women, with extensive use of superimposed images deployed throughout. The hallucinatory sequence concludes with Wasja smashing a glass with his bare hands before cutting to another piece of smashed glass, with which he attempts to attract his comrades' attention. It is a small example of the way in which non-realist cinematic forms are utilised to deal with traumatic events. Ultimately, thirst drives Wasja to enter a nearby village where a priest attracts the attention of Nationalist soldiers by tolling the church bell and the thirst-crazed Soviet fighter is captured. Inspired by Wasja's experience, the villagers unearth guns and turn their weapons on the Nationalist troops: one older villager prays, 'Blessed virgin, a candle for every hit', suggesting that even the most religious of the villagers support the anti-fascist cause. This scene furthers the depiction of the conflict as a National Revolutionary War, exemplified by the fact that, with the solitary exception of the priest, the only figures supporting the Nationalist cause are members of the army. All the other Spanish participants are either neutral, such as the villagers who observe Wasja's capture but do not intervene, or provide support for the International Brigaders, like the peasants who take up arms and fire at the Nationalist soldiers.

Later the group rescue Wasja; however, as they struggle to reach their destination, individual human frailties emerge. During Wasja's

rescue, Willi risks his life to secure water, but manages barely to fill the bottom of his water bottle. He is then shown trying furtively to drink water while Wasja lies dying of thirst; Willi eventually hands over the water and looks embarrassed. 'Shame is a sign of sanity', says José. McLellan notes that veterans of the conflict often rejected the official valorisation of the Brigades for failing to depict the complexities of their situation and she quotes a veteran in the following terms: 'Everyone who had resisted was a hero. Only the heroic struggle was shown. But the whole filth and so on . . . Fear is something human. But a hero can't be frightened.' (2006: 83) This scene, then, presents a more nuanced depiction of the men, highlighting their own frailties; that it is Willi, the young German communist and inheritor of his commissar's political ideology, who displays weakness furthers a more nuanced depiction of specifically German communist resistance.[18]

There is less room for doubt, however, about the heroism of the Soviet character. When the group become trapped on the hillside, Nationalist soldiers throw them a bag of rations along with a note that reads 'Here's how we live: don't be dumb join us instead.' Wasja responds by returning the bag, now filled with straw, and a note that reads 'Here's how we live, but we're not joining you bastards.' At one level, the rejection of the offer is a representation of the prioritisation of politics and principle over materialistic gain, but it can also be read as a wider political rejection of the appeal of Western consumerism. As the group prepare to escape from their entrapped position, Wasja, echoing Jordan's self-sacrifice in *For Whom the Bell Tolls*, remains behind to enhance their chances of escape. Apparently willing to be captured, he stands, arms aloft, in surrender; but, as the enemy approach, he detonates a hand grenade, thus sacrificing his own life for the group's collective interests, killing numerous Nationalist soldiers in the process.

In contrast to Wasja's display of bravery, the remaining characters' human weaknesses are foregrounded as their mission appears increasingly futile. The burden of what they believe to be the enemy's plans becomes considerable: 'It's not a sketch but a whip', says Pierre, who suggests going their separate ways. The group debate whether they should split up, with Dimitri threatening to shoot Oleg and Willi's mental health appearing to degenerate. Facing disintegration, José asserts control and successfully reunites the group, reinforcing his position as a hero among heroes. The newly established resolve is only temporary, however, as Pierre slips his cartridge case into

Willi's pocket before making a desperate bid to reach a watering hole. Resting after taking a drink from a well, he is shot in the back by Nationalist soldiers, thereby paying the ultimate price for departing from his commissar's advice and from communist ideology.

The theme of impending disintegration continually returns as the four remaining group members struggle onwards, on hands and knees. 'It's all senseless . . . we have to split up or we will all die,' pronounces Oleg before casting his cartridge to the ground. Dimitri and Willi join him in discarding their shells. As the camera pans slowly left across the thirst-crazed and broken men's faces, José appeals to them to carry on together, but on this occasion his gentle request falls on deaf ears. José picks up the four cartridges from the ground and heads onwards alone. The camera once again pans, this time rightwards, over the men's faces as they each contemplate the implications of their betrayal. Oleg calls out 'José' and then he, Dimitri and Willi rejoin José and each take their allocated cartridge: 'We brought the cases this far,' says Jose, 'now they will take us to headquarters.' He thereby empowers the cartridges with a metonymic representation of ideas of struggle and solidarity.

Within the group the Spaniard, José, emerges as the undisputed leader; his status as the most determined of the group evident when he enters a village in a vain attempt to secure water and when he kills two Nationalist sentries on a bridge. Yet as the group's journey progresses, even José's weaknesses emerge when the men reach the Ebro, the river continuing the film's thematic concern with water. Here, José offers advice to the group on how to cross the river, stipulating the importance of them not drinking excessively during the crossing. Willi asks 'What about you? Why did you say "we"', to which José replies, 'I can't swim.' Oleg laughs in the background, but the group members' faces grow increasingly sombre as José slowly hands his cartridge to the young German communist. The sound of the stirring music from the opening song is again heard before an off-screen International Brigade officer announces the order to fire, signalling the start of the offensive. This is followed by a solitary piece of actuality footage followed by a shot, filmed from a hill-top overlooking the river, of the four group members heading towards the Ebro's edge. Reinforcing the sense of political and personal solidarity, all four cross the river as a collective unit with José buoyed by a combination of support from Willi and a collection of empty water bottles. Hailed as heroes on being reunited with their battalion, they hand over the

cartridge cases, only to discover that the contents are not fascist battle plans as they had thought, but a piece of paper with the simple inscription, 'Stay together, that way you will survive.' As the group read the inscription, all four are again placed in a single frame, a cinematic expression of the sense of solidarity that Wittig successfully imbued in them. This is followed by a flashback to the opening sequence in which the commissar appeals for five volunteers and the camera again pans over the men's faces in close-up, focusing penultimately on José then, finally, Wittig.

The leading characters' nationalities are, again, far from incidental: Wittig, who both opens and closes the film, symbolises the inspirational figure from Germany's revolutionary past whose personal and political history and spirit of self-sacrifice was a vital component in the conflict; José, as a Spaniard, is the dominant member of the group; Wasja is prepared to sacrifice his life for the group, perhaps symbolising the importance the SED would have placed on maintaining good relations with the Soviet Union; Pierre, the Frenchman and only westerner, departs from the group and is killed, ensuring that no other communist countries would be offended; Oleg and Dimitri are relatively solid comrades from other Eastern European satellite states, but play secondary roles to both the Spanish and German characters; and, finally, the youthful Willi is characterised by courage and frailty, innocence and bravery, and stands as the intended inheritor of Wittig's revolutionary spirit. In short, the narratives of the individual characters are constructed in such a way as to reject an idealised version of events, one often at odds with the experience of the real-life members of the International Brigades. In highlighting the fighters' frailties, the film presents a warm and sympathetic, but also complex, portrayal of the International Brigades. Of course, the medium of dramatic cinema lends itself to more nuanced levels of characterisation than that evident in Cremer's monument; nevertheless, it refuses to elevate them to the status of Stakhanovite supermen.

The film's final shot is of the Spanish sierra and Ernst Busch's rousing words from the opening song are heard once more:

The song of Jarama all will inspire
To battle with hearts set afire
Whenever the hour of glory arrives,
When all of the ghosts we do ban,
The world entire a Jarama will be
Like the struggle in February.

The inclusion of the song connects two of the most famous battles of the conflict, the Battle of Jarama in February 1937, a rare Republican victory in which the International Brigades played a significant role, and the Battle of the Ebro, fought between July and November 1938. The initial success of the Ebro offensive was the Republic's last significant military success, though it proved to be short-lived and the offensive's eventual failure was a major factor in determining the Nationalists' victory in 1939. (Thomas, 2003: 813–21) Yet the film's relationship to its historical referent itself is somewhat loose. As Eisenstein had transformed the defeat of the 1905 Russian Revolution into a victorious rebellion in *Battleship Potemkin*, similarly Republican defeat at the Ebro is erased from *Five Cartridges*, allowing the film to focus on the small on-screen victory of the International Brigaders. This is in keeping with East German historiography at the time, which, as McLellan notes, 'tried to explain the end of the war as a victory of sorts: as a part of an anti-fascist chronology it was possible to see the ultimate result of the Spanish Civil War as the foundation of the GDR, the state which fulfilled the ideals for which the volunteers had fought'. (2004: 109) That is only achieved, however, at the expense of any detailed historical analysis.

Five Cartridges provides a further example of the way in which cinema is an ideal medium for the construction of narrative accounts of the past which are suitable to the needs of those in power. The heroism displayed by the characters is symptomatic of the way that the SED's propagandist desires found a reflection in cinema. However, although it appears to be a straightforward piece of propaganda, closer analysis reveals a greater level of complexity in its depiction of the International Brigades, which anticipates Beyer's future problems with the state over the political content of *Spur der Steine/Traces of Stones*. It is another example of the way in which cinematic depictions of the events in Spain between 1936 and 1939 can be narrativised to suit particular interests, in this case those of the ruling SED: but it also highlights that these might not always go according to state plan.

Notes

1 The Spanish Civil War appears to have been more important in the GDR than elsewhere in Eastern Europe, at least to the state bureaucracies: other films featuring the conflict are *Mich dürstet/Plagued by Thirst* (Paryla, 1956) and *Wo du hingehst/Wherever You Go* (Hellberg, 1957). A

small number of films set during the period were produced across Eastern Europe, for instance, *Osadeni Dushi/Doomed Souls* (Radev, Bulgaria, 1975), an adaptation of Dimitar Dimov's novel. Andrei Tarkovsky's celebrated autobiographical film *Zerkalo/Mirror* (USSR, 1975) also touches on the civil war and contains actuality footage that also appears in *The Spanish Earth*. For an overview of the Spanish Civil War in Soviet cinema see Kowalsky (2007).

2 See Soldovieri (2007) for a comparative analysis of two German films set during the civil war, *Five Cartridges* and *Solange du lebst* (Reini, FRG, 1955) from West Germany. Soldovieri suggests that despite their contrasting politics – the latter he argues is avowedly Nazi-apologist – both films, as he puts it, 'reveal a shared if differently focused preoccupation with German suffering and sacrifice'.

3 The Spanish Civil War also features strongly in the documentary *Unbändiges Spanien/Untameable Spain* (Jeanne and Kurt Stern, GDR, 1962).

4 Set in Buchenwald concentration camp, *Naked Among Wolves* focuses on communist resistance in the camp. The film contains a rather ambivalent ending from which can also be read subtle signs of the filmmakers' political disquiet with official communist policy.

5 Although Beyer was a member of the SED, after the controversy over *Spur der Steine* he was banned from working in film production for eight years. He refused to accept that his film was suspect politically, fuelling further the authorities' anger. He was permitted to work in television and theatre, but he did not return to cinema until he directed the Academy Award nominated *Jakob der Lügner/Jacob, the Liar* (GDR, 1974). For more information see Feinstein (2002: 176–93).

6 The collapse of the Berlin Wall in November 1989 signalled the communist state's imminent demise.

7 For an analysis of cinematic representations of the German Peasants' War see Walinksi-Kiehl (2006).

8 The formal qualities and subject matter of Brecht's *Señora Carrar's Rifles* ensured that, in addition to being adapted for East German television in 1954, it became the most frequently performed play in the history of the GDR.

9 Outside Spain, membership of the International Brigades often functions as shorthand for establishing a character's heroic credentials; this is evident, for instance, in *Song for a Raggy Boy* (Walsh, Ireland/Spain, 2003), which narrates the true-life tale of the former Irish International Brigader William Franklin's campaign against the brutal behaviour meted out to young male residents at a Catholic-run borstal in the immediate post-civil war period.

10 Representations of the civil war conflicting openly with the official state narrative were suppressed. For instance, *For Whom the Bell Tolls* was

banned until 1967, because it included a chapter depicting the torture of communist members of the International Brigade by other communists. (Krammer, 2004: 554)

11 Also see Mückenberger (1999) for more information on anti-fascist cinema at DEFA.

12 The International Brigades, while organised predominantly on national lines, often consisted of soldiers from varying countries and it would not have been uncommon to find such an international mix in the one unit.

13 Manfred Krug and Armin Mueller-Stahl, who play Oleg and Pierre respectively, were two of the GDR's most famous post-war actors. Following their decision to protest the removal of the singer Karl Wolf Biermann's citizenship in 1976, they defected to the west: the film was subsequently removed from the state television schedules.

14 The phrase could be interpreted as suggesting that the Eastern European communist states should stick together in the face of the threat of consumer capitalism.

15 Thälmann was the dominant figure in the German communist party during the inter-war years. He stood as a candidate in the presidential elections of both 1928 and 1932, receiving 7% and 13% of the vote respectively. After Hitler came to power in 1933 he was arrested immediately and held in captivity until his execution in 1944 at Buchenwald concentration camp.

16 In responding to the documentary methods employed by Vertov, Eisenstein also raises the figure of the clenched fist when he stated: 'I don't believe in kino-eye, I believe in kino-fist.' (quoted in Wollen, 1969: 41)

17 For more information on the *Indianerfilm* see Dika (2008). Perhaps the most famous example is *Die Söhne der großen Bärin/Sons of the Great Mother Bear* (Mach, GDR, 1966).

18 McLellan argues that the overwhelming majority of the Thälmann Brigade were politically committed; but she also notes that around 10% of them were, at one point, imprisoned by their own command for breaches of discipline and, in a small number of cases, desertion. (2006: 302–3)

Surrealism and the past: Fernando Arrabal and the Spanish Civil War

> Surrealism was a cultural and artistic success; but these were precisely the areas of least importance to most Surrealists. Their aim was not to establish a glorious place for themselves in the annals of art and literature, but to change the world, to transform life itself.
>
> Luis Buñuel (quoted in Harper and Stone, 2007: 3)

The previous chapters examined cinematic representations of the Spanish Civil War whose politics were in keeping with the dominant ideological positions of the countries from which they emanated. This chapter, in contrast, deals with two films directed by a filmmaker who rebelled against both the nation state in which he was born and against the one in which he has spent most of his life. Fernando Arrabal was born and raised in the Spanish-Moroccan city of Melilla during the 1930s and his wartime experiences indelibly marked both his life and his *oeuvre*.[1] After migrating to France in 1955 Arrabal emerged as a significant figure in the Parisian avant-garde. Alongside important artistic contributions across diverse art forms, he directed two Surrealist-inspired films which are set during the civil war: *¡Viva La Muerte!/Long Live Death!* (France/Tunisia, 1971) an episodic, auto-biographical testimony of childhood trauma, and *L'arbre de Guernica/ The Tree of Guernica* (France/Italy, 1975) an unconventional narrative of love, violence and revolution which covers this three-year-long traumatic period.[2] As has already been shown, Hayden White argues that the realist mode is an inappropriate representational form for what he terms 'holocaustal' events. White is not arguing that events such as the Spanish Civil War are unrepresentable, but that realism is incapable of expressing their scale, violence and mediated nature. In rejecting the realist mode, White champions alternative representational techniques, and Arrabal's films, while worthy of study in

and of themselves, can help explore the possibilities that a Surrealist cinematic practice offers in attempting to represent traumatic histories, in this instance the director's childhood trauma and the collective trauma of the civil war. This chapter also explores the efficacy of Arrabal's deployment of shock tactics as an attempt to provoke a political response from the audience.

Surrealism, shock and trauma

The word 'surreal' has entered everyday language as a term for an unexpected or out-of-the-ordinary occurrence. Its original usage, however, was not to account for experiences such as bumping into your next-door neighbour while holidaying in the Amazon rainforest. Rather, its origins are in a movement committed to revolutionary transformation. The unofficial Surrealist leader, the Parisian critic André Breton, offers this definition in his 1924 'Manifesto of Surrealism':

> SURREALISM, n. Psychic automatism in its pure state, by which one proposes to express verbally, by means of the written word, or in any other manner – the actual functioning of thought. Dictated by thought, in the absence of any control exercised by reason, exempt from any aesthetic or moral concern. (1982: 26)

The attempt to get to 'the actual functioning of thought' liberated from the tyranny of 'reason' was central to the Surrealist project as it strived to subvert and, indeed, overthrow the established aesthetic, moral and political norms of bourgeois society. The Surrealists drew inspiration from the work of Sigmund Freud, the Austrian psychotherapist who viewed dreams as the mechanism through which the human unconscious processed and assimilated past experience. But whereas Freud used the raw material that emerged from dreams in an attempt to cure psychosis, the Surrealists mined the unconscious in an attempt to liberate the imagination as part of an insurrectionary striking back against the rational order of capitalism.

In the visual arts they championed endeavours which replicated the dream state: these apparently random images were often violent, shocking and highly sexualised, and free from realist or figurative representational forms.[3] Breton argued: 'I believe in the future resolution of these two states, dream and reality, which are seemingly so contradictory, into a kind of absolute reality, a surreality, if one may

speak.' (1982: 14) Not surprisingly, the capacity of cinema, or 'The Dream Factory', to recreate something approximating to an oneiric condition ensured that it captured the early Surrealists' attention, and Surrealism continues to exercise significant influence on contemporary cinema.[4] As a result of Surrealism's success artistically it is in these terms in which the movement is primarily understood; yet, as this chapter's epigraph makes clear, the creation of celebrated artworks was far from their primary objective. Rather, they utilised art as part of an emancipatory political project, one which fused Marx's desire for socialist emancipation with the French poet Arthur Rimbaud's demand for personal transformation.[5]

Many leading Surrealists, then, were aligned closely with left-wing politics; Breton, for instance, joined the French Communist Party in 1927 and numerous Surrealists argued that it was the artistic equivalent of communism.[6] When the Spanish generals launched their *coup d'état* from the shores of North Africa in July 1936 the Surrealists expressed unequivocal support for the Republican government and, from their Paris base, implored the left-wing French Popular Front government to intervene: 'Down with speeches and empty gestures; up with volunteers and material aid! . . . *Front populaire*: organize the masses quickly! Establish drill, and arm the proletarian militias'. (quoted in Greeley, 2006: 2)[7] The Surrealists' call was to fall on deaf ears as the French government used the Non-Intervention Committee as a cover for its inaction; however, individual Surrealists, such as the writer Benjamin Peret, travelled to Spain to fight with the revolutionary militias.[8]

Arrabal's relationship with Surrealism developed following his move to Paris where he encountered Breton and joined the Paris Surrealist Group. While Surrealism in Spain was shaped by, and often accommodated itself to, external political forces, or was, as Greely (2006: 99) puts it, 'easily co-opted for any political or ideological use', the Paris group was committed resolutely to a revolutionary agenda. In 'The Second Manifesto of Surrealism', first published in 1930, Breton declares: 'Everything remains to be done, every means worth trying, in order to lay waste to the ideas of *family, country, religion*.' (1982: 128) Arrabal's wartime experience fuelled a similar antipathy towards the targets of the Surrealists' wrath and, although he left the group in the early 1960s as a result of what he perceived as the group's dictatorial and dogmatic approach, the influence of Surrealism, both formally and thematically, is evident throughout his work.

In 1963 Arrabal, together with Alejandro Jodorowsky, who directed *El Topo* (Mexico, 1970) and La Montaña Sagrada *The Holy Mountain* (Mexico/USA, 1973), and the celebrated illustrator and writer Roland Topor, created Panique, a theatre of chaos and rebellion, which celebrated the Greek god Pan. (Arrabal and Kronik, 1975: 54)[9] Working with Panique, Arrabal created a series of experimental theatrical events, or happenings, which drew on Antonin Artaud's Theatre of Cruelty and which were marked by extreme and shocking imagery.[10] For Arrabal, the aesthetic strategies they employed were intended to provoke political action: 'We cannot hide our heads in the sand; we must look reality in the face, as witnesses to it. That may shock you. I would like it to shock you more deeply yet, to the point of getting you to cry out against this horror and keep it from happening again.' (Arrabal and Kronik, 1975: 54). In his analysis of the avant-garde, Peter Bürger makes clear the rationale behind the employment of shock tactics: 'Shock is aimed for as a stimulus to change one's conduct of life; it is the means to break through aesthetic immanence and to usher in (initiate) a change in the recipient's life praxis.' (2002: 80) Arrabal's shock tactics are evident both formally and thematically in these examples of 'Cinema of Cruelty'.

¡Viva La Muerte! – a response to individual trauma

Arrabal's cinematic debut, ¡*Viva La Muerte!*, is based on his 1959 autobiographical novel, *Baal Babylone*. Set in what appears to be a non-specific, Spanish-occupied North African locale as the civil war draws to a close, the film's narrative parallels a key event in Arrabal's life: the disappearance of his father, a Spanish army officer with communist and atheist beliefs, who was sentenced to death for refusing to participate in the coup. According to Peter Podol (1985: 203), Arrabal's mother denied her son all knowledge of his father; that he disappeared after being released from, or escaping, captivity fuelled Arrabal's speculation over the reason for his absence. Podol (1985: 203) suggests that his suspicion of his mother's involvement in his father's disappearance repulsed Arrabal, while he was simultaneously attracted to her sexually, and these themes are played out in his artistic output. They are certainly central to ¡*Viva La Muerte!* in which the Oedipal desires of a young boy named Fando, a derivative of the director's own name, are coupled with feelings of disgust at his mother's complicity in his father's arrest,

emotions which are expressed in a series of depictions of his fantastic imaginings.

In bringing this highly personal subject matter to the screen, Arrabal states that his intention is not to account for the civil war in its totality, but to create an impression of the experience:

> *¡Viva La Muerte!* has as its sole aim the portrayal of a child who witnesses the arrival of fascism and crime. It is very simple. Take a book that describes a situation in general terms, let's say the Spanish Civil War. You can't really form an impression of it, but if you talk to me about it, you can, because I can tell you about the food, about what one saw every day, and in that way you can understand what happened. (Arrabal and Kronik, 1975: 59)

In accordance with the Surrealists' aims, this childhood perspective on 'fascism and crime' attempts to obfuscate the division between the real and the unreal, the inner world of Fando and the exterior reality of everyday wartime experience. What follows is an outline of the film's opening section in an attempt to deconstruct the film form employed, its thematic concerns and its affective qualities.

The film's thematic interest in both sex and death are foreshadowed in the Hieronymus Bosch-like artwork accompanying the opening credits. Here, the camera moves back and forth across Roland Topor's expansive monochrome illustration, pausing momentarily on the sketches within: a copulating couple lies adjacent to headless and speared corpses; a body hoist in mid-air defecates on helpless souls imprisoned below; there are bare-buttocked women, one being devoured by a giant plant, another straddling a large and ejaculating phallus-shaped vegetable; a pair of legs lie on the ground, knotted entrails taking the place of a missing torso. These images, and many similar ones, are juxtaposed with the soft, gentle voice of a child singing a Dutch playground song. This is followed by an establishing shot of a mountainous landscape: in the distance, a military vehicle carrying Nationalist soldiers approaches. Through a loudspeaker attached to the vehicle a male voice announces: 'The war is over. Traitors will be relentlessly hunted down. If necessary we will kill half the country.'[11] Parallel editing is used to introduce Fando who, wrapped in a blanket, watches the approaching vehicle. As it passes him, 'Long Live Death!' emanates from the loudspeaker and the thin, dark-haired boy runs hurriedly down the hill. The film then cuts to an out-of-focus close-up of his face as a non-diegetic voice shouts: 'Papa,

I don't want them to kill you.'[12] This is followed by the first in a series of psychedelic solarised sequences, a process whereby the image is shot on videotape before being processed through colour filters and returned to film, producing a darker, grainier image against a coloured backdrop.[13] In the sequence, which utilises blues, purples and reds, a man adorned with religious paraphernalia screams in agony as two masked and bare-chested executioners garrotte him. We then see Fando running home through what appears to be an anachronistic 1970s' North African market. In his house, the link between sex and death is again apparent. Here Fando sits at his mother's (Nuria Espert) feet, stroking her toes and discussing the nature of mortality, asking: 'When we die is it forever?'[14] By this point Fando is standing as he gently caresses his mother's face before placing his forefinger in her mouth and gently pulling her tongue. Then, as she applies a liberal amount of moisturiser to her face, there is a cut to solarised footage of Fando observing his mother, naked and standing upright in a cage, massaging her neck and breasts as she showers in a thick, milky substance. This is followed by a shot of Fando's extended family in their kitchen. As the boy stares at his Aunt Clara (Anouk Ferjac), who is sitting with a basket between her legs, his right leg moves rhythmically and uncontrollably, an obvious reference to masturbation. Following more solarised footage, this time in green tones, of the semi-naked aunt caressing her breasts while holding a bowl between her legs, the film cuts back briefly to the kitchen before, following an exchange of eroticised glances between Fando and his aunt, returning to solarised footage of his sexually aroused aunt massaging her breasts. Fando prepares to strike the woman with an axe but, as he lowers the phallic object towards her, there is a cut to an image of an over-ripe watermelon being cleaved in two and the boy sensuously rubs his hands in the fruit's flesh. The film returns to the family home where Fando straps a metal cilice to his lower thigh and attempts to mortify his flesh. As he does so, a non-diegetic voice says: 'My son, when you feel the pricklings of the flesh, put on a hairshirt and say an "Our Father."' The aunt then enters, raises the boy's shorts and tightens the cilice firmly around his upper thigh. As blood seeps through the cilice, Fando screams in agony. Displaying signs of sexual pleasure, his aunt takes a seed from her cleavage and places it in a urine-filled chamber pot. There is then a cut to a close-up of a scene from Topor's illustration: a grotesque collection of bodies inhabiting a giant pot. The camera pulls out to reveal a hanged man defecating on

its occupants, thereby forging a link between the illustration's content and the film's narrative. Shortly after, a blind man delivers a model aeroplane and Fando reads aloud the inscription: 'Prison. Remember your papa.' This is followed by another solarised sequence in which Fando's father leads a donkey around a prison courtyard while his mother luxuriates in a soapy bath and a blindfolded Fando looks on, aircraft in hand. Shortly after, Fando discovers correspondence implicating his mother in his father's disappearance, followed by a flashback sequence, which is notably not solarised, in which Nationalist soldiers arrest his father. Marsha Kinder (1993: 200) observes that 'For the Spanish son, the patriarchal mother is frequently both an object of desire and the instrument of its repression – contradictory functions that are sometimes embodied in one woman and other times split between two.' In *¡Viva La Muerte!*, however, both female figures are figures of sexual attraction and simultaneously conduct repressive actions.

This recounting of *¡Viva La Muerte!*'s opening section marks out the distinct separation between the 'real' events in Fando's life, which are represented on film, and his 'unreal' sexualised and sadistic imaginings, which are contained in the solarised footage.[15] As the film progresses, further solarised sequences expressing antipathy to both state and Church correlate with Fando's interior world: his father, buried neck-deep in sand, has his head crushed by a cavalry troop; a priest restrains Fando as an army officer removes the boy's eyeballs with a hot iron then laughs gratuitously as he chews on one, developing further the blinding motif which reappears throughout the film. Two further examples fuse together complex adolescent anxieties: in one scene his mother looks on in orgasmic pleasure as his father is whipped; in another she stands above him, removes her underwear, and defecates on his head.[16] While I hope that this account gives a flavour of the film's formal qualities and thematic concerns, it might not sufficiently evoke its experiential or affective qualities. On first viewing, *¡Viva La Muerte!* appears both obscure and abstruse, more a random assemblage of disconnected violent and shocking images than a coherent whole. The garish solarised sequences further heighten the sense that the audience is being assaulted at an aesthetic as well as a moral or political level. Critics have differed on the efficacy of the film's affective qualities. Podol, for instance, suggests that the grotesque nature of the scene in which Fando's mother watches her husband being tortured 'is heightened by music, the use of color,

and the violent rupture of normal chronology – techniques whose efficacy is enhanced by the cinematic medium'. (1985: 203) Michael Richardson, conversely, argues that, while the employment of shock tactics seems 'never to be gratuitous or arbitrary but to be necessary responses to trauma' (2006: 143), the apparent intention of assaulting the audience is diluted in the cinematic experience. (2006: 146)[17] Perhaps ¡Viva La Muerte! does not possess the same affecting qualities as Arrabal's live theatrical performances; nevertheless, the film has a strong visceral impact. Bürger notes, however: 'Nothing loses its effectiveness more quickly than shock; by its very nature, it is a unique experience.' (2002: 80) So, while ¡Viva La Muerte! initially creates an effective visceral experience, although at the expense of an analytical response, very quickly the expectation of further sadistic, sexualised violence somewhat neuters the shock factor.

In the film's opening section, formal qualities demarcate clearly the division between 'real' and 'unreal'; however, this becomes increasingly obfuscated as the film progresses, correlating with Breton's desire for the fusion of these states into a surreality. Two examples illustrate this. First, in one scene Fando observes a group of Nationalist soldiers conducting an execution in a cemetery. One man survives the first round of gunfire and cries: 'I'm saved, I'm not dead.' The commanding officer comments, 'A faggot. Finish him off up the ass.' 'Execute the poet, Lorca', he continues before shooting the wounded man in the anus. The film then cuts to yellow solarised footage in which a young boy says, 'They've killed Federico García Lorca', followed by a shot of a group of naked boys wrapping the corpse in white cloth and carrying it up a hill. Although this scene suggests that children will be the custodians of Lorca's spirit, the fact that the poet was executed in August 1936, three years prior to the start of the film's narrative, and in Granada, not North Africa, suggests that this sequence cannot be Fando's direct experience.[18] This is also the case in the sequence in which a group of boys are belting each other with a leather strap. 'Go on, a hard one,' one boy exclaims, before stating 'The little ol' priest oughta bless your whip.' This is followed by a cut to solarised footage in which the Church's backing for the Nationalist cause is made explicit as, to the sound of organ music, a priest blesses rifles before distributing them to Nationalist soldiers. A group of boys force the priest backwards on to an altar; then, as one boy shouts, 'Cut his nuts off. Put 'em in his mouth, dirty priest', they do just that. 'Oh, my balls. How tasty they are!' the clergyman states, as he becomes

gastronomically familiar with his own testicles. 'Thank you, Lord, for this divine dish. God, you gave them to me and you took them away. Blessed be your holy name,' he says, as he looks to the heavens, his palms clasped in prayer. A torture worthy of the most hardened Spanish Inquisitioner, the sequence is one of the most sacrilegious in cinema, matching anything on display in the early Surrealist films, *Un Chien Andalou* (Buñuel, France, 1929) and *L'Age D'Or* (Buñuel, France, 1930). A further series of non-solarised sequences further obfuscate the division between the two worlds, most notably when Fando's mother slashes a bull's throat then, in an echo of the previous sequence, implores a young man, presumably an older Fando, to castrate the animal. The mother writhes sexually in the dead animal's blood before stitching Fando inside the animal's eviscerated carcass. The scene connects Fando's Oedipal fantasies with broader politics, his mother bearing responsibility for the bull's death, a symbolic representation of Spain, and, in encasing Fando in the carcass, adopting the role of the castrating mother by emasculating Fando. An intertextual reference to Eisenstein's *Strike*, the scene also brings to mind *The Hunt*, which is discussed in the following chapter, and *Pascual Duarte* (Franco, Spain, 1976), the cinematic adaptation of Camilo José Cela's celebrated novel, *The Family of Pascual Duarte*. Set in Extramadura during the civil war, Pascual Duarte's repeated real-life violence against animals is all the more 'shocking' because of the film's realist mode. In ¡*Viva La Muerte!*, however, the sheer scale of the repeated acts of sexualised violence means that it is easy to become increasingly anaesthetised to the attempted sensuous assault.

In a seemingly orthodox conclusion, Fando, increasingly pallid as his tuberculosis worsens, recuperates during a six-month stay on a hospital-ship where he undergoes a lung operation, which is depicted through graphic actuality footage.[19] Fando's young friend, Thérèse (Jazia Klibi), informs him that his 'father has escaped with the maquis' and the film concludes with a shot of Thérèse pushing a cart carrying Fando up the hill that appeared in the opening sequence. Before disappearing out of view, they pass another military truck, a voice from which repeats the refrain from the film's opening sequence. In the closing shot, the camera tilts skywards against the sound of rather incongruous sacred music. Cured medically, and freed from the strictures of matriarchal control, Fando departs his hometown in search of his father in the mountains.

¡*Viva La Muerte!* is the most well known and celebrated of Arrabal's

3.1 *¡Viva La Muerte!/Long Live Death!* In a sequence that blurs the line between dream and reality, a mature Fando is kissed by his mother while he is stitched inside a bull's carcass.

films, its shocking and violent imagery a fitting cinematic depiction of childhood fear and fantasy, and a passionate and spirited howl against the three pillars of Franco's Spain: family, country and religion, but focused more clearly on family and religion.[20] Fando's trauma over his father's absence remains unresolved, as did the wider trauma of the Spanish Civil War for Arrabal. It is notable that when he turned his attention to the conflict once more and attempted a wider political commentary on the civil war, Arrabal adopted a more narrative-based format, albeit one a world removed from the generally realist form apparent in both *For Whom the Bell Tolls* and *Five Cartridges*.

The Tree of Guernica: a response to collective trauma

The Tree of Guernica marks a significant switch in focus from the director's personal trauma to broader historical and political concerns. Although more conventional than Arrabal's cinematic debut four years previously, *The Tree of Guernica* is far from a straightforward depiction of the Spanish Civil War. The film covers three periods: the July 1936 coup and the revolutionary response to it, the bombing of Guernica in April 1937 and Franco's pronouncement of victory in April 1939. Yet, in the absence of any signifiers indicating temporal movement, these events are condensed into what appears to be days rather than years. The targets of the Surrealists' wrath – family, country and religion – are again on display and attacked with a similar level of violent and sexual imagery. In terms of content, much of the imagery remains as shocking as that on display in *¡Viva La*

Muerte!; however, the absence of solarised footage and the presence of a more linear, albeit chronologically abridged, narrative structure renders it considerably less of an assault on the senses. The attempt to collapse the division between the real and the unreal remains, but in a manner decidedly more subtle than in *¡Viva La Muerte!*

Analysis of the opening sequence makes this evident: a street-sign on the right-hand side of the screen locates the action in Villa Ramiro. On the left emerge seven girls dressed in white Communion dresses and carrying red-and-black anarchist flags. Shot in slow motion, they walk through what appears to be a North African town as the score shifts from the rhythmic chanting of young male voices to a choral rendition of 'Hosanna in Excelsis'. The camera pans across the town's rooftops before tilting skywards as the credits roll; in blood red, the text stands out boldly against the blue and white sky. We are then introduced to Vandale (Mariangela Melato), a black-clad woman riding a donkey towards Ramiro. When she arrives, a 360-degree zip-pan depicts the frenetic, vibrant atmosphere of the town carnival before the film cuts to a shot of castle walls and then pans across to a Spanish flag. The inclusion of the Spanish and anarchist flags suggests a higher level of political engagement with the civil war, further evidenced when a male voice – Count Cerralbo (Bento Urago) – states: 'Our castle was a well-respected sacred place before the Republic. Look at it now, surrounded, threatened by that filth.' Following a cut to an interior shot, the Count continues: 'To think that for all these years, all these centuries, our family ruled Ramiro and its surroundings. And now . . . I have to release the dogs into the courtyard of our property to deter the excesses of the most vindictive and excited of all that riff-raff.' He is, of course, referring to the townspeople; however, as he speaks, the camera focuses on his three nephews, shot from below, as they ogle Vandale riding by. The shot puts into question the morality of his own family and, by extension, the morality of the landowning class. The Count continues to lament the Republic's arrival before concluding: 'The nation that up until yesterday was subjected to the righteous authority of the aristocrats is now dreaming of launching a revolution.' As he speaks, his nephews laugh menacingly and in the following shot attack Vandale. When she escapes to a house adorned with the trappings of witchcraft and repels their attack by showering them with a nest of vipers, the film introduces a supernatural element, one that highlights the Surrealist concern with magic and the occult.

This opening sequence contains all the ingredients of the main-

3.2 *L'arbre de Guernica/The Tree of Guernica* The revolution's heroine, Vandale, rides into Villa Romero.

stream historical film: the setting is established through *mise-en-scène*, the central characters are introduced, expository dialogue defines the social, historical and political context, and dramatic conflict between the male protagonists and Vandale is established. The sequences that follow, however, mark a significant shift in register: the film cuts to a naked woman lying on her back surrounded by a group of dwarves.[21] One of them is naked and lowers himself on to the woman; this is followed by a shot of a group of naked boys pushing a six-foot long dagger which is attached to a pair of giant ears; the film then cuts back to the dwarf and the woman copulating as two other dwarves cover the couple with a white sheet. It then cuts back to the boys with the ear-adorned phallus before cutting to a classroom where, after a teacher explains Republican ideals to the dwarves, one responds 'When that day arrives, dwarves will be men like all the others.' We then witness an exchange between the Count and his only son, Goya (Ron Faber), a surrealist artist. His father recounts some of Goya's provocative stunts, which are recreated in flashback, such as bursting into a church during Communion and announcing that the Communion wafers are poisoned. Goya's disdain for his father is evident when he ejaculates into his father's drink and returns the glass stating: 'This is what you gave me yesterday and what I'm giving back to you today.' Of course, Goya is the perfect name for the artist, referencing as it does the real-life Goya whose etchings, *Los Desastres de la Guerra (The Disasters of War)*, remain a disturbing and influential response to the atrocities of war. Goya's interest in the supernatural and the uncanny, moreover, ensured that he exercised a major influence on the Surrealists and therefore creates a connection between the Count's son and Vandale. In contrast to *¡Viva La Muerte!*,

which locates much of the dream imagery in Fando's interior world, there is nothing so far to suggest that any of the content emanates directly from the characters' dreams or imaginings. Moreover, the fact that it is all presented with a similar aesthetic, notably through the absence of solarised footage, creates a considerably less shocking viewing experience and allows for a more cerebral audience response.

Two of the targets of Arrabal's wrath from ¡*Viva La Muerte!*, the Church and the military, reappear in the sequence that follows as their representatives meet to discuss the impending military rebellion. Intercut with actuality footage of military marches and Republican demonstrations, one officer states: 'Villa Ramiro will be a reflection of what will happen in the whole of Spain.' The plotters, assisted by members of the fascist Falange, compose lists of those to be arrested and assassinated. One officer comments: 'If necessary we will kill half the village', a reference to Franco's words which feature in ¡*Viva La Muerte!*, with the shift from 'country' to 'village' highlighting that the village stands as a microcosm of Spain itself. Actuality footage signifies the start of the coup and a Radio Paris broadcaster announces: 'The Spanish Civil War has just begun.' Hugh Thomas (2003: 911) suggests that the Spanish Civil War 'is partly the history of the abuse of technology' and, within the film, this is the first of a number of references to technology and the importance of the media in the conflict.[22] Intercut with actuality footage of the mobilisation of Republican and Nationalist forces, the broadcaster continues: 'Villa Ramiro is in the hands of the people who have decided to take over the Count's castle; a symbol of the tyranny that enslaved them for centuries.' Following this, the villagers storm the castle and its occupants depart, led by a priest carrying a large crucifix. As he departs, the camera focuses in tightly on the image of a villager staring at the crucifix. This is followed by a scene – presumably the villager's fantasy – of the crucifix being shot to pieces, before the film returns to the castle where the massed assembly shout 'Vamos! Vamos!' and ransack the castle, a cinematic rendering of the revolutionary response to the coup. Continuing the blasphemous tone, a man urinates on a statue of Christ while corpses, presumably the Count's ancestors, are disinterred and red-and-white banners proclaiming them 'exploiters', 'fascists' and 'capitalists' are lain over their skeletal remains. Then, mirroring the previous sex sequence, a dwarf climbs atop a statue of the Virgin Mary and masturbates. As two other dwarves cover them with a white blanket, the dwarf ejaculates and smears his semen over

the statue's lips as the assembled audience applaud rapturously. The film presents, then, a rather unusual cinematic rendering of the revolution, one that does not shy away from what might be regarded as its more unpleasant aspects, specifically the anti-clerical violence that occurred in the conflict's early months, and that is shown in the most provocative manner.[23]

While Villa Romero is gripped by revolution, Goya and Vandale flee the town and travel, separately, to Guernica, its walls covered with revolutionary posters of the workers' organisations. Here a child's voice outlines the Guernica Tree's importance as a symbol of liberty and freedom, accompanied by actuality footage of German aircraft taking off, effectively collapsing the time between the start of the coup and the bombing of Guernica the following year. In the town, the couple meet for the first time and an instant attraction is formed. As they embrace, however, exploding bombs detonate around the market town and they are separated in the chaos and return, again separately, to Villa Romero – Goya after enlisting with the Republican militias, Vandale after resisting the advances of one of the Count's nephews, Rafael (Cosimo Cinieri), who now commands the blue-shirted Falangists. In the town she becomes the embodiment of the revolution and addresses a demonstration, her neck adorned with a red bandana, with an impassioned speech that invokes the Republic's most celebrated female orator, La Pasionaria: 'It's better to die standing tall than to live on your knees . . . No Pasaran!' As she speaks, Goya flies over the assembled crowd, dropping from the aircraft leaflets imploring the villagers to resist the impending invasion. Thus the town stands as a microcosm of the beleaguered Republic, transformed socially, but under siege by superior military forces. When Rafael appeals to the villagers to surrender, Vandale again highlights her powers of sorcery when she replies, 'We are waiting and this time we have more than vipers to defend ourselves.' Goya launches a successful aerial attack and Rafael is forced to call for assistance. Referencing the importance of the Nationalists' foreign support, an officer responds to Rafael's request by stating: 'We'll send the German Condor Legion . . . and two of Mussolini's divisions.' As Nationalist forces take the town, a close-up of the three cousins being driven through the town emphasises that the old ruling class is back in power.

Mirroring the ruthless nature of Franco's immediate post-war repression, the regime's opponents are killed in a series of brutal executions: a pacifist teacher is garrotted, and the revolution's leaders

are strapped to wagon wheels and machine-gunned, the camera following the gun's movement in an ever-quickening 360-degree pan, which recalls the opening shot of the town's carnival.[24] The most grotesque execution, however, is reserved for the dwarves. As a soldier announces that the Pope has described the Nationalist war effort as a 'Crusade', horns announce the arrival of a matador (Diego Bardon), flanked by four leather-clad executioners. He scratches his groin, says 'Arriba España', and blesses himself before the crowd, which is assembled on wooden carts adorned with the Spanish flag. It comprises military personnel, religious dignitaries and an array of black-clad spectators, including skeletons, suggesting the regime's supporters' decrepit and backward-looking nature. The camera then cuts to a close-up of his first 'opponent': a dwarf tied to a wooden three-wheeled contraption with a bull's head, which a Falangist wheels into place. Following a series of manouevres which the spectators applaud mechanically, the matador spears his prey with three banderillas and then, as he says 'For you my general', thrusts his sword into the dwarf's groin. We then see a close-up of the dead dwarf lying on a white sheet before the camera pulls back to reveal all five dead dwarves as the triumphant bullfighter, the executioners and the spectators look on. In *Auch Zwerge haben klein angefangen/ Even Dwarves Started Small* (Herzog, West Germany, 1970), a group of dwarves organise a revolution against their guards, but the revolt descends into destruction. In *The Tree of Guernica*, however, the slaughter of the dwarves represents the death of the revolution and the Republic, not by its own hand, but at the hand of Spanish tradition and the Spanish state.

The film's conclusion, in an echo of *¡Viva La Muerte!*, strives to find hope amid the despair. Goya and Vandale, who had previously been captured, escape. As they do, they pass by Nationalist soldiers listening to Franco declare on the radio: 'The war is over', which is followed by actuality footage of goose-stepping soldiers and of Franco meeting with Mussolini and Hitler and then being decorated by the Church. 'Hosanna in Excelsis' is once more heard as the couple ascend a mountain with Villa Romero in the distance. Then in a two-shot, with a glaring sun forming a backdrop, Vandale removes the bloodied bandages that cover Goya's eyes, the result of his being blinded in captivity, and a reminder of the blinding theme in *¡Viva La Muerte!* 'My name is Goya', he says. 'I am Vandale', she replies as superimposed slow-motion images of Vandale with a group of naked children

appear. Vandale continues: 'We can't give up. Our people must be free again. The Tree of Guernica, covered in ashes, still stands like our hope.'

The film concludes fantastically as the lovers kiss and embrace, the music swells and the sun sets in the background. Despite the historical reality of triumphant fascist dictatorship, there emerges a moment of *amour fou*, or crazy love. The Surrealists adopted a rather different view of love to that sanctified by bourgeois society. As Octavio Paz suggests, 'To realise itself, love must violate the laws of the world. It is scandalous and disorderly, a transgression committed by two stars that break out of their predestined orbits and rush together in the midst of space.' (quoted in Richardson, 2006: 64) Neither comforting nor safe, *amour fou* represents the possibility of a radical transformation of the self: here, as Goya and Vandale 'rush together in the midst of space', it enables a moment of fantastical, if perhaps somewhat unbelievable, narrative closure.

Despite their differences, aesthetically and experientially, both films sit comfortably alongside the demands that White places on those responding artistically to 'holocaustal' events or what we might call 'traumatic histories'. Twenty-first-century audiences are likely to find the Freudian themes symbolically excessive and rather obvious. Nevertheless, *¡Viva La Muerte!* is an engaging and visceral cinematic expression of Arrabal's tortured childhood consciousness. The affective qualities of the bizarre and provocative imagery force a turning away from the screen, yet, simultaneously, encourage a turning towards the past, one that is explored in more narrative-based terms in *The Tree of Guernica*. Here, the use of a more coherent narrative combined with the extensive use of actuality footage grounds the film in its historical period. Taken together they create a valuable, if critically underexplored, contribution to cinematic depictions of the civil war. In representing these traumatic events Arrabal was at liberty to employ whatever representational forms he deemed appropriate. Inside Spain, however, strict censorial restraints forced oppositional filmmakers to adopt more subtle forms of critique; it is to their attempts to represent the conflict that we now turn.

Notes

1 Melilla was the location from which the insurgents launched their rebellion. (Thomas, 2003: 204)

2 The phrase, the motto of the Spanish Foreign Legion, was popularised by José Millán-Astray, the Legion's founder. During an infamous exchange with the Basque philosopher Miguel de Unamuno at the University of Salamanca in October 1936, Astray declared: '¡Mueran los intelectuales! ¡Viva la Muerte!/Death to intellectuals! Long live death!' (Thomas, 2003: 486–8)

3 That the Surrealist artist José Caballero designed Nationalist propaganda posters during the conflict should dispel the notion that Surrealist artworks are inherently progressive. This notion is further complicated by any study of the relationship between art and politics in the work of Dalí. Greeley (2006) provides a comprehensive overview of the relationship between the Spanish Civil War and Surrealism: for more information on Dalí in this context see Greeley (2006: 51–89).

4 For the most recent accounts of Surrealism and cinema see Richardson (2006) and Harper and Stone (2007).

5 For a detailed analysis of the relationship between Surrealism and Marxism see Löwy and LaCoss (2009).

6 Surrealism became increasingly out of step with orthodox communist ideology after the Soviet Union adopted the policy of Socialist Realism in 1934. Breton and the exiled Russian revolutionary leader Leon Trotsky co-authored *Manifesto: Towards a Free Revolutionary Art* in Mexico in 1938.

7 In 1937 *Las Hurdes/Land Without Bread* was re-released with new introductory intertitles expressing support for the Republican government.

8 Peret fought with both the POUM, the Marxist party popularised in *Land and Freedom*, and the anarchist group Friends of Durutti, which took its name from the celebrated anarchist leader.

9 For more information on Arrabal and theatre see Farmer (1971).

10 Breton had previously intimated his 'love of shocking the reader'. (1982: 20)

11 These words are attributed to Franco in a speech at the end of the war. (Valleau, 1982: 143)

12 Non-diegetic sound is sound, usually added during the editing process, that does not emanate from within the world of the film itself.

13 Solarisation was first used in cinema by the celebrated cinematographer and director Jack Cardiff in *The Girl on a Motorcycle* (Cardiff, UK/France, 1968).

14 In the 1924 'Manifesto of Surrealism', Breton writes: 'Surrealism will usher you into death, which is a secret society.' (1982: 32)

15 Arrabal's propensity for utilising acidic-looking images perhaps helps explain why audiences queued round the block for midnight screenings in New York on the film's US release in 1974.

16 Valleau (1982: 136) notes that the film was initially banned in France, but cleared for release in April 1971.

17 Richardson (2006: 146) argues that *¡Viva La Muerte!* falls short of the experience of the understated *El espíritu de la colmena/Spirit of the Beehive* (Erice, Spain, 1973). Widely regarded as the pinnacle of Spanish art-house cinema, *Spirit of the Beehive* is set in 1940 and was produced in the dying days of the dictatorship when oppositional filmmakers faced difficulties depicting the civil war, as discussed at greater length in the following chapter.

18 A colleague of both Buñuel and Dalí, Lorca collaborated with various avant-garde artists throughout the 1920s and 1930s. Lorca's politics are not explicit in the film; however, the poet had previously remarked: 'I will always be on the side of those who have nothing, of those to whom even the peace of nothingness is denied. We – and by we I mean those of us who are intellectuals, educated in well-off middle-class families – are being called to make sacrifices. Let's accept the challenge.' (quoted in Gibson, 1987: 34) At the outbreak of the civil war, he returned to his hometown of Granada where he was executed by a Nationalist firing squad and buried in an unmarked grave. Arrabal (Arrabal and Kronik, 1975: 60) cites Gibson as a source for this material and comments: 'Once again, the most innocent of all is the one to have suffered.'

19 As a child Arrabal also suffered from tuberculosis.

20 Valleau (1982: 145) takes a rather different view of the film, describing it as 'sincere but disappointing' and the adult Arrabal as 'a narcissistic adolescent'.

21 The US director Tod Browning was also influenced by Surrealism; it is noteworthy that dwarves are also represented sympathetically in his films, for instance *The Holy Three* (US, 1925) and *Freaks* (US, 1932).

22 See Davies (1999) for information on the propagandist use of radio during the conflict.

23 For instance, Helen Graham notes that almost 7000, overwhelmingly male, clergy were killed by Republicans during the conflict. She suggests, however, that this arose because 'they were seen as representing an oppressive Church historically associated with the rich and the powerful whose ecclesiastical hierarchy had backed the military rebellion'. (2005: 27)

24 The execution of political opponents by means of the garrotte was a medi-aeval practice favoured by the Franco regime. The last man killed by the garrotte in Spain was the Catalan anarchist Salvador Puig Antich, who was executed on 2 March 1974. His life is depicted in *Salvador* (Huerga, Spain/UK, 2006).

4

Film under Franco: *La caza/The Hunt* and *El jardín de las delicias/The Garden of Delights*

One couldn't talk about the Spanish Civil War when Franco was alive. Well you could talk about it, but only from the fascists' point of view, not from the Republicans'. A lot of young film directors and writers wanted to show the other side of the civil war and also the Spanish reality of the forties and fifties, but censorship was very strong and we had no freedom of expression whatsoever. So in order to make a film like *The Hunt*, when you are faced with censorship and a very repressive system, you are using your intelligence, going around things, telling the story indirectly. You could never approach the subject directly. I found that it had certain advantages because as you have to go to it indirectly, another thing can come out of it.

Carlos Saura[1]

On 11 July 1974 the Spanish premiere of *La prima Angélica/Cousin Angelica* (Saura, Spain, 1974) at Barcelona's Balmes cinema ended abruptly and violently when neo-fascists loyal to their dying president firebombed the cinema. (Deveny, 1993: 172) This fierce right-wing response to the first Spanish film to represent the civil war from a Republican perspective highlights how, decades after the conflict's official conclusion, cinematic representations of the Spanish Civil War remained hotly contested within Spain. It is not surprising that the work of Carlos Saura provoked this aggressive right-wing response: a key filmmaker working under the dictatorship, his *oeuvre* includes a number of films that comment critically on the civil war and its aftermath. As has already been outlined, in the years immediately preceding Franco's victory the dictatorship attempted to prevent any open displays of dissent in either the political or cultural sphere. As the regime courted international legitimacy, both Spain and Spanish cinema underwent significant changes and dissent became increas-

ingly manifest in both areas.[2] In relation to cinema, government censors exercised tight control over film production, distribution and exhibition; a glimpse into the nature of this control emerges in Saura's recounting of an exchange he had with a government official while negotiating the script for his debut feature, *Los golfos/The Hooligans* (Spain, 1959), which depicts the lives of Madrileño teenagers attempting to escape poverty through the world of bull-fighting. As the discussion became increasingly fraught, Saura notes that the official 'opened his drawer, pulled out a gun, and stated, "If you are going to be like that then we will just go outside and start shooting."'[3] Censorship, then, enforced most directly, actively prevented oppositional filmmakers from political and social commentary; however, as the epigraph from Saura indicates, through the skilful deployment of *cine metafórico*, or metaphorical cinema, which utilised allegory, metaphor and symbolism, oppositional filmmakers presented searing, if somewhat complex and oblique, critiques of the regime. Saura's key films of the period are *The Hunt* (Spain, 1966), *The Garden of Delights* (Spain, 1970), *Ana y los lobos/Ana and the Wolves* (Spain, 1972), *Cousin Angelica* and perhaps Saura's most critically acclaimed film, *Cría cuervos/Raise Ravens* (Spain, 1976).[4] In an essay exploring cinematic representations of the conflict, Antonio Monegal suggests that 'To make a film about a war, any war, may involve the challenge of representing the unrepresentable.' (1998: 213) In an echo of Hayden White's position, Monegal champions allegorical or poetic accounts of past wars and concludes his essay with the following: 'only poetry can meet the challenge of exceeding the limits of representation.' (1998: 214) This chapter examines two films directed by Saura that reference the civil war and its political and social fallout, *The Hunt* and *The Garden of Delights*. Although there are numerous films set in the postwar period, I have chosen these films specifically because they reveal how filmmakers under the dictatorship employed *cine metafórico* to depict the post-civil war period when they were unable to make films set during the period itself. In doing so, I test further the ability of film forms other than the mainstream historical film to represent the conflict.

La caza/The Hunt

Saura received the Silver Bear for Best Director at the 1966 Berlin International Film Festival for his work on *The Hunt*, the first of his

thirteen collaborations with the celebrated left-wing producer Elías Querejeta.[5] Saura's third feature, the most overtly political work of his early career, centres on three Nationalist civil war veterans, now fifty-something businessmen, as they participate in a rabbit hunt. Paco (Alfredo Mayo) is the group's dominant figure: superficially the franquista soldier *par excellence*, his business success suggests that his commercial ruthlessness parallels his wartime behaviour. That Mayo, who starred as a thinly disguised Franco in *Raza*, takes the role of Paco creates an intertextual reference and contributes to the fierce critique of the celebration of machismo and the military in previous pro-Franco civil war films.[6] Paco is joined by José (Ismael Merlo) who invites the men to a hunt on his land as a pretext to discuss borrowing money from Paco in an attempt to prop up his failing commercial concerns. Luis (José María Prada), José's business partner, who has struggled in all aspects of his life (as he puts it, 'I've been a fool. In marriage. In business') and Paco's brother-in-law, Enrique (Emilio Gutiérrez Caba), a generation younger than the former combatants, complete the group. The ex-servicemen are also haunted, however, by the memory of their dead business partner, Arturo, who according to Paco embezzled money and committed suicide. Despite the group's close personal associations, signs of tension emerge when they stop off for morning coffee before the hunt. In a roadside café, Paco expresses annoyance at Luis's decision to commence the day with a few brandies, the latter's consumption signifying the alcohol-dependency that will fuel subsequent events. As the group undertake the hunt itself, which is accompanied by non-diegetic, militaristic drum rolls, the tensions surface in the searing heat and, as the percussive score grows increasingly discordant, a brutal shoot-out ends in the death of all three ex-servicemen. Enrique survives, however, and the final scene consists of the desperate and petrified young man fleeing the carnage, his image captured in a freeze-frame mid-shot as the sound of his nervous, heavy breathing continues for a further ten seconds as the closing titles appear.

Hunting and violence

Paul Preston notes that hunting was one of Franco's favourite pastimes: 'His main objective seemed to be to kill as much as possible, suggesting that hunting, like soldiering before it, was the outlet for the sublimated aggression of the outwardly timid Franco.' (Preston,

2000: 65) It is not therefore surprising that the theme of hunting emerges in a number of oppositional films produced in Spain, notably *Furtivos/Poachers* (José Luis Boras, Spain, 1975), and *La escopeta nacional/National Shotgun* (García Berlanga, Spain, 1978). In *The Hunt*, the veterans' activities and the hunt's increasingly violent nature invite parallels with Nationalist violence during the civil war and with the repressive post-civil war dictatorship. References to a non-specified previous war are quickly made apparent: when the group arrive at the hunt's location, a battlefield from a previous war,[7] Enrique surveys three caves overlooking the arid space and asks Luis, 'What are those caves?' Luis responds, 'The Loyalists tried to hide in them during the war. But they had to come out. And we shot them.' The reference to 'Loyalists' is clearly to Republican soldiers and is repeated in the following exchange. Here, framed in a two-shot, José says, 'Remember this place Paco?' to which Paco replies, 'Yes, we fought the Loyalists here.' José creates the first clear connection between their past and present activities when he continues, 'It was a different form of hunting then.' The next scene reinforces the connection between past and present visually as the camera zooms in on three rabbit holes, thereby creating a parallel with the three hillside caves shown earlier.

Throughout the opening scenes, Luis Cuadrado's stark, monochromatic cinematography bears the hallmarks of an Italian neo-realist cinematic aesthetic; however, the realist film form is abruptly interrupted by a fourth-wall-breaking scene in which the four central characters speak direct to camera. It begins with Luis removing his spectacles, turning to face the camera, and stating: 'There really isn't much fun in hunting rabbits.' Paco adds that they are 'defenceless creatures', before, in an echo of Nationalist civil war propaganda, postulating that the 'sick must die . . . only the fittest survive'. 'That's cruel,' responds Enrique, signifying the rejection of fascistic values by a younger generation. José concurs with Luis's desire to engage with a more powerful foe: 'When your opponent is stronger it's more fun . . . it's power against power.' Paco continues the discussion, but steers it in the direction of fishing: 'The big fish always eat the small ones.' José interjects, 'Not always. What about piranhas?' As the film returns to more conventional editing techniques, Paco appears visibly unnerved by the proposition that the collective actions of a multitude of small creatures could destroy a larger, more significant enemy. These Brechtian distancing techniques are deployed to jolt the viewer

out of the, until this moment, conventional narrative in an attempt to provoke reflection on the nature of fascist ideology and the possibility of overthrowing the dictatorship.

Censorial constraints ensured the absence of direct references to the actual war in which the combatants had fought (D'Lugo, 1991: 56). Thus, when the group assemble for lunch, Paco, commenting on a skeleton that José reveals to him during a visit to one of the hillside caves, observes: 'It's probably someone killed in the war.' Enrique asks 'What war?', and Luis responds, 'What difference does it make?' Despite the censors' restrictions on alluding to the civil war directly, it is inconceivable that contemporary Spanish audiences would have been unable to decipher these barely concealed references. This is further exemplified when Enrique is shown armed with his father's Luger, at which Paco comments, 'Many of our rebels were killed by faulty Lugers', thereby referencing German involvement in the unnamed conflict, a point elaborated on when 'Deutschland Über Alles' is sung. In addition to obliquely referencing the civil war, the filmmakers make more general points about class struggle and the possibilities for societal change that were central to the conflict. This is evident in the character of Juan, the peasant who works José's land and who, in contrast to the Nationalist soldiers, only hunts for food, not pleasure. When he first appears, he is captured on-screen as if seen through the sights of Luis's rifle. Descending the hillside towards the group, he is geographically sited in the same landscape in which the Loyalists (Republicans) had been hunted.[8] His limp, moreover, invokes Paco's disdain when, continuing in the vein of his previous fascistic discourse, he states: 'I can't stand the sight of cripples . . . I'd rather die than become an invalid.' When the hunters find a myxomatosis–ridden rabbit, the diseased animal invites further comparison with Juan's injury and further ties this representative of the impoverished and landless agricultural workers with the ageing hunters' prey. The possibility of revolutionary transformation also emerges when, echoing the earlier discussion, Luis states: 'Some day, the rabbits will attack mankind. They'll create a new civilisation. But since they are very small, there'll be no room for all of us. No more class wars.' Indeed, Hugh Thomas makes a similar connection between rabbits and the Nationalists' wartime enemies when he suggests that the officers who presided over military tribunals during, and at the end of, the civil war 'thought no more of condemning young men to death than shooting rabbits'. (2003: 499)[9] Thus, although

4.1 *La caza/The Hunt* The four hunters undertake the shoot, which functions as a metaphor for Nationalist violence during the civil war and the post-war dictatorship.

not raised overtly, the veterans' violence operates as a stark analogue for the regime's violence and their debates over hunting and fishing prompt reflection on wider discussions about societal change, reflection that is very deliberately provoked through the use of Brechtian distantiation techniques that rupture the narrative. In addition to the Brechtian devices – interior monologues, direct address, etc. – the film also repeatedly references the powers of representation, which further invites reflection on the film's constructed nature. For instance, when the men finish the first hunt, they pose for a photograph before the camera cuts to a still shot of the men and then to an extreme close-up of the camera that had taken the photograph.

Sally Faulkner (2006: 148) notes that critics have previously understood the rabbit hunt primarily as a metaphorical representation of the civil war and the hunters' demise at the film's conclusion as a harbinger of the dictatorship's inevitable collapse. She suggests, however, that the ferocious slaughter of the rabbits, which is displayed graphically and often in close-up, functions, not metaphorically, but as a direct interruption in the film's narrative (2006: 148). In support of her position, Faulkner cites Stone's assertion that critics should 'Observe the indisputable reality of these incidents rather than the narrative-bound symbolism of the slaughter'. (quoted in 2006: 149; original citation is Stone, 2004: 76) Adding authorial weight to this position, she cites a 1969 interview with Saura in which the director states that he removed allusions to the conflict in the script because they were too readily identifiable and in order to broaden the film's possible interpretations (2006: 150). Yet, despite Saura's quote and Faulkner's analysis, it is difficult to avoid what appear to be clear,

and not particularly oblique, references to the historical conflict. As Gwynne Edwards (1997: 194) puts it, 'As rabbits are shot and roll downhill, the image of men cut down in war is never far away.' Rather than establishing a false opposition between two potential readings, it is possible to argue that these sequences can function as a Brechtian device – paralleling the previous fourth-wall-breaking scene in which the characters speak direct to camera – which forces the reader out of the predominantly realist narrative to consider the real-life slaughter of the rabbits *and* to reflect on the regime's violence.[10]

Faulkner's position is more persuasive when she argues that the main critique of the dictatorship emerges in the film's exploration of ageing. In an insightful analysis of a sequence in which the hunters take a siesta before embarking on their final hunt, Faulkner notes that the film 'debunks, succinctly and effectively, the rhetoric of virile masculinity that reaches its climax in Saura's portrayal of the snapshot of the hunters/warriors with their spoils'. (2006: 162) Of course the regime's celebration of machismo connected militaristic masculinity and the continuing army-enforced dictatorship. The critique that Faulkner identifies emerges most clearly as the camera slowly pans across Paco/Mayo's muscularly sculpted body, which shows considerable signs of ageing. Paralleling the decaying nature of Franco specifically, and the regime generally, the veteran's ageing physique is contrasted with the youthful bodies of both Enrique and Juan's niece, Carmen, who in one scene are shown dancing to sixties music, thereby suggesting that the future lies, not with the over-the-hill hunters, but with a new generation of Spaniards growing up with alternative cultural and political references to those favoured by the regime. A further conflict emerges when José kneels down by the river and stares, Narcissus-like, into his reflection. When Enrique take his picture José gets angry and rips it up. Like the regime, he wants no representations that he cannot control, and particularly none taken by considerably younger people.

Freezing history

The film concludes in a melee of orgiastic violence as the group's aggression turns in on itself: Paco blasts the ferrets; José shoots Paco in the face; Luis attempts to kill José by driving a jeep directly at him, but José shoots him first; Luis, fatally wounded and covered in blood, kills José as he flees. Thus all three ex-combatants are killed by the

methods that they both celebrated and participated in. In the closing sequence, Enrique flees the violence; as he nears the top of a hill, the film concludes with a freeze-frame mid-shot of the young man. Faulkner notes that, again, critics have conflicting interpretations: 'either in a negative sense, whereby Enrique stands for the younger generation trapped by the hatred and violence of the older one (Kinder 1993: 165; Wood 1999: 369); or a positive one, according to which Enrique represents a generation that has succeeded in running away from these murderous rivalries of the former (Millar 1975: 236)'. Drawing on Gilles Deleuze's notion of the 'time image', Faulkner suggests that 'The shot indicates man trapped by time: both the vertiginous rush from past to future (the panting on the soundtrack) and the terrifying stasis of the present (the freeze-frame).' (2006: 164–5) The conclusion invites comparison with that of *Les quatre cents coups/400 Blows* (Truffaut, France, 1959), which ends similarly with a ten-second freeze-frame of the character Antoine as he flees from a reformatory. But as Bordwell and Thomson (1992: 70) note in relation to Antoine, since we never learn whether he escapes it leaves the audience to speculate on his future. Of course, cinematic characters are compounds of signifiers that have no existence beyond the screen; nevertheless, by forcing the viewer's gaze on to the static image, the ending of *The Hunt* also forces speculation about the future that lies ahead of the fictional Enrique and, by extension, a younger generation turning their back on the violence of the regime. Despite censorial constraints, then, *The Hunt* very effectively provokes reflection on the brutality of the civil war and the Franco dictatorship. Its open-ended conclusion, moreover, allows connections to be drawn between past battles and its own present, suggesting, not stasis, but that the future, at least at the time of its production, is yet to be determined and is up for grabs.

El jardín de las delicias/The Garden of Delights

Taking its name from a Hieronymus Bosch triptych, *The Garden of Earthly Delights*, Saura's seventh feature is a Surrealist-inspired, at times comically grotesque film that also utilises Brechtian techniques. The film premiered at the New York Film Festival after the Spanish government banned domestic screenings for seven months and prevented its exhibition at the Berlin, Cannes and Venice film festivals; indeed it was only screened after Querejeta smuggled a print out of

the country. (D'Lugo, 1991: 107; Besas, 1985: 123) Saura's success on the international film festival circuit was crucial in giving him leverage with both censors and distributors as the government was eager to appropriate Spanish cinema – even oppositional cinema – to legitimate its rule. As Saura points out:

> At that time it was very difficult to tell any stories and everything we could say was limited. But I've been able to make cinema just because my films were able to go out of Spain. I was lucky in that international film festivals like Cannes or Berlin showed an interest in the films that I was making, and they put pressure on the Spanish government to make sure that my films could go to those festivals. And once I had a certain status, particularly in France, the government had to be much more careful when they were trying to stop me.[11]

Produced during the first period of the *dictablanda* or 'soft dictatorship', when the regime relaxed restrictions on artistic production, the film contains direct references to the civil war, which would have been unimaginable in the early years of the *dictadura* or 'hard dictatorship', or even at the time of *The Hunt*'s production only five years previously.[12] While *The Hunt* centres its critique on the military, *The Garden of Delights* shifts focus to one of the regime's cornerstones, the family. The film's central character is forty-five-year-old businessman Don Antonio Cano (José Luis López Vázquez). Confined to a wheelchair following a car crash, Antonio has lost the use of most of his faculties, both physical and mental, including, crucially for the film's thematic concerns, his memory.[13] As he is able only to recognise partial elements of his life, both past and present, Antonio's family, desperate to learn both the details of a Swiss bank account in which the patriarchal figure has secreted away the family fortune and the number of the family safe's combination lock, stage reconstructions from critical moments in his life in an attempt to assist his process of memory reclamation. As outlined in the previous chapter, Arrabal employed cinematic shock tactics to force a political response from the spectator. Here, the family employ similar shock tactics, mining Antonio's unconscious in an attempt to jolt his memory and, thereby, solve their own financial dilemmas. *The Garden of Delights* can be viewed, then, as a cinematic attempt to tap into the nation's unconscious or repressed memories of the civil war – both contemporaneous and those created in the post-civil war period – in order to stimulate political action against the country's ailing dictator.

Initially, Antonio is unable to differentiate between the world of the real and his oneiric imaginings, and between his past and present, a process paralleled in the film's form. According to Saura's original shooting script, the film takes place on five separate planes of action: recreated past, evoked past, present, future and Antonio's oneiric world. (Kovács, 1981: 47) The demarcation between these planes of action is not always clear; for instance, in one scene, which takes place following the second of the family's reconstructions, Antonio is in his wheelchair in the estate gardens staring blankly at the world around him when he sees, emerging through a group of trees in the distance, three men wearing full body armour riding on horseback towards him, lances at the ready. The scene appears to correspond with an image on the family safe that also depicts armoured horsemen. As Katherine S. Kovács (1981: 49) observes, the only visual clue that this represents Antonio's interior world emerges when the camera closes in on his face as he looks into space before the action.[14] A further illustration of this blurring of the planes of action occurs in a sequence that appears to be one of Antonio's recollections or imaginings. As the adult Antonio lies in bed, he is caressed and kissed by his favourite aunt, and the depiction has an erotic sensibility suggestive of his childlike incestuous urges; however, it is never in fact clear that this is the amnesiac's oneiric world. Thus, as Antonio struggles to differentiate between these worlds, the complex shifting between the planes of action ensures a similar degree of difficulty for audiences.

Staging the past 1: the birth of the Republic

This analysis concentrates, primarily, on the scenes in the first plane of action, the recreated past, which, on the whole, are demarcated more clearly. While Antonio spends most of his time in the gardens, the reconstructions take place within the family home. In the first of a series of reconstructed episodes from his past, Antonio is locked in a room with a pig, a reference to a childhood traumatic incident. 'We can't be sentimental', says his father, Don Pedro (Francisco Pierrá), 'his subconscious must respond.' Terrorised by the animal's presence at such close proximity, Antonio faints but, when he recovers, his faltering powers of recall remain unimproved. Undeterred, the family organise two further reconstructed sequences from critical moments in Antonio's life that are coterminous with critical moments in twentieth-century Spanish history. The first reconstruction occurs

immediately after a scene in which the family's motivations become clear. Here, his father opens Antonio's childhood atlas and points to a map of Switzerland before spreading banknotes across the page and saying 'Swiss money, Swiss money . . . We have need of these millions now.' This reference to the need for cash to stave off a takeover of the family business, however, fails to provoke the intended response. Instead, Antonio, signifying his childlike state of mind, drinks his milkshake through a straw, his face remaining blank throughout his father's increasingly desperate pleas. As his father exclaims, 'What are we going to do with you my son?', the film cuts to a full-screen shot of a red theatre curtain, which is drawn back to reveal a bemused Antonio sitting in an armchair that stands in the middle of a red carpet on a makeshift stage. The camera pulls out to reveal the back of the head of a young boy, an actor playing a youthful Antonio standing in the middle of the family's storeroom, which has been transformed into a church. Here, a priest addresses the boy by name as an organ plays, choirboys sing and family members and other actors, dressed in 1930s' attire, take their places in the congregation. Antonio's father approaches and embraces his son and, with the two men framed in a two-shot, he recalls the events of Antonio's First Communion, which coincided with the date of the birth of the Second Spanish Republic: '14 April, 1931. The happiest day of your life.' His father continues, 'and when you were about to take Communion . . . that bastard of an organist', and he motions the organist to commence playing a Republican tune: 'That bastard with his rebels profaned this church. Listen! Listen!' This is followed by a cut to a group of demonstrators who are brandishing Republican flags breaking down the doors and chanting 'Long Live the Republic!' Amid the chaos, the priest removes the young Antonio from the room while Antonio himself tilts his head to one side like a confused animal as Republicans, storming the altar and wrestling with the churchgoers while chanting 'Viva la Republica', surround him. The father cries 'Long Live the Sacred Heart of Jesus!' and appeals to the organist to return to the hymn, and Antonio's eyes dart feverishly around the room as he surveys this stage-managed re-enactment of his first Holy Communion, before, displaying signs of internal perturbation and memory recall, he utters 'The Saints! The Saints!' His father calls for silence as an anguished Antonio cries for his aunt and there is a cut to a long shot of his aunt, the one who had previously kissed him so passionately, who enters and walks down the red carpet to greet him. As she does so, a siren

is heard off-screen and he cries 'Take away the Saints!' His father then makes reference to specific historical events: 'Yes, son, they proclaimed the Republic. Remember 1931. Eibar, Barcelona, San Sebastian.' As the sound of machine-gun fire and exploding bombs is heard, Antonio makes a connection between his Communion, the political events of the period then the outbreak of the civil war: 'Auntie. The Reds. And 1936.' As the sound of aircraft is heard, he says 'the planes' and, clearly traumatised, rises to his feet while his father looks on, pleasantly surprised by his son's sudden physical recovery and the signs of memory reclamation that he displays. We have in this scene, then, references to the civil war and the Republic, the inclusion of which would have been impossible if the filmmakers had attempted it in any realist cinematic depiction. As their inclusion is part of a scheme to assist the recuperation of a member of Spain's industrial class, it is possible to see how the filmmakers were able to persuade the censors to accept these scenes. Thus the filmmakers use the family's attempts to cure the amnesiac Antonio as a way of breaking through the wider cultural and political amnesia about the civil war.

Staging the past 2: Franco's victory

The second reconstruction of the civil war takes place after Antonio has shown significant signs of recovery and is able to both walk and talk freely, although his powers of recall have not matched the progress in other areas. The scene begins with monochrome actuality footage of Nationalist soldiers marching while military aircraft fly in formation above. The footage, which, as D'Lugo (1991: 104) observes, implicates the cinematic apparatus in the promotion of fascism, is looped while off-screen we hear the Nicaraguan writer Rubén Darío's poem, 'La marcha triunfal/The Triumphal March'. The camera then cuts to a mid-shot of Antonio as he looks slightly off-centre; a light shining above his left shoulder indicates that he is watching the projected footage. His father, dressed in a Spanish army uniform, suddenly breaks through the screen in a quite literal fourth-wall-breaking action and addresses him directly: 'Victory, my son, victory! Father returned from the front and amidst so much joy he faced the greatest sadness of his life.' He kneels next to Antonio and, lamenting the death of Antonio's mother, embraces him. 'What will become of us my son? Come, come with me', he says as he tries to help

him from the chair. Antonio rejects the assistance, transfixed as he is by the footage, and slurs the words 'the film, the film' as his father leads him forcefully to an adjacent room. Here, artificial snow falls on a nativity scene and Christmas carols are heard in the background as his father recounts tales of the boy as a twelve-year-old. He is taken out into the garden where a woman runs then falls dramatically on a piece of garden furniture. 'Your mother Antonio, your mother,' his father cries. 'Julia. No, it's not mum,' Antonio states, 'that's auntie.' Impressed by further signs of Antonio's memory reclamation, his father, still wearing his civil war uniform, says, 'You are improving my son' and embraces him.

Commenting on the film's civil war scenes, Deveny (1993: 163) notes that 'the memories of the civil war are viewed as so deeply entrenched in the subconscious that they, among all of his memories, will provide the key to reawakening his mental faculties.' Yet Antonio's recovery is not sufficient to oblige his family's desires. Narrative identification with his character's attempted recovery invites both audience empathy and sympathy; however, as his position slowly improves, he reveals himself to be a hard-nosed, cruel patriarch, as much a regressive character as the family who subject him to such tortuous 'healing' processes. Indeed, one is left in no doubt that if Antonio were in his father's position, his actions would not be dissimilar. The family is shown to have enriched itself during the reconstruction in post-civil war Spain and the pursuit of money is the motive for their returning to the period, this time through staged reconstructions. Thus the filmmakers, despite the constraints under which they operated, managed to bring elements of the civil war on to the Spanish screen and, simultaneously, embed the civil war within a critique of the Spanish industrial ruling class, which is also evident in the film's conclusion.

Polysemic endings

The film's concluding scene begins with a long shot of Antonio, now declared legally insane, in his wheelchair as it rolls slowly down a hill with a slight gradient. A close-up of Antonio's face, which suggests that this is the central character's oneiric imaginings, precedes the scene. Antonio is joined in the gardens by five close family members, all sitting in wheelchairs as they move around the gardens unaided yet not self-propelled. The film's last image is a tableau in which all

six family members sit, stationary, in the gardens, recalling both the film's title and the Bosch painting that inspired it. Peter Besas (1985: 203) notes that the film's original script ended with the family being savaged by dogs, but technical difficulties prevented this ending being realised. This, at least, gives us an idea of how Saura and his co-script-writer Rafael Azcona might have wanted Spanish audiences to view the family. It is not, however, the film that we are left with. Critics have differed on the sombre, multivalent conclusion. Marjorie Valleau (1982: 135), for instance, suggests that 'Saura shows to the Spanish people a reflection of their political behaviour and offers no hope for the future.' Stone (2002: 69) suggests that Antonio can be read as a satirical manifestation of the dictator and that the family represent the 'Spanish people, whose attempts to recreate scenes from their direct past are hopelessly staged and artificial because their patriarch has denied them any notion of themselves beyond his autocracy.' Kovács (1981: 51) also draws a parallel between the family's position and the condition of Spain following decades of Franco's rule. A more positive reading moves beyond a straightforward parallel between Antonio and Franco, suggesting that the family (and by extension the Franco dictatorship and the Spanish ruling elite) but not necessarily Spain as a whole are stuck or paralysed by their connections with the civil war. *The Garden of Delights*, then, forms part of a wider critique of the Spanish ruling class; unable to progress, the family stand as rep-resentative of a paralysed and parasitic ruling class and the film sug-gests that only by shaking off their authority and control will Spain be able to progress.[15]

Conclusion

Although both films under discussion here achieved significant inter-national success, some critics have suggested that they did not have the impact that the filmmakers desired. Stone (2007: 28), for instance, argues that Spanish audiences were less likely to draw the parallels that the filmmakers intended: '*Cine metafórico* created an alternative reality that excited the unconscious mind, but the fantasy on-screen was easily dismissed as irrelevant because the language of metaphor, as opposed to that of the state, was too elusive. What was missing was a recognisable, collectively agreed-upon point to the whole venture: a punchline.' D'Lugo (1991: 100) suggests that Saura and Querejeta were aware that the complexities of the script and film form employed

in *The Garden of Delights* would ensure that the censors, expecting it to have a limited appeal, would treat it leniently. Of course, it is impossible now to speculate with any authority on the film's impact on Spanish audiences at the time; nevertheless, we do know that direct political cinema was simply not an option for filmmakers who remained in Spain.

There is no common aesthetic strand linking the films; *The Hunt* fuses Brechtian techniques with an Italian neo-realist aesthetic in a vividly clear critique of the military, whereas *The Garden of Delights*' critique of Spain's ruling elite is considerably more opaque. What unites both films, however, is an obdurate desire on the filmmakers' part to force the civil war on to the cinema screen under the most difficult of conditions.[16] The absence of direct references to the civil war ensured that *The Hunt* had broader appeal in the present, while the specific historical references in *The Garden of Delights*, coupled with its ambiguity, particularly in its conclusion, gave the film a more limited resonance in the present. Through being forced to depict the civil war, as Saura puts it in the epigraph, 'indirectly', 'certain advantages' are indeed apparent in the films. Despite or indeed, because the filmmakers could not represent the civil war unimpeded by the censor, the result is two poetic, cerebral representations that, through their essential polysemousness, force reflection and debate on the conflict and how it is both memorialised and remembered. As with the Arrabal films discussed in the previous chapter, Saura's cinematic practice is one that would be in keeping with the film form championed by Rosenstone and White. Marked by thematic complexity, acute perceptiveness and a mastery of various cinematic forms, these films stand among the highest achievements in Saura's expansive and celebrated corpus of work. They also remain highly memorable and stinging critiques of the conflict's victors and of Spain's post-civil war dictatorship.

Notes

1 Interview with author, London 2002, translated simultaneously by staff from the Cervantes Institute.
2 The regime had always lacked the support of Spain's leading filmmakers. In a celebrated attack at a conference in Salamanca in 1955, Juan Antonio Bardem argued that 'After seventy years of anaemia, Spanish cinema is politically useless; socially false; intellectually inferior; esthetically non-existent, and industrially sick.' (cited in Higginbotham, 1988:

28) Saura was regarded as an important figure in what became known as 'The New Spanish Cinema'.

3 Interview with author, London 2002.

4 Following the release of *Cría Cuervos*, Saura's most celebrated films concern themselves with the world of dance; notably his Flamenco Trilogy: *Bodas de Sangre/Blood Wedding* (Spain/France, 1981), *Carmen* (Spain, 1983) and *El amor brujo* (Spain, 1986). He returned to the civil war with the release of *¡Ay Carmela!* (Spain, 1990), which is discussed in more detail in chapter six.

5 Both these films were produced by what became characterised as 'La factoria Querejeta/The Querejeta Factory'. For an overview of Querejeta's work see Whittaker (2010). *The Hunt* was co-scripted by Saura and Angelino Fons; *The Garden of Delights* by Saura and Azcona. *El productor/ The Producer* (Fernando Méndez Leite, Spain, 2006) is a documentary tribute to Querejeta's work.

6 Mayo also stars as a Nationalist soldier in *¡A mí la legión!*, as does Ismael Merlo in *La fiel infantería*.

7 The film was shot on a former civil war battlefield. (D'Lugo, 1991: 57)

8 See Thomas A. Whittaker (2010) for a discussion of the use of space in the film. He highlights the way in which space 'almost becomes a protagonist' and takes on an 'overt political function'.

9 Critics have noted that Sam Peckinpah has cited *The Hunt* as a major influence on *The Wild Bunch*, and similarities can be drawn between the hunt sequence in *The Hunt* and the ambush sequence in *The Wild Bunch* (US, 1969). (Kinder, 1993: 165)

10 That the killing is shot in black and white somewhat lessens the visceral impact, certainly compared to the slaughter of the bull in *¡Viva La Muerte!*, discussed in the previous chapter.

11 Interview with author, London 2002.

12 Deveny notes that there were three components of the film that the censors objected to: the obvious parallels between Antonio and Franco, the Republican flags in the civil war reconstructions and the inclusion of Dario's poem. (1993: 165)

13 The inspiration for the film came from a real-life incident involving Juan March, the industrialist who helped finance the military uprising in July 1936. (Deveny, 1993: 160)

14 Valleau suggests that, in escaping the personal and political complexities of his life, 'Antonio finds refuge only in his amnesia and in fantasies about his aunt, the one person in the film who offers him freedom from sexual repression.' (1982: 135)

15 Valleau (1982: 113) also notes that, in the use of the Prokofiev score from Eisenstein's *Alexander Nevsky* (USSR, 1938), the film makes a link between Stalin and Franco.

16 The influence of Surrealism is also evident in *El espíritu de la colmena/Spirit of the Beehive* (Erice, Spain, 1973), which presents an oblique commentary on the enforced silence following Franco's victory, yet contains none of the shock tactics or violence associated with either Arrabal's or Saura's work.

5

Recycling Basque history: patterns of the past in *Vacas/Cows*

History never repeats itself. Man always does.

Voltaire

Vacas/Cows (Spain, 1992) is the self-reflexive, experimental debut from Basque-born director Julio Medem. A significant critical success (Medem won the Best New Director Goya in 1993), on its release *Vacas* was also one of the most successful films at the Spanish box office. Yet, despite its critical and commercial success, *Vacas* is a perplexing film that denies easy analysis; even after multiple viewings it is likely to leave audiences scratching their heads over the contents of its 96-minute-long narrative. Barry Jordan and Rikki Morgan-Tamosunas suggest that, throughout the 1980s and 1990s, Spanish cinema generally represents the past 'in terms of the domestic, the everyday and focused from the point of view of the individual, the family or other small groups and communities rather than through documentary analyses and broad historical reconstructions of the epic type'. (1998: 39) *Vacas* is concentrated on the domestic realm, dealing with the lives of two rural families in the Basque country; however, this is placed within a broad, if unconventional, historical sweep. The events in *Vacas* take place between the Second Carlist War (1872–76) and the Spanish Civil War's outbreak in July 1936; only the closing third is set during the civil war, but the film is included here because it raises interesting questions about the manner in which the past can be represented cinematically, and suggests, moreover, that the civil war, at least in the Basque country, is perhaps best understood as part of a continuing, cyclical, historical process. Rather than locating the civil war as a violent aberration in an otherwise peaceful historical trajectory, by framing the action both

in and between two wars *Vacas* presents it as only the latest instalment in a prolonged pattern of conflict. This, then, is no wistful or nostalgic looking back, but a perplexing account of a problematic past. *Vacas* does not deal in detail with particular historical events, nor is there any socio-economic motivation for the events contained within in its narrative. Rather, it appears to suggest that the civil war's social or historical contexts are a mere sideshow; it is enough to know that war will always occur, armed conflict a seemingly inevitable by-product of human nature and of Basque history and politics.[1] The film, in addition, in its concentration on cycles and circles, can be read as a commentary on general trends in historical development, challenging, as it does, both the traditional linear and 'the past as chaos' historiographical models outlined in the introduction. This chapter offers an analysis of the way that these perspectives are presented in *Vacas*, both at the level of content and form, explores debates concerning the cyclical nature of history, and also touches on the ability of alternative narrative film forms to encourage viewers to contextualise or actively engage with what is projected on to cinema screens. Finally, the chapter grounds the film in a Basque context, exploring Medem's own relationship with Basque politics and the importance of Basque history to any understanding of the civil war.

Synopsis

Vacas is a complex film, requiring, indeed almost demanding, multiple viewings; the complexity of the narrative should be apparent from this brief, if unavoidably tortuous, plot synopsis. Set in the Basque country, *Vacas* follows two feuding families between the Second Carlist War and the outbreak of the Spanish Civil War. Carmelo Mendiluze (Kandido Uranga) and Manuel Irigibel (Carmelo Gómez), rival *aizkolaris* (log-cutters), are Carlist soldiers fighting at the front. When Carmelo is shot and fatally wounded, Manuel, traumatised by his wartime experience, uses blood from Carmelo's neck-wound to feign his own death and escapes, suffering a serious leg wound in the process. He travels in a cart full of dead bodies from which he manages to free himself before crawling through a field where he encounters a large white cow. The camera zooms in towards the cow's eye before appearing to enter the eye, travel through a tunnel, and re-emerge thirty years later where Manuel, now an old man, is adding the finishing touches to the eye of a cow in a painting. His

three granddaughters, the daughters of his son, Ignacio (also played by Carmelo Gómez), assist him. In a neighbouring house resides Carmelo's son, Juan (also played by Kandido Uranga), and log-cutting contests between Ignacio and Juan fuel the feud between the families. The feud is complicated further by Ignacio's sexual desire for Juan's sister, Catalina (Ana Torrent). Jumping forward ten years, Ignacio and Catalina's illegitimate son, Peru (the young Peru is played by Miguel Ángel García), establishes a close friendship with Ignacio's father, Manuel (also Peru's own grandfather), and Ignacio's daughter, Cristina (Peru's half-sister, played by Ana Sánchez). Peru develops an adolescent, incestuous sexual interest in Cristina. Catalina, Ignacio and Peru emigrate to the United States and Peru and Cristina remain in contact by letter. At the outbreak of the civil war, Peru (played by Carmelo Gómez), now a grown man, returns to the Basque country to photograph the war for an American newspaper. The film's ending allows for conflicting readings: at the outbreak of the Spanish Civil War, after a battle in the woods, either Peru and Cristina flee to France, or they are both killed.

Cycles

Rob Stone attests to the influence of Surrealism on Medem's work and suggests that 'Where Surrealist filmmakers aspire to a shift from concrete reality to the intangibility of a world beyond reason they find liberation in the infinite and therefore often end up going round in circles, happily trapped in a cyclical patterning.' (2007, 36) Medem himself states that *Vacas* 'is about time . . . there's a cyclic sense to it; it begins and ends with a war and everything's predestined to repeat itself from generation to generation'. (quoted in Anne M. White, 1999: 4) This suggestion of predestination is evident from the opening credits as Ignacio, while practising his log-cutting skills, brings his axe down on a log and a small piece of wood hurtles skyward and is captured in a freeze-frame close-up. The shot is connotative of the old saying 'a chip off the old block', raising questions about the extent to which personal histories are genetically predetermined, a recurring thematic concern. The film is split into four acts. The first act begins with a close-up of the burning head of a dead cow before the camera pans across the scarred remnants of a battlefront with intertitles locating the action in a Guipuzcoan valley in the Basque province of Bizkaia during the Second Carlist War. Here, Carmelo receives news

of the birth of his son, Juan, only to be shot in the neck minutes later. Yet his dying words, 'I'm not dead', suggest a belief in his own immortality; that the transfer of his genes to his newborn son will ensure that he continues in some form. By taking the blood from Carmelo's fatal wound and smearing it across his face, Manuel creates a blood tie between the two families, forewarning of the conflict that will befall them. Following his re-birth from a cart of broken and bloodied dead bodies, there is an exchange of glances between Manuel and a white cow before the camera cuts to an extreme close-up of the cow's eye. The camera zooms towards the cow, appears to enter its eye and travel through it, re-emerging, as intertitles inform us, in 1905, at Manuel's Guipuzcoan home. Thus, the narrative takes a cosmic shortcut through space and time; thirty years have passed and we are introduced to a new generation of characters, including Manuel's son, Ignacio, and Carmelo's son, Juan. However, although the world may have moved on a generation, the present appears to carry the genetic imprint of previous generations, corresponding to a pattern of interminable, cyclical movement. This cyclical progression is cinematically foregrounded by the casting of one actor, Medem regular Carmelo Gómez, in the role of three generations of Irigibels, Manuel, Ignacio and the adult Peru. It is reinforced in the casting of Kandido Uranga as both Carmelo and Juan, and Karra Elejade as the family associate, Illegori, and his son, Lucas. Death, therefore, is never what it seems, as the same actors reappear to portray their offspring, bringing to mind the epigraph at the opening of this chapter.

Isabel C. Santaolalla suggests that in the film 'one dimensional or essentialist notions of identity and subjectivity are ruthlessly exposed: in *Vacas* successive generations of male characters lose their individuality as the same actor performs all the various roles'. (1999: 312) Some of the characters' behavioural characteristics are certainly presented as transferred genetically; thus Ignacio, like his father, is a first-class *aizkolari*: during a contest between Juan and Ignacio, the judge declares to the triumphant Ignacio, 'Irigibel the Second. If you go like this, you'll make a lot of money. You're as good as your father. It's in the blood', thus suggesting a genetic transfer of skills across generations. Similarly, following his capture in the woods, Peru pleads with the Nationalist officer to spare his life, emulating his grandfather's shaking hands and 'cowardly' behaviour at the Carlist front sixty years previously. Yet there is something more complex at work than never-changing human nature; the three generations are

5.1 *Vacas/Cows* Manuel stares into the pupil of a cow before the camera appears to enter the cow's eye and re-emerge decades later.

not simply carbon copies of each other. Peru may have 'inherited' his grandfather's interest in the process of representation, but he is uninterested in his father's macho pastimes. Ignacio, unlike his father, has no interest in reproduction – other than the 'reproductive' pleasures that come with his furtive sexual encounters with Catalina. Manuel's life experience, moreover, leads him to reject the machismo of war, whereas Ignacio maintains, indeed revels in, his macho if peaceful *aizkolari* role. *Vacas* posits human behaviour as a combination of both genetic inheritance and social experience; however, by casting actors in multiple roles, the film appears to suggest that the balance weighs more heavily towards the former. *Vacas* is full of circular visual metaphors that further develop this perspective, evident in the concentration on cows' eyes, the circular movement of Manuel's mysterious scythe-man, the tree stump located in the woods, the logs that the *aizcolaris* cut and, not least, the iris of the camera, all combining to connote a cyclical movement through time.[2]

Cycles of history

Vacas posits a cyclical view of historical development, a view that itself has a long history.[3] For instance, Alex Callinicos asserts that, during classical antiquity, three assumptions were implicit in the practice of Greek historiography: first, that human nature is constant and, therefore, human beings presented with similar choices and placed in similar positions will respond in similar ways; secondly, and flowing from the first assumption, that the past can be seen as a space that can be studied in order to forewarn of possible dangers and to offer lessons

for future generations; thirdly, that the rise and fall of organised societies can only be comprehended as part of a cyclical process. Callinicos states that 'The cycle is thus one of decline and degeneration, powered by the infirmities of human nature: each good form of government becomes corrupted when a generation unfamiliar with the circumstances which led to its introduction takes the helm.' (1997: 58) Herodotus, the 'father of history', suggests a similar approach when he outlines his own historiographical methodology: 'I will proceed with my history, telling the story as I go along of small cities no less than of great. For most of those which were great once are small today; and those which used to be small were great in my own time . . . human prosperity never abides long in the same place.' (1996: 5) Rather than only viewing history as a story of cyclical regression, however, Callinicos suggests that the possibility of cyclical views of history congruent with notions of progress emerged with the onset of industrial capitalism. (1997: 63)

Cyclical views of history can, therefore, be utilised to describe the process of history as one of progress or as one of regression and decline. In *Vacas* a number of signifiers illustrate the appearance of capitalist modernity in the valley and suggest historical progress, for instance, the arrival of the car that Ignacio wins in a log-cutting contest, or the camera that records his victory celebrations. A number of these inventions, however, are blocked, or partially restrained, by the rural environment, most noticeably when Catalina and Ignacio attempt to escape to the United States and their car is confronted by another seemingly immovable cow, suggesting a conflict between the rural environment and technological developments. Of the importance of the environment to the historical process in the film Santaolalla observes that

> Although the inexorable progression of history is economically conjured up by the changes in guns, uniforms, and by the gradual introduction of horses, cameras, and cars, its course is less linear than one would expect . . . It is almost as if the valley, the forest, and their inhabitants were occupying the motionless centre of a rotating wheel: history here takes a rather curved and spiralling trajectory, trapped as it is in a centripetal force which moves around but never really abandons the centre. (1999: 317)

In *Vacas*, then, history is presented as a complex, contradictory, circuitous phenomenon, which, through a self-reflexive cinematic

approach foregrounding its status as a representation of the past, invites contemplation of the historical process and, moreover, of the constructed nature of cinematic representations of historical events and processes.

Representation of the past in art-cinema

Jordan and Morgan-Tamosunas point out that *Vacas* 'displays a clear awareness of its status as a textual production; it presents itself as a text which is both a clarification as well as another mystification of Basque history and identity'. (1998: 196) The emphasis on representation is repeatedly foregrounded throughout and there is a continued focus on eyes, on looking and on art and photography. Manuel becomes fascinated with looking and the eye becomes the gateway to a special type of knowledge; thus when he stares into the eyes of the cow, he seems able to predict her coming pregnancy. Manuel becomes increasingly preoccupied with his own representations – his surreal artistry and his kinetic sculptures. He is fascinated further by the camera's arrival, drawn to its ability to create a different perspective, a different representation; he urges his grandchildren to steal the camera and hide it in the woods. This interest in the means of representation is, in turn, 'inherited' by Peru who, by pursuing a career in photography, continues his grandfather's work of representing the world. The sustained concentration on looking and representation highlights the fact that there are no representations of events that are not mediated. For instance, even when Peru and Cristina remain in contact through their exchange of letters, their illiteracy ensures that their thoughts and words are mediated through the writing and reading of others. As the audience look at the cinema screen and its own cinematic 'reality', they are invited to contextualise how reality itself is mediated, whether through painting, the eye of the cow or the lens of the camera. *Vacas*, as with the films discussed in the last two chapters, albeit to varying degrees, invites reflection on its own constructedness in a manner which Rosenstone and White are likely to favour.

The potential power of representation is apparent in the battle sequence in the woods. Here, Peru has traded the weapons of previous generations for reproductive weaponry, using his camera to frame the enemy before capturing their cinematic images. After his capture by Nationalist soldiers, Peru initially thinks that the soldiers have taken his camera and says to Catherine, 'I'm nobody without my camera',

thereby emphasising the importance he attaches to the reproductive process. Anne M. White speculates that Peru's attention to the importance of his camera also reveals that, as she puts it, 'he sees his photographs, the results of mechanical rather than human reproduction, as a surer way of guaranteeing his immortality'. (1999: 9–10) Hence, when he realises that he still has it and says to Catherine 'What a relief', his relief derives from being reunited with the immortalising reproductive qualities that the camera brings.

Manuel also attempts to extend his own mortality by creating his own offspring; not his children, but the scythe-man and the boar-killer that he constructs. The futility of human life is captured by Manuel's axe-wielding sculpture as it stands in the forest continually striking at imaginary boars. It also emerges in the scythe-man, which sardonically comments on the futility of human existence. Sporting a Carlist red beret and a broken leg, the sculptural self-portrait moves circuitously as the wind blows, forced by the pressure of nature. Yet, despite the importance placed on the means of reproduction, these representations all evaporate. Manuel's mysterious figures either disintegrate or else are destroyed by Nationalist soldiers, thereby suggesting that war is a great devourer, not only of human beings, but also of art and culture. Even Medem's camera itself appears to be consumed in the closing sequence as it enters the mysterious tree stump located in the woods. In raising issues dealing with artistic and cinematic representation, *Vacas* becomes more than a self-reflexive film that comments on the events within its own narrative; by focusing on the artifice of representation, it invites spectators to view all cinema, all art and, indeed, all history as mediated representations.

In its concentration on the importance of looking, and in its own self-reflexive cinematic style, *Vacas* presents the historical process as one of change, contradiction and conflict. It allows new ways of looking at the world, provoking an intellectual engagement with the audience through the very form of its representation as much as through the content. This foregrounding of the cinematic process helps foster what Bill Nichols describes as a 'historical consciousness' in the viewer. According to Nichols,

> Historical consciousness requires the spectator's recognition of the double, or paradoxical, status of moving images that are present referring to past events. This formulation involves viewing the present moment of a film as we relate to past moments such that our own

present becomes past, or prologue, to a common future which, through this very process, we may bring into being. (1994: 118)

Nichols argues that it is impossible to predict the impact of particular formal characteristics; however, he suggests that 'some forms lend themselves to certain subjectivities and interpretations more than others', and he champions 'forms that intensify the need for retrospection, that require recall in order to grasp the pattern they propose, that heighten the tension between a representation and its historical referent, that invoke both past and present in the dialectic of constructing a future'. (1994: 119) As the narrative in *Vacas* unfolds, its self-reflexivity encourages consideration of both past and present political and historical processes in the Basque county, and beyond.

In his work on narrative in cinema, David Bordwell suggests that in mainstream cinema reality 'is assumed to be a tacit coherence among events, a consistency and clarity of individual identity. Realistic motivation corroborates the compositional motivation achieved through cause and effect.' (1985: 210) Theses points could be applied to both *For Whom the Bell Tolls* and to *Five Cartridges*. In relation to art-cinema, however, which draws on the experimental techniques of literary modernism, he argues that 'the very construction of the narration becomes the object of spectator hypotheses: how is the story being told? why tell the story this way?' (1985: 210) Moreover, Bordwell asserts that 'Odd ("arty") camera angles or camera movements independent of the action can register the presence of self-conscious narration.' (1985: 210) *Vacas* continually invites its audience to reflect on its own constructedness by inviting consideration of a number of questions: Why does one actor play more than one character? Why does the camera appear to take shortcuts through space and time? Why is the camera often placed in positions that break with mainstream cinematic convention? In relation to the latter question, Paul Julian Smith observes that Medem has become renowned for his 'playful use of cinematic point of view, of "subjective shots" from the perspective of animals or objects'. (2000: 146) This process is evident in the sequence when Catalina and Ignacio have sex in the woods. The camera is positioned at the level of the copulating couple whose rhythmical writhing is at one with the natural world as the camera pans across both their bodies and the grass beneath them. Here, the camera departs from conventional point-of-view shots to give the perspective of anonymous, perhaps non-human witnesses

to the events depicted. As Jordan and Morgan-Tamosunas observe, 'the spectator is positioned by imaginative camerawork to adopt the optical viewpoint of the cows, to follow a flying axe on its dizzy trajectory through the air, to be sucked into the head of a cow or the hollow trunk of a "magical" tree, creating a world in which the unexpected and the fantastical intrude on the realist'. (1998: 51) The film's narrative structure, casting and cinematography coalesce together and invite reflection on both the cinematic and the historical process.

In terms of its content, *Vacas* also provides an oblique criticism of the conflicts that have marred Basque history; for instance when Manuel surveys the after-effects of a log contest, he strides along the grass where woodchips litter the floor and comments despairingly, 'What is this for? What a waste.' The scattered woodchips are the consequence of the *aizkolaris'* pointless destruction of the logs and stand, metonymically, for the pointless destruction of human life that war engenders. This finds an echo in the scene where the cow, Txagorri, and Manuel's granddaughter are in the woods; they both look at Ignacio, the phallus-wielding woodcutter chopping his log, before appearing to exchange quizzical glances. Embedded within this scene is a critique of a patriarchal world of log cutting and fighting, in which male peacetime activities are as destructive and wasteful as wartime endeavours. Humans are always chopping logs and, although their impact is minimal as the forest endures, this reinforces a sense that the characters and human behaviour are out of synch with the natural world which they inhabit. Thus, Manuel, having witnessed the madness of the real world at the front, finds refuge in his own world, in what he describes as the 'other side'. Manuel's art has also gone over to the 'other side'; in a movement away from a naturalistic representation of the world around him, his paintings have no straightforward figurative relationship to their referent, displaying a modernist style which, although he lives isolated in a small village, corresponds with the explosion of Modernism in the wider art world at that time. Eagleton suggests

> Modernism reflected the crack-up of a whole civilization. All the beliefs which had served nineteenth-century middle-class society so splendidly – liberalism, democracy, individualism, scientific enquiry, historical progress, the sovereignty of reason – were now in crisis. There was a dramatic speed-up in technology, along with widespread political instability. It was becoming hard to believe that there was any innate order in the world. Instead, what order we discovered in the world was one we

had put there ourselves. Realism in art, which had taken such an order for granted, began to buckle and implode. A cultural form which had been riding high since the Renaissance now seemed to be approaching exhaustion. (2003: 64)

Modernist art movements, such as Symbolism, Futurism, Cubism, Expressionism and Surrealism, rejected realist forms of representation, which many critics identified as inadequate to represent the complexities of capitalist modernity. This rejection of realist representational forms emerges in Manuel's painting of a boy and girl who are wearing Carlist berets and sit astride a two-headed cow. It is more explicit in his painting *War*, his portrayal of his own traumatic past. The subject of the painting is a boy and two cows, one which is lying with its neck slashed, like Carmelo in the opening act. This link between cows and animals in Manuel's art is also paralleled through the film's editing techniques, for instance when a shot of a painting of a cow's head dissolves into a shot of Peru sitting with his arms in the position of a cow's ears. The link suggests an oblique crossing over of the world of humans with the world of cows. This shift between worlds is also apparent in Medem's directorial style, of which he states:

I usually like to create situations which can incorporate various worlds at the same time. I often like to use a very real, very immediate and recognizable photography, adjusting myself to the rules of reality as it is known and shared by all of us. But I am also interested in contrasting this reality with another one, with another space which looks like this reality but which has not yet been made and which is somehow connected to it; and sometimes I want to narrate the trajectory from one world to another. (quoted in Santaolalla, 1999: 313)

This movement between two worlds is evident in the contrast between the expansion of the pupil of a cow and the opening of the lens of a camera when the camera appears to enter a cow's eye, then initially blacks out before expanding from a pin-hole of colour to fill the entire screen at the start of Act I. It is also evident at the start of Act III, 'The Burning Hole', which opens with a shot of the mysterious tree stump, then cuts to the birth of a cow. Here, Ignacio has his arm inside a cow's womb pulling out a calf, thus linking Peru's birth ten years previously with the birth of the cow and with the burning hole, a symbol of the Basque landscape itself, which again raises questions concerning the cyclical movement of time.

Cyclical progress or stasis?

Vacas, then, revels in its self-reflexivity, with Medem freely experimenting with perception and reality through his surreal rendering of the film's complex narrative. Arguably the worldview presented in this narrative has a tendency towards fatalistic, biologically determinist politics, for although characters are influenced by their own particular historical experiences, the film seems to suggests that everything changes but everything stays the same. There are conflicting historiographical models that posit history as cyclical progress or history as the eternal return of the same. But what kind of cyclical process is to be found in *Vacas*? The answer to this question hinges on the interpretation of the film's concluding sequence. Of the film's ending Stone suggests that 'It is a ludicrous, fairy-tale ending to a film that so consistently undermines stereotypes and genre conventions.' (2002: 166) Stone's reading suggests that Cristina and Peru survive the civil war and prepare to flee to France, a reading that permits the possibility of cyclical progress through escaping from both the Basque country and from war. Santaolalla also appears to take a positive approach to the ending when she states that 'the fact that the film actually ends with the *agujero encendido* and the cow seem to imply that, even though violence, death, and expatriation are on the agenda now, the potential for inclusion and regeneration still permeates the land'. (1999: 324)

An alternative reading, however, suggests a more pessimistic prognosis, one of cyclical repetition or even regression, with the *agujero encendido*, or burning hole, representative of the idea that all human activity is consumed, indeed destroyed, by the Basque landscape. This reading centres on the sequence that takes place at the outbreak of the civil war when, following a Nationalist attack, Peru is captured and brought before a firing squad. He appeals to his uncle Juan, who is clothed in the Carlist red beret and uniform of his father, to intervene. In *The Eighteenth Brumaire of Louis Bonaparte*, Marx (1980: 96) mockingly refers to the leaders of the 1848–51 revolutions who, in his view, had metaphorically clothed themselves in the garments of their predecessors sixty years earlier. Here, Juan is not only dressed in his father's clothes, but by multiple casting is also wrapped in his father's skin. An alternative reading to that offered by Stone would suggest that Peru is in fact executed in this sequence. Although Juan attempts to intervene, appealing to the firing squad's command-

5.2 *Vacas/Cows* Juan, dressed in a Carlist uniform, attempts to intervene to prevent Peru's death at the hands of a Nationalist firing squad.

ing officer to spare Peru on the basis that he is the grandson of two heroic Carlist fighters, the firing squad shoot at the line-up of captured Republican fighters and Peru, along with the other villagers, falls backwards into the green field as if he has been killed. In the following shot, however, he re-emerges from the trench of dead bodies (as his grandfather, Manuel, emerged from a cart of corpses two generations previously) and walks past the Nationalist soldiers, although neither they nor the officer acknowledge his existence. Moreover, none of the soldiers, or indeed Juan, establishes eye contact with him as he walks, like a ghostly presence, away from the firing squad. That Peru has in fact been executed is reinforced by the inclusion in the scene of the sound of disembodied breathing, hinting at some kind of otherworldly presence.

In the sequence that follows, then, it is a legitimate reading to suggest that it is not Peru but the ghost of Peru that meets up, not with Cristina, but with the ghost of Cristina in the woods. When Christina, who we learn has rested after a long sleep, sees Peru she says, 'I fell asleep. I feel much better now.' Noticeably, in an echo of Arrabal and the Surrealists' association of insects and death, the buzzing of flies is heard over her breathing. In the previous battle in the woods she had looked barely alive but she now asserts that she is 'fine, just hungry'. Cristina and Peru both state that they have seen their dead grandfather, Manuel, and they appear to depart, on horseback, for France. But their destination lies, not across the border, but much closer to their birthplace. As the couple ride off, the camera tracks back through the woods to the mysterious, magical tree stump. As Cristina utters the film's closing words, 'We're nearly there', the

camera cranes downwards into the dark, circular trunk of the tree stump. As it returns to the earth it is almost as if the Basque landscape has consumed the young couple, connotative of a historical pattern of cyclical destruction and decline. The opportunity of escape lies not in France; rather, their only escape is through death.[4]

This inability to flee is further evidenced by the fact that, apart from the opening battlefront sequence, the narrative itself never leaves the valley. As the characters strive to escape, the camera remains in the Basque countryside. Moreover, in this reading, both family life-lines are terminated; the possibility of Juan being able to continue his blood-line in old age (he is 59 by the end of the film) is increasingly unlikely, and Peru's bloodline can only continue with the children that he has fathered through his marriage in the US, not within the Basque country itself. All three generations of Irigibels have fled: Manuel flees the war, finding freedom in 'madness'; Ignacio success-fully escapes further conflict with Juan by emigrating; yet his son, Peru, a continuation of his genetic pattern, returns to his homeland and attempts to avoid the war by opting to document the passing of history, but finds that in a civil war neutrality is impossible. Notably, all three attempts at escape are interrupted by confrontations with cows, which operate as cinematic metaphors for the rural landscape or for the restrictions of the Basque country itself: Manuel as he flees the war; Ignacio during a car ride with Catalina; and, finally, Peru and Cristina (or their ghosts) as they attempt their escape at the film's conclusion. *Vacas*, therefore, presents a somewhat bleak perspective on human existence, representing the civil war as part of an ongoing process of conflict and violence; one embedded within the vagaries of human nature itself and within Basque history and politics.

'Basqueness'

Medem's relationship with both the Basque country and Basque cinema was highlighted at the 2003 San Sebastián/Donostia Film Festival with the screening of his film *La pelota Vasca: La piel contra la piedra/The Basque Ball: The Skin Against the Stone* (Medem, Spain, 2003). Heavily criticised by Spain's then culture minister, Pilar del Castillo, and subjected to an attempted ban by the governing Popular Party, the documentary concerns the Basque country's ongoing national conflict. To the dismay of many Spanish politicians of the

time, the film advocates the necessity of negotiations between the Spanish government and ETA, the military wing of the Basque separatist movement. In press notes accompanying the film's release, Medem comments that 'After a long period in which I confess that I distanced myself, especially politically, from all things Basque, the rise in the ultra Spanish nationalism of Aznar [the then right-wing prime minister of Spain], which had gradually become unbearable in its totalitarian confrontation with Basque nationalism, meant that, after *Sex and Lucia*, I decided to try again to write something minimally fair about the Basque conflict.'[5] It is worthwhile, therefore, to place Medem's work within a Basque, not simply a Spanish, context. This is not a straightforward process, however, as Medem makes clear his oppositional stance towards Basque nationalism. Speaking of his decision to live in Madrid he states that

> It hurts me to have left the Basque country, but I think I have gained something. Leftwing nationalism is fascistic. They tell you how you have to be to be a true Basque, how you should feel. The nationalist press exaggerates and promotes difference, but everybody should have the right to behave as they feel. (quoted in Glaister, 2000)

Paul Julian Smith notes, moreover, that 'Medem has refused to take up the public position of "Basque filmmaker", bravely resisting those who appeal to violence in support of a dualistic and antagonistic nationalism.' (2000: 149) Smith also asserts that 'Medem denies the existence of a distinctively Basque cinema, whether it is based on artistic or commercial criteria: he claims to have nothing in common with other Basque directors of his "generation".' (2000: 160). Despite, or perhaps because of, Medem's ambiguous relationship with the Basque country, *Vacas* is a striking cinematic debut, which challenges preconceived ideas about Basque politics and history, but also about wider historical processes in a highly innovative and engaging manner. Utilising a film form that invites a contemplative, critical response, it suggests that, to one degree or another, war has been a constant in the Basque country in recent centuries, and that, rather than looking at outside factors that may have influenced the civil war, it is necessary to look both at human nature and at the specificities of the Basque country in order to understand the conflict. *Vacas*, however, is more than an account of Basque history or a sombre reflection on the human condition; it is also an intriguing, provocative film about the writing or filming of the historical process itself.

Notes

1 A brief summary of Basque history is provided in Kurlansky (1999). In particular, see chapters seven and eight for an account of the development of Carlism in the nineteenth century.

2 The use of circles is also evident in *Los Amantes del Círculo Polar/The Lovers of the Arctic Circle* (Medem, Spain/France, 1999) where even the characters, Ana and Otto, are given palindromic or 'circular' names. The film, which also deals with movement through time, returns to the subject of the Spanish Civil War through the character of a pilot who had fought during the war.

3 Another example is that of the Aztecs who developed three types of calendar: the ritual calendar, the annual calendar and the 52-year calendar. They also developed a 260-day cycle to record ritual events and attempt to forecast future developments. Thus their worldview tied together astronomical forecasting with fatalistic views of human development. For further information see Michael E. Smith (1996).

4 In her reading of *Vacas*, Jo Evans also suggests that Peru dies, although she notes that earlier drafts of the script include scenes with Peru as an old man. (2007: 20)

5 Anonymous, '*La pelota Vasca: La piel contra la piedra/The Basque Ball: The Skin Against the Stone* British Production Notes' (2004: 5). *Lucía y el sexo/Sex and Lucia* was released in 2001.

6

No laughing matter? Comedy and the Spanish Civil War in cinema

War, it might be said, is no laughing matter; certainly it seems a far from appropriate response to the bloody conflict that engulfed Spain in the 1930s. This chapter analyses four Spanish films employing comic elements which are set during, or in the years preceding, this traumatic period: *La vaquilla* (Luis García Berlanga, Spain, 1985), *¡Ay, Carmela!* (Saura, Spain, 1990), *Belle Époque* (Fernando Trueba, Spain, 1992) and *Libertarias/Libertarians* (Aranda, Spain, 1996).[1] My interest here lies in returning to issues that were first raised in the introduction over whether the past contains discernible patterns and whether representations of the past, written or cinematic, are determined by the intrinsic nature of the events that they purport to represent or, conversely, whether these representations are determined by the emplotment and narrativisation choices of those operating in the present. In relation to this debate, Hayden White (1987: 44) argues that 'Since no given set or sequence of real events is intrinsically tragic, comic, farcical and so on, but can be constructed as such only by the imposition of the structure of a given story type on the events, it is the choice of the story type and its imposition upon the events that endow them with meaning.' In highlighting the constructed nature of historical representations, White challenges the widely held philosophical notion that the past contains inherent patterns: of Hegel's assertion that history repeats itself, Marx (1980: 96) famously writes, 'Hegel remarks somewhere that all facts and personages of great importance in world history occur, as it were, twice. He forgot to add: the first time as tragedy, the second as farce.' Marx (1992: 247–8) developed his analysis from his earlier writings on Germany in the 1840s in which he argues that, in contrast to the *tragic* demise of its French counterpart, the German *ancien régime* was, as he puts

it, 'merely the clown of a world order whose *real heroes* are dead'. Marx proceeds to make connections between the past and its literary representations:

> History is thorough and passes through many stages while bearing an ancient form to its grave. The last phase of a world-historical form is its comedy. The Greek gods, who already died once of their wounds in Aeschylus's tragedy *Prometheus Bound*, were forced to die a second death – this time a comic one – in Lucian's Dialogues. Why does history take this course? So that mankind may part happily with its past.

Marx, then, contra White, appears to suggest that the past does indeed have discernible patterns; moreover, he argues that patterns emerge in artistic representations of the past which are ultimately represented in comic form. Terry Eagleton (1981: 161) draws on more contemporary events to problematise the assertion that the past, or its artistic representations, are as malleable as either White or Marx suggest:

> it is not of course true that all tragic concerns are changeable, just as carnival is wrong to believe that anything can be converted into humour. There is nothing comic about gang rape, or Auschwitz. There are always blasphemies, words that must on no account be uttered because they defile the tongue. Those who believe that the sacred and the profane belong to a benighted past need only to consider whether they would be prepared to pronounce certain words about Auschwitz even as a joke.

For Eagleton, there are clear moral or political imperatives that impose limits on representations of the past, or certainly of traumatic events in the past.

What, then, might be the relationship between comedy and the cinematic depictions of the Spanish Civil War? It might be worthwhile here to draw a distinction between the comic and comedy: in their work on comedy and film, Steve Neale and Frank Krutnik (1990: 1) argue that, whereas the former is what makes us laugh, the latter is specific to certain narrative forms. Laughter alone, they argue, is insufficient to make something a comedy; indeed, they note that some comedies can make audiences cry as much as they can make them laugh. Neale and Krutnik cite the *Concise Oxford Dictionary* definition: '*Comedy* n. Stage-play of light, amusing and often satirical character, chiefly representing everyday life, and with a happy ending.' (1990: 11) They suggest, therefore, that a comedy is characterised not simply by its 'light' or 'amusing' elements, but also by its concern with the

representation of everyday life and its conclusion, which is usually a happy one. (1990: 1) A further feature of the comic form is its political, even subversive, potential: Walter Benjamin (2003: 101) points to its cerebral qualities when he asserts that 'there is no better starting point for thought than laughter; speaking more precisely, spasms of the diaphragm generally offer better chances of thought than spasms of the soul'. Similarly, commenting on Brecht's Epic Theatre, Eagleton (1981: 157) highlights the potentially political side of the comic when he states that 'Comic estrangement allows the audience to "think above the action" . . . thought is freer than pity or fear: it is a matter of thinking around, across and above the dramatic action.' The subversive nature of humour during Franco's reign is evident in a strand of satirical cartoons, exemplified by Juan M. Molina's *Noche sobre España*, which was published underground by the anarchist trade union, Confederación Nacional del Trabajo, or in the work of the cartoonist José María Pérez González (Peridis). In the world of cinema, which was subject to strict censorship, humour was also utilised to critique life under the dictatorship with *¡Bienvenido, Mister Marshall!/ Welcome Mr Marshall!* (Luis García Berlanga, 1952) and *Calle Mayor* (Juan Antonio Bardem, Spain, 1956) notable examples.[2] As outlined in chapter four, oppositional filmmakers struggled to depict the civil war cinematically, and, when it did surface, the conflict was generally referred to obliquely. It was only following Franco's death in 1975 and the scrapping of censorship in cinema two years later that filmmakers were able to turn their attention to the conflict freely. It is far from accidental, therefore, that all four films discussed here emerged decades after the civil war's official conclusion. The films all reflect a broadly anti-Franco perspective, contain comic elements and deal with everyday life, albeit in a civil war setting. This chapter analyses the means by which they allow audiences to laugh about aspects of the civil war and explores whether they should be classified as comedies, in the sense outlined by Neale and Krutnik, and whether the civil war itself can be narrativised as a comedy in cinema.

Belle Époque

Belle Époque is a conventional comedy in that it opens with a misfortune – the comic death of two members of the Guardia Civil – and concludes with a happy ending as a young, newly married couple prepare to depart Spain. Set in 1931, the cinematic world created in

Belle Époque is a million miles removed from the harsh experience of rural life in early 1930s Spain.[3] The central characters inhabit a world free from worry over financial concerns; a world where an abundance of good food is washed down with good wine, and where personal freedom is closely identified with sexual liberation. It is a space where the central characters are breaking free from the repressive strictures of the Catholic Church and joyfully transgressing historically established patriarchal restrictions. Although the strikes and demonstrations sweeping through Spain in this period are referred to, they are located in the urban centres, far removed from this pre-modern idyll on the outskirts of Madrid. It is an idealised sleepy hollow; a world where, as the patriarchal figurehead, Don Manolo (Fernando Fernán Gómez), says, 'We get the papers three days late', but where no one seems the worse for it. This air of libertarian freedom is embodied in Manolo's family, which represents the antithesis of the strict bourgeois model favoured by the Church. Manolo's family may be a fractured one – his wife travels the globe with her boyfriend, returning occasionally for sexual trysts with her husband while her 'cuckolded' lover waits, impatiently, outside the bedroom – but it remains happy, kept together by mutual consent, not legal stipulation.

Belle Époque, then, presents a utopian world where the characters revel in elements of the carnivalesque. In his work on the popular folk culture of the Middle Ages, Bakhtin argues that carnival and other marketplace festivals represented a space where it was possible for the lower classes to live, albeit temporarily, relatively free from the strictures of the day. Carnival represented a space where traditional hierarchies and restrictions could be overturned, where all that was fixed and established was open to change and transformation. As Bakhtin (1984: 10) suggests, 'carnival celebrated temporary liberation from the prevailing truth and from the established order; it marked the suspension of all hierarchical rank, privileges, norms, and prohibitions. Carnival was the true feast of time, the feast of becoming, change, and renewal. It was hostile to all that was immortalized and completed.' During the period of carnival, Bakhtin continues, 'People were, so to speak, reborn for new, purely human relations. These truly human relations were not only a fruit of imagination or abstract thought; they were experienced. The utopian ideal and the realistic merged in this carnival experience, unique of its kind.' (1984: 10) This is evident in the world of sexual relations in *Belle Époque*; there exists a utopian world of gender reversal in which, with the exception

6.1 *Belle Époque* Fernando and Violeta begin their cross-dressed sexual encounter.

of the youngest, Luz (Penélope Cruz), none of Manolo's daughters fulfil traditional female roles. The four sisters are neither dull nor domesticated, but confident, independent young women whose culinary shortcomings are contrasted sharply with the cooking skills of Fernando (Jorge Sanz), the young army deserter who arrives in the village. This reversal of conventional gender roles is apparent when, following Fernando's sexual frolics with all four daughters, it is he who fulfils the traditional female role of actively pursuing marriage, while the sisters, with the exception of Luz, pursue only the transient joys of carnal pleasure. The potential fluidity of gender identities is illustrated in the sequence that occurs, appropriately enough, on the night of the village carnival. Bedecked in Fernando's army uniform and sporting a thin, black, pencilled moustache, Manolo's lesbian daughter, Violeta (Ariadna Gil), leads the young soldier, who is dressed in a maid's uniform, to a quiet barn, throws him to the straw-covered floor, straddles him as he lies on his back, and has sex with the bemused but delighted young man. As the couple's copulation reaches its orgasmic heights, Fernando shows Violeta how to blow his army regulation horn, thus restoring patriarchal climactic control; however, rather than simply reversing the natural order of things, in highlighting the fluidity of Violeta's sexuality the scene breaks down binaries between homo- and heterosexuality. Indeed, Jacky Collins and Chris Perriam (2000: 218) argue that, while the film is conformist in many ways, this particular scene 'contains some of the most advanced representations of lesbianism in Spanish cinema'. It is noteworthy that Violeta's lesbianism is socially acceptable both within the family structure and within the world of the film, thereby creating a link between the fictionalised on-screen utopia and the more liberated sexual politics of post-Franco Spain. Marsha Kinder (1997: 5)

highlights this connection when she states that through the film 'the so-called new liberated mentality of Socialist Spain is shown to have historic roots in the pre-Civil War era'. *Belle Époque* certainly creates a comic and romantic account of the pre-civil war period, one that elides the harsh experience of the 1930s; nevertheless, its attention to social and sexual dynamics invites a socio-historical comparison with its moment of production. Paul Julian Smith (1994: 38) suggests that the film's attitude to the past is one of 'aesthetic amnesia' and, more-over, that 'its sunny good humour conjures away the real conflicts of Spanish history'. *Belle Époque* may only contain passing references to the political events of its time; however, it is far from incidental that the action takes place on the cusp of the abdication of the monarchy and the establishment of the Second Republic in April 1931. In the film's conclusion, Fernando and Luz depart from Spain (and the looming turbulence of the pre-civil war period) leaving Manolo to drive his horse and trap back to his tranquil, pastoral home, thereby satisfying one of the key traditional conventions of comedy, that of a happy ending. It is, noteworthy, however that the action takes place in 1931, at a moment of historical potential, and studiously avoids the traumatic years of the civil war itself.

¡Ay, Carmela!

While *Belle Époque* creates a romanticised, rural idyll in the years preceding the conflict, *¡Ay Carmela!*, partially shot in the remnants of the battered town of Belchite,[4] focuses on life at the Aragón Front in 1938. As I outlined in chapter four, Carlos Saura had previously directed a number of films touching on the civil war from a perspec-tive sympathetic to the Republican side and highly critical of the dictatorship. His previous films, however, are considerably more serious in tone. As Saura points out: 'The Spanish Civil War appears in many of my earlier films, but in a different way. But it has never been spoken of in the same way as I do in *¡Ay, Carmela!* It was only after Franco was dead that you could make *¡Ay, Carmela!*'[5] The war setting is foregrounded in the opening sequence as the camera pans over a war-ravaged town where depressed, dejected soldiers squat at street corners. A Republican armoured car sits immobilised. The walls are covered in torn and tattered left-wing posters. Intertitles locate the film on the Aragón Front in 1938; not a pleasant place for Republican soldiers caught in a war that seems increasingly unwin-

nable. Yet the non-diegetic singing of '¡Ay Carmela!', a popular song among Republican soldiers, introduces a lighter side; a contrast in tone that is developed continually until the film's tragic conclusion. The film follows Carmela (Carmen Maura), Paulino (Andrés Pajares) and Gustavete (Gabino Diego), members of the Tip-Top Variety show, a travelling theatre troupe that performs cabaret acts for Republican soldiers, who, while attempting to flee life at the front, are captured by Nationalist troops. ¡Ay Carmela! is no neutral, apolitical comedy, however, and it illustrates the foreign influences on Spain that helped shape the civil war's outcome. Thus the war is not represented as a solely Spanish affair, but as an arena of international conflict which preceded the larger conflagration of the Second World War. This is hinted at initially in the opening theatre scene when the Republican soldiers sit in fear of the planes overhead and Paulino says, 'It sounds like one of those German turkeys', and it is developed later in the film.

A key use of humour in the film emerges in its blurring of the lines between 'good' Republicans and 'evil' fascists. Carmela, Paulino and Gustavete are captured by Franco's troops as they flee the front. Their far from heroic departure, however, involves Carmela offering sexual favours to distract a sleazy Republican driver while Paulino and Gustavete siphon much-needed petrol for their intended escape to Valencia. Thus, the central characters desert the sinking ship while the Republican soldier who asks of Carmela, 'Let me warm my hands on your titties', is represented as little more than a frustrated sex pest. 'Evil' may remain, as illustrated when a group of prisoners are taken out and executed against a wall; however, not all the fascists fall into this category. This is most clearly exemplified by the Italian officer, Lieutenant Amelio di Ripamonte (Maurizio De Razzo), and his comically camp troop of soldiers who are disparagingly described as a 'bunch of fairies' by a Spanish officer. In the past these representations may have attracted political condemnation; however, by enclosing them in a comic wrapper, Saura has the scope to break black-and-white categorisations, free from the risk of harsh political criticism.

Pérez González (2000: 18) points out that Spain has a long literary tradition of protagonists who 'repeatedly find themselves in an impecunious situation, or simply end up penniless and hungry, and devote all their waking hours and best efforts in trying to avoid its awful consequences'. It is a description that fits perfectly with Paulino who is characterised by aspects of 'grotesque realism' referred to by Bakhtin. For Bakhtin, grotesque realism was opposed to all that was regarded

as high or abstract culture. It was culture transferred to a base mate-
rial level, one often associated with the body, particularly the lower
part, including the genital organs, the stomach and the buttocks.
Whereas the body, and bodily functions, are systematically written
out of official culture, in folk culture the body is not to be hidden from,
but highlighted and celebrated. Bakhtin suggests that the bodily
element is a deeply positive component of life, something universal,
affecting all people. Paulino's constant hunger, which leads to his
inadvertent consumption of a cat, corresponds with his insatiable
desire to take Carmela, his lover, on frequent trips to 'Uruguay', his
euphemism for sexual intercourse. Paulino's desire for sex and gastro-
nomic gratification is only matched by his ability to fart at will, and in
key, a skill employed in one of his comic routines, 'The Farts', which
further connects his character with Bahktin's 'base' organs. Bakhtin
(1984: 20) argues

> To degrade is to bury, to sow, and to kill simultaneously, in order to
> bring forth something more and better. To degrade also means to
> concern oneself with the lower stratum of the body, the life of the belly
> and the reproductive organs; it therefore relates to acts of defecation
> and copulation, conception, pregnancy, and birth. Degradation digs
> a bodily grave for a new birth; it has not only a destructive, negative
> aspect, but also a regenerating one. To degrade an object does not imply
> merely hurling it into the void of nonexistence, into absolute destruc-
> tion, but to hurl it down to the reproductive lower stratum, the zone
> in which conception and a new birth take place. Grotesque realism
> knows no other level; it is the fruitful earth and the womb. It is always
> conceiving.

The level of international involvement in the war is manifestly
clear in the closing theatre sequence where the audience comprises
an international collection of German, Italian, Moroccan and Spanish
soldiers. The military support Franco received from Germany and
Italy is clear from the physical presence of their troops and highlighted
further when Paulino exhorts, 'three peoples, three cultures and one
single victory'. On the other side of the divide sit the captured Polish
International Brigaders, representative of the 40,000 international
volunteers who travelled to Spain to fight fascism. In represent-
ing the Brigaders as Polish, however, the film also suggests a link
with Germany's invasion of Poland in 1939, the event that marked
the start of the Second World War. The Soviet Union's support for

the Republican government is also suggested through Gustavete's hammer-and-sickle-adorned red sweater which he wears in the theatrical sketch 'The Republic Goes to the Doctor'. Thus, rather than representing the war as a primarily Spanish affair, the film locates it within a wider international perspective. The sketch they perform involves Carmela removing her militia costume to reveal a Republican flag partially covering her body, the sight of the flag provoking a hostile response from the fascist troops.[6] This sequence also raises questions about the role of artists living under dictatorship and presents two possible alternatives. The first is the practical pragmatism of Paulino, who may have Republican sympathies but moves relatively effortlessly between both sides, and who earlier states, 'We're artists, we do as we're told.' On the other hand, Carmela may be prepared to compromise but she has her limits. When she removes her militia costume it provokes a cacophony of jeers and abuse from the fascist troops. As the Polish prisoners burst into a rendition of '¡Ay Carmela!', she joins their defiant chorus and bares her breasts to the prisoners, their last sexual 'treat' before death. Her actions are not motivated by an obscure idealism; she is simply not prepared to see others humiliated and stand idly by. In contrast, Paulino attempts to deflect the situation by resorting to 'The Farts', a comic routine that utilises his flatulence to great effect. However, when a Nationalist officer fires a solitary pistol-shot from the theatre auditorium the camera cuts to a slow-motion shot of Carmela falling to the stage floor as the bullet strikes her forehead. The comic is instantly transformed into tragedy, with Carmela's death standing as representative of the many who died fighting fascism in Spain.

When Carmela falls the comic tone, which has grown increasingly dark in the preceding scenes, becomes tragic. It is perhaps a weakness of the film that as the narrative moves towards its dramatic conclusion, Carmela's period is about to start, thus placing her heroism in the context of some kind of biologically induced emotionalism rather than being the noble act of a traditional heroine. Despite this she is presented as a positive figure who cannot be bought and sold. She is not prepared to compromise her art and dies; Paulino toes the line and lives. ¡Ay Carmela! raises questions, however, about the quality of the life that he will lead. Indeed this is made more clear in the 1986 play by José Sanchís Sinisterra on which the film is based. Here the story is told in flashback, with Paulino sweeping the floors of an old theatre, his status reduced from that of proud performer to humble janitor.

6.2 *¡Ay, Carmela!* The members of the Tip-Top Variety Show act out the
sketch 'The Republic Goes to the Doctor'.

Saura credits the original playwright with developing this contrast
between the tragic and the comic when he comments:

> Something very intelligent is done by José Sanchís Sinisterra. If it had
> come just from myself I would never have been able to do that sort of
> tragic-comic style. But after watching the play and reading it, I realised
> the amazing possibilities that working along those lines had. Because
> there is this double game, you find the humour that you can find every-
> where in life, even in the most tragic situations. And sometimes that's
> exciting. It's what reinforces the most tragic moment because of the
> contrast.[7]

Carmela's death is also linked to rebirth through the character
of Gustavete, a childlike figure who is parented by this unorthodox
couple. As Saura states of the impact of Carmela's death on Gustavete,
'When Gustavete speaks he recovers his speech, he lost it with a tragic
event and he recovers it with another tragic event and obviously it is
the memory of Carmela that remains.'[8] Thus, just as Bakhtin suggests
a dialectical link between death and birth, the voice of Carmela, of
defiance, of opposition to authority and to the regime, will continue
in the character of Gustavete. In the closing scene, the tragic conclu-
sion is encapsulated in a shot of Paulino and Gustavete laying flowers
at Carmela's graveside; the possibility of flowering, of building a new
world, lies hopelessly crushed. However, as they drive off into a barren
Spanish wasteland, with Gustavete reborn, the memory of Carmela's
struggle against injustice finds life in his newly found voice. And the
closing upbeat non-diegetic singing of '¡Ay Carmela!' strives to break
the potential despondency, suggesting that inspiration can be found

from the example of those prepared to make a stand against oppression, regardless of the personal consequences.

Libertarias

Set in Barcelona at the outbreak of the civil war, as the military revolt is met by a revolutionary response from workers throughout Catalonia, *Libertarias* follows a group of women who are involved with Spain's anarchist women's movement, *Mujeres Libres* (Free Women).[9] In doing so, it highlights the revolutionary dimensions of the conflict, which are laid bare in the introductory intertitles:

*Summer 1936

*18 July. The Spanish army rises against the Republican government.

*19 July. In Barcelona and Madrid the army is defeated thanks to the people's heroic efforts.

*20 July. The masses demand a revolutionary state. The legal government is unable to control the situation.

*21 July. The Spanish Civil War begins. The last idealistic war. The last dream of a people striving for the impossible. For Utopia.

The opening slow-motion montage sequence of men and women marching defiantly, their raised clenched fists highlighting their allegiance to the workers' movement, firmly locates the narrative in the turbulent public sphere of revolutionary Spain. A black-and-white shot of a church cross falling signifies the Republican movement's anti-clerical aspects. As the image is colourised, a black-and-red anarchist flag is flown proudly as groups of workers boldly proclaim, 'Down with capitalism! Death to priests! Long live Durruti! Long live the workers!' The revolutionary nature of the conflict and the class struggles at the heart of it are further alluded to in *Libertarias* when one of the militiamen shouts across the trenches to Nationalist soldiers on the other side of the barricades: 'You are trying to defend the interests of your millionaire generals.'

Libertarias explores the internal politics of the Republican movement by focusing on an assorted group of women, notably anarchist activists, prostitutes and a nun, fighting with *Mujeres Libres*. Through its focus on female protagonists, the film attempts to analyse the position of women in the war, but it also strives to recover, and indeed celebrate, the neglected history of Spain's anarchist movement. Commendable aims perhaps, but despite its intentions, the film's focus on women fails to move beyond the level of caricature.

The central characters are all textbook, male-fantasy figures, thrown together incongruously. Comedy is often born from figures being in the wrong place at the wrong time or, as Neale and Krutnik (1990: 3) put it, 'comedy necessarily trades upon the surprising, the improper, the unlikely, and the transgressive in order to make us laugh; it plays on deviations from socio-cultural norms, and from the rules that govern other genres and aesthetic regimes'. *Libertarias* derives much of its comic content from the notion of the civil war being fought by an unlikely assortment of female protagonists.

Over and above exploring issues of war and revolution, *Libertarias'* particular focus is on the role of women in the war and the film progresses from the somewhat cynical attitudes expressed by the initial response of the freshly liberated prostitutes to a genuine comradeship that develops among the female protagonists. However, as the women prepare to fight at the front, they are forced to endure sexist ridicule from some of the militiamen, one of whom shouts, 'Comrades don't your tits get in the way when you shoot?' The initial sexism they face lays the ground for a more generalised assault on the position of women fighting at the front. The anarchists leaders' willingness to forego their principles is initially suggested when the anarchist leader Durruti asserts, 'If it's necessary we'll impose an iron discipline. I'm willing to renounce everything except victory.' He later decrees that women are to be banned from fighting: 'Of ten militiawomen examined five have gonorrhoea and three are pregnant. We have more casualties from the clap than from enemy bullets . . . I want no women at the front.' Thus the liberation movement is seen to be incapable of accommodating half of those sympathetic to the aims of the revolution. The rolling back of the progressive nature of the revolution becomes even more clear when one of the prostitutes reads out a letter from one of her co-workers from Barcelona: 'We were amazed to see that the pussy game was more popular than ever. The union guys gave us a house and we've set ourselves up. There is a constant line of militiamen.' Thus the initial gains of the revolution prove to be short-lived as the sexual division of labour and 'natural' order begins to be reimposed in the rear as it is at the front.

Libertarias' central character, the aptly named nun María (Ariadna Gil), highlights the potentially liberating qualities of the anarchist movement. The narrative charts her spiritual journey from Christianity and convents, through brothels, trenches and her appropriation of a quasi-anarcho spirituality, until she reaches her ultimate destination

6.3 *Libertarias/Libertarians* A female militia member appeals to the prostitutes to join the revolution.

in a fascist detention centre. Her spiritual transformation begins when she encounters the medium, Floren (Victoria Abril), who, when asked 'Are you an anarchist too?', replies that she is both anarchist and spiritualist and links the two apparently contradictory philosophical outlooks by asserting that 'Jesus was the first anarchist.' The sexual politics at play are also developed when Floren asserts that 'Jesus isn't a man she's a woman.' María's transition from Catholic nun to nun of the revolution begins and she moves rapidly from the word of God to the word of the anarchist theoretician Kropotkin, citing his writings as she persuades peasants to feed the militia and appeals to the Nationalist troops to come over to the Republican side. The film, moreover, is awash with incongruous moments, such as when María is forced to flee her convent, accidentally finds herself in a brothel and is forced to hide from the anarchist militia by climbing into bed with a sparsely clad, obese priest who, undertaking a short sabbatical from his clerical duties, is visiting the brothel to sample the pleasures of the flesh.

The political issues at stake are summed up in the speech given to the 'liberated' prostitutes by the chronically caricatured anarchist Concha (Laura Mañá), who croaks to the cynical hookers, 'Our country is now in revolt. The symbols of repression are burning. The workers have occupied the factories and barracks . . . freedom has broken out. A word is heard repeatedly in homes, factories and work-shops: revolution.' While Concha's political polemic falls on deaf ears,

Pilar (Ana Belén), her fellow militiawoman, skilfully wins them over to the side of the revolution with a more basic appeal to their immediate self-interest when she states, 'What do you want? To be whores all your life? To have cocks stuck up you 10 or 15 times a day? And all for a bowl of stew.'

Although *Libertarias* deals with serious subject matter, it is introduced in a whimsical, light-hearted fashion, exemplified in the scene where the women are required to undertake a mass urine sample to test for any possible sexually transmitted diseases they may have contracted at the front. Richard Porton (1999: 96) describes *Libertarias* as 'a curious amalgam of historical epic and mildly risqué sex farce . . . The film takes a salacious pleasure in highlighting the comic incongruousness of former nuns and prostitutes fighting alongside Bakunin-spouting women at the front.' Thus, any attempt at an examination of sexual and revolutionary politics is undermined by the film's reactionary representations.

Despite the comic tone throughout most of the film, *Libertarias* ends tragically when a group of Moroccan troops attack the militia in a brutal display of misogynist, penetrative violence; one woman is raped and has her throat slit, one has a dagger thrust into her body, and María is raped while another Moorish soldier holds a knife against her lips. This displacement of real, historical, Spanish violence on to the fictional actions of a savage African 'other' represents an all-too-convenient conclusion, one that adds further to the reactionary politics of *Libertarias*. The closing sequence attempts to tie the strands of anarchism and spirituality clearly together. Pilar lies dying, her throat slashed in the previous scene. As María cradles her head, non-diegetic, angelic choral music fills the air and María declares:

> One day in the time of the Lord, this planet will no longer be called Earth. It will be called Freedom. That day the exploiters of the people will be cast into the outer darkness where there will be wailing and gnashing of teeth and the angels of heaven on the most high will sing in joy as they behold the star Freedom, more blue and more radiant than ever. Because peace and justice will reign there. Because paradise will always be there and death will no longer exist.

Thus *Libertarias* concludes on a utopian, spiritual note, continuing the thread that has been developed throughout the film's narrative. Aranda states that 'There are many examples in history of events that seemed impossible, but have happened. That's why we have to keep

on believing in utopia. The film talks about two utopias: women's and society's. They both end tragically, but there is still hope enough to keep fighting.' (quoted in Cameron, 2000) *Libertarias'* spiritual thread, however, somewhat dissipates this hope and weakens its political analysis, formulating possible solutions to contemporary problems in religious utopian strivings rather than utopian strivings in the material world. Fredric Jameson asserts that the role of political art is 'to convey the sense of a hermeneutic relationship to the past which is able to grasp its own present as history only on condition it manages to keep the idea of the future, and of radical and utopian transformation, alive'. (1979: 72) It is a role that *Libertarias* fails to fulfil.

La vaquilla

On its release in 1985 *La vaquilla* was one of the most commercially successful films within Spain. (Deveny, 1993: 46) Prior to working on *La vaquilla*, Berlanga had directed a number of films which employed elements of comedy to critique the Franco regime, perhaps most famously *¡Bienvenido, Mister Marshall!/Welcome Mr Marshall!* (Spain, 1952) but also a trilogy of films made following the dictator's death, *La escopeta nacional/National Shotgun* (Spain, 1978), *Patrimonio nacional/National Patrimony* (Spain, 1981) and *Nacional III/National III* (Spain, 1983). *La vaquilla* was the first film, however, in which he turned his attention to the civil war. Berlanga states that the film is based on a script that had been rejected by the censors in 1956 (Deveny, 1993: 46); however, by the mid-1980s the absence of state censorship created more artistic freedom for filmmakers.

As with *¡Ay, Carmela!*, the film is set on the Aragón Front in 1938. However, the focus of *La vaquilla* is on the exploits of a group of Republican soldiers who venture surreptitiously into enemy territory in order to steal a bull that the Nationalists are planning to use in a bull run during a forthcoming town festival. The film suggests that the civil war is dividing Spain down the middle and a number of scenes point to the absurdity of a nation carved in two. This is exemplified in one early scene where soldiers from both sides exchange supplies because the Republican soldiers have tobacco, but no cigarette papers, the Nationalists papers, but no tobacco. Central to the plot is Mariano (Guillermo Montesinos), an innocent, naive young man who has a girlfriend in the local town but is worried that he will lose her affections, or that she will be sexually disloyal, at the impending

festival. When the troops hear that the Nationalists are planning a special dance on the night, their leader, Sergeant Castro (Alfredo Landa), concerned that his troops will defect, assembles a crew of volunteers who construct a plan to steal the bull in order to wreck the planned festivities, while simultaneously using the adventure to raise his own troops' morale. Thus the civil war forms the backdrop to an absurd, whimsical tale of cattle rustling more reminiscent of a television situation comedy than a serious war film.

Throughout *La vaquilla*, narrative identification is with the Republican soldiers, thus inviting sympathy with their position; however, the film generally steers clear of any heavy-handed or overt politicising. Mariano, we learn, may have voted for the left in the elections, but his main concern flows from doubts over his girlfriend's faithfulness. His worst fears are confirmed when he discovers that she is engaged to a Nationalist officer and he attempts to kidnap her and scupper any potential wedding. As with *Libertarias*, the audience are invited to laugh at characters caught up in the wrong place at the wrong time. For instance, as the Republican soldiers venture further into enemy territory, they find themselves, inadvertently, in a brothel where a soldier says, 'Aristotle had it right. You work for two things; to eat and to make it with charming females.' To this Sergeant Castro replies, 'You're so right, forget communism and fascism, when it comes to getting it on, we all agree.' Thus, the film suggests that there are universal human desires which run deeper than ideological divisions and which can unite all Spaniards.

La vaquilla does not engage with the specific horror of war and, although it is set on the front line, there is not a single shot fired. Indeed the civil war is represented as a calamitous adventure carried out by politically unaware combatants. But there are moments when the generally apolitical nature of the narrative is punctured, such as when the priest blesses the military aircraft, thus highlighting the Church's support for Franco. Moreover, much of the humour is derived from poking fun at the gout-ridden marquis, who is representative of the landowners' support for the Nationalists even if, despite his pious rhetoric, he is far from supportive of the Nationalists' war effort in practice. *La vaquilla* mocks the Church, the oligarchy and Franco, but there is no sense of what the Republic is fighting for and, while there is a sympathetic portrayal of the Republican soldiers, it is more for their plight than for their politics. As with the character of Paulino in *¡Ay, Carmela!*, the soldiers are caught in a conflict in which they

6.4 *La vaquilla* Vultures feed on the carcass of a dead bull in the film's closing scene.

have no real interest. In common with the carnival theme present in *Belle Époque*, the bull run is due to coincide with the town's Our Lady of the Assumption festival. The event ends in chaos, however, and the Republican soldiers decamp to the home of Mariano's father, who we learn is caretaker to the marquis and has been in hiding since the war broke out. Thomas Deveny points out that the film has been cited as an example of the *esperpento*, a term coined by the Spanish writer Rámon del Valle-Inclán. Deveny (1993: 47) suggests that the *esperpento* 'represents a systematic distortion of characters and indeed reality that Valle-Inclán created in his dramas and novels'. Deveny notes that, for Valle-Inclán, it was necessary to use 'the grotesque, the absurd, and the ridiculous' in order to get to the reality of Spain. This absurdity is apparent when the soldiers take the marquis hostage, strap him in his wheelchair and push him through a minefield before depositing him in no-man's land. As the film draws towards a conclusion, the Republicans return to their own lines and a small black bull and two bullfighters appear on the horizon. A bullfight ensues before the bullfighters depart leaving the bull lying dead on the grass; as vultures sweep down and pick over the carcass, the animal symbolically represents the damage inflicted on war-ravaged Spain.[10] Thus, while the civil war is presented as both divisive and tragic, the film is relatively unproblematic in that it poses few complex or difficult questions about Spain's fractured past. Its significance lies in the fact that it is the first film in which those sympathetic to the Republic are presented with the opportunity to laugh about elements of the past, even if it does not end as light-heartedly as it begins.

Dying with laughter?

It is not incidental that three of the films discussed here end in death;
Carmela is killed with a single shot from a Nationalist officer's pistol
in ¡Ay, Carmela!, anarchist militiawomen are raped and murdered
by Moroccan soldiers in Libertarias, and the dead bull on the Spanish
landscape is the closing image in La vaquilla. The endings of these films
stand in stark contrast to that of Belle Époque, which ends happily as
the young newly-weds depart for the US. If Belle Époque's rose-tinted
engagement with Spanish history raises the possibility of what might
have been, and what may be possible in the present, then the endings
of ¡Ay, Carmela!, Libertarias and La vaquilla serve as reminders of the
bitter consequences of defeat, the bruising humour only heightening
the tragedy and inviting the audience to 'think above the action' as
Eagleton suggests. Belle Époque, by starting with death but ending
happily, is the only film that fulfils the traditional conventions of a
comedy. It does so, however, by avoiding the specific period of the
civil war and it is difficult to imagine how the film could have utilised
a similar narrative structure and been set during the civil war. Does
this absence of traditional comedies set during the civil war flow from
the subjective narrativisation or emplotment choices of filmmakers
as White might suggest? Or is it a consequence of the tragic nature
of the event itself? The establishment of distance, whether temporal
or geographical, allows greater opportunities for the construction of
new narratives about the past; however, the contentious nature of the
Spanish Civil War in contemporary Spain, combined with its tragic
nature, undoubtedly imposes limits on its representation in cinema.
Openly comic elements, at least at significant levels, began to appear
in cinematic representations of the civil war in 1985, ten years after
the death of Franco and almost fifty years after the end of the war.
Twenty-five years further on and there has still been no attempt to
represent the Spanish Civil War as a comedy in cinema, at least in the
sense outlined by Neale and Krutnik. The Spanish Civil War remains
an event that people are far from ready to depart from 'happily' and,
therefore, thus far at least, films set during the Spanish Civil War that
employ comic elements may enable audiences to laugh momentarily
at the absurdity or incongruity of war situations but, ultimately, must
end in tears.

Notes

1 Three of the films discussed here, La vaquilla, ¡Ay, Carmela! and Belle Époque, were written by Rafael Azcona, the most prolific of the screenwriters who cover the civil war.

2 For an analysis of ¡Bienvenido Mr Marshall!/Welcome Mr Marshall! see Marsh (2006: 97–121); for an analysis of Calle Mayor see Roberts (1999).

3 In sharp contrast, see Luis Buñuel's documentary Las Hurdes/Land Without Bread (1931) for a rather different take on life in rural Spain at that time.

4 The battle-scarred town of Belchite, located 30–40 kilometres from Zaragoza, has been left untouched as a monument to the civil war.

5 Interview with author, London, 2002; simultaneously translated by staff at the Instituto Cervantes.

6 With her bare-breasted body wrapped in the Republican flag, Carmela brings to mind Eugene Delacroix's painting Liberty Leading the People (1830), which features a semi-naked female figure wrapped in the French tricolore.

7 Interview with author, London, 2002.

8 Ibid.

9 For a historical account of the role of women in the war see Mangini (1995) and Nash (1995).

10 Marsh (2006: 137) notes that throughout Berlanga's extensive oeuvre, his films rarely end happily.

7

Ghosts of the past: *El espinazo del Diablo/The Devil's Backbone*

I always wanted to make a ghost story against a historical background.
I truly believe that the best ghost story is a ghost story that is set against
a war, which leaves shit-loads of ghosts behind.[1]

Guillermo del Toro

In the previous chapter I examined the possibility, or otherwise, of
representing the Spanish Civil War as a comedy; this chapter explores
what happens to the conflict when it is represented in the horror
genre, specifically, the ghost story. The focus here is on *El espinazo del
Diablo/The Devil's Backbone*[2] (del Toro, Spain/Mexico, 2001), which is
set in the conflict's closing months. The sixth most successful Spanish
film of 2001 (Lázaro-Reboll, 2007: 39), the film helped lay the ground
for the success of its companion piece, the Academy Award-winning
film, *El laberinto del fauno/Pan's Labyrinth* (del Toro, Spain/Mexico/
USA, 2006), which follows a group of maquis fighters in Spain in
1944. The success of both films, commercially and critically, is tes-
timony to the undoubted skill and artistry of del Toro, a filmmaker
who has traversed the gap between small-scale independent produc-
tions, such as *The Devil's Backbone* and *Pan's Labyrinth*, and larger
Hollywood projects such as *Hellboy* (del Toro, USA, 2004). The films'
success also points to the civil war's widening cinematic appeal, both
in Spain and internationally.[3] The film's success inside Spain flows,
in part, from its resonance with contemporary Spanish events, its
concentration on ghosts evoking parallels with the way that the dead
from the civil war continue to haunt twenty-first-century Spanish
political discourse.[4] This chapter explores debates about the figure
of the ghost in popular culture and its relationship to debates over
the historical process, before proceeding to analyse the use of ghosts

in this specific film. The chapter then examines the cyclical view of history represented in the film, before charting the film's journey from its original setting during the Mexican Revolution to the Spanish Civil War, and analysing del Toro's appropriation of cinematic styles. The chapter concludes by reading this film against contemporaneous political processes in Spain.

Ghosts and the past

In a well-known statement outlining his views on history, Marx argues that 'Men make their own history, but they do not make it just as they please; they do not make it under circumstances chosen by themselves, but under circumstances directly encountered, given and transmitted from the past. The tradition of all the dead generations weighs like a nightmare on the brains of the living.' (1980: 96) Throughout his writings, Marx repeatedly highlights the importance of understanding the past's impact on the present: the quote above, in addition to stressing the importance of human agency, outlines his view that the dead, through the invocation of their memory, continue to exercise influence long after the expiration of their physical existence. This process finds an artistic expression in the figure of the ghost, a process traceable to classical antiquity.[5] Peter Buse and Andrew Stott note that in contemporary culture, ghosts have been eclipsed by the increased prevalence of creatures from outer space. Yet the figure of the ghost has not been exorcised completely and remains a staple of popular culture.[6] In highlighting the continuing relevance of ghosts to contemporary culture, Avery Gordon argues that 'Haunting is a constituent element of social life. It is neither premodern superstition nor individual psychosis; it is a generalizable social phenomenon of great import. To study social life one must confront the ghostly aspects of it.' (2008: 7) The ghost figure suggests some kind of historical trajectory, albeit a disjointed, discontinuous one, and because it appears to undermine a linear historical process that separates out past, present and future it disrupts the authority of conventional historical thinking. The return of the revenant can be seen to represent an anachronistic haunting, where someone or something from the past is stuck in the present, where it is, so to speak, out of time. Buse and Stott (1999: 1), argue that 'anachronism might well be the defining feature of ghosts', although they also problematise the notion when they state: 'The temporality to which the ghost

is subject is therefore paradoxical, as at once they "return" *and* make their apparitional debut.' (1999: 11). There is clearly a distinction to be drawn between the ontological and/or temporal dislocation that the ghost figure conjures up; however, we might best understand the use of ghosts in popular culture as representing the return of the past, or what is commonly referred to as history. As noted previously, Eagleton suggests that if the past is no longer with us, its effects most certainly are. (1981: 51) So we can read the presence of ghosts, or the undead, as traces of the past operating in the present or, as is more often the case, as traces of a past that has not been settled, a past that has not yet been laid to rest and that continues to haunt the present. Drawing on Freud's work, Jo Labanyi suggests that, in relation to Spain's traumatic past, there are three ways to deal with ghosts/ the past:

> One can refuse to see them or shut them out, as the official discourses of the State have always done with the official manifestations of the popular imaginary, where for good reasons ghost stories are endemic. One can cling to them obsessively through the pathological process of introjection that Freud called melancholia, allowing the past to take over the present and convert it into a 'living dead'. Or one can offer them habitation in order to acknowledge their presence, through the healing introjection process that is mourning, which, for Freud, differs from melancholia in that it allows one to lay the ghosts of the past to rest by, precisely, acknowledging them as past. (2000: 66)

Labanyi suggests that her first two options, in conflicting ways, result in a denial of history; however, the third option, she argues, presents a more fruitful alternative in that it is possible to exorcise the ghosts of the past, not by denying or hiding from them, but through a process of constructive engagement. I am not concerned here with metaphysical discussions about whether ghosts exist in the world of the real, but with discussing their existence in the 'unreal' world, that is, in the world of cinema. Like the ghosts of the past, in cinema memories or representations of the civil war increasingly haunt Spain. Their hauntings, however, are not born of malicious intent, but flow from a need for an acknowledgement of past crimes and an attempt to seek reparation.

Ghosts in *The Devil's Backbone*

In an interview with del Toro at the time of the initial release of *The Devil's Backbone*, he argues: 'Every real event in humanity needs an imaginary re-telling of itself; the Spanish civil war needed its own fictionalised retelling. It really completes the horror of it to a much deeper mythological way. It takes it to a different level. The horror of the war is not only physical it is also spiritual.' Del Toro's use of the word 'spiritual' is noteworthy because the film attempts to explore the horror of war by recourse to spirits, more commonly referred to as ghosts. Set in the dying days of the civil war, *The Devil's Backbone* centres on a group of young boys in the remote Santa Lucía school. Carmen (Marisa Peredes) and Dr Casares (Federico Luppi), who have been together since the death of Carmen's left-wing husband twenty years previously, run the school, which now functions as an orphanage for children of Republican parentage. They display Republican sympathies and Carmen safeguards Republican gold in the orphanage safe. A Republican fighter brings a young boy, Carlos (Fernando Tielve), to the orphanage after the boy's father's death at the front. After initial conflict with the boys, Carlos becomes accepted into the group. The orphanage's janitor, Jacinto (Eduardo Noriega), has secret sexual encounters with Carmen during which he attempts to steal the safe keys. Throughout the film the ghost of Santi (Junio Valverde), a young boy killed by Jacinto, haunts the boys. Fearing impending Nationalist victory, the old couple attempt to escape with the boys. Jacinto prevents their departure, killing Carmen, the maid and a number of the boys in an explosion. Casares is seriously wounded in the explosion and later dies of his injuries. After initially fleeing, Jacinto returns and takes control of the orphanage. He locks the boys in a cellar while he searches for and finds the gold. Released by Casares' ghost, the boys escape and then collectively overwhelm and wound Jacinto. Jacinto falls into a pool of water and the stolen gold weighs him down: as he struggles to rid himself of the gold, which he has tied to his body, Santi's ghost appears and pulls him deeper underwater to his death. The boys depart the orphanage, walking off into the Spanish landscape and leaving the doctor's ghost, shotgun in hand, standing guard over the crumbling building.

The general and most straightforward definition of a ghost is a person who returns from the dead to intervene in the affairs of the living. Ghosts generally return from the past; rarely do they appear

from the future. In the world of fiction, however, ghosts are not present for the sake of the past; they return from the past to make demands on the present in order to recast what is yet to come. The narrator in *The Devil's Backbone*, however, presents a different way of thinking about ghosts when, in the opening sequence, he poses the following question

> What is a ghost?[7]
> A tragedy condemned to repeat itself time and again?
> An instant of pain, perhaps
> Something dead which still seems to be alive
> An emotion suspended in time
> Like a blurred photograph
> Like an insect trapped in amber

The narrator's somewhat elusive definition is far removed from the idea of a ghost as a literal manifestation of a dead person, presenting, instead, ghosts as a much more complex phenomenon. It is a definition that chimes with that offered in *Specters of Marx*, Jacques Derrida's attempted rapprochement with Marxism: 'The specter is a paradoxical incorporation, the becoming body, a certain phenomenal and carnal form of spirit. It becomes, rather, some "thing" that remains difficult to name: neither soul nor body, and both one and the other.' (2006: 6) The narrator's opening words also suggest the idea of temporal dislocation and open up a way of thinking about the use of ghosts in the film.[8]

The Devil's Backbone contains a wide variety of different ghosts. There is the ghostly presence of the flickering shadows on the cinema screen, photographs moving at twenty-four frames a second, images both present and absent. One definition of a ghost offered by the film's narrator is of 'a blurred photograph'. Photographs signify both the presence and the absence of that which they refer to and, like ghosts, they are, simultaneously, both there (in the form of the ghost/image) and not there (in the form of the ghost's material body/the referent). The notion of the blurred photograph also raises ideas about the referential and iconic capacity of photography to represent the real. If a blurred photograph is an image of the past that does not exactly equate with the past itself, the ghost returns as a presence that carries similarities and differences with what it is the ghost of. In addition to the flickering shadows, there are also fictional characters from the 1930s who would probably be 'ghosts' by the time of the film's

release. As del Toro states, 'I believe that everybody in the movie is a ghost, I'm not saying objectively, I'm saying that all of the movie is a memory, the entire movie is about dead people. We are in 2001 and these are people who lived in 1939.'[9] Another ghostly presence is the bomb that is dropped in the opening sequence. Despite being deactivated, it makes an eerie, preternatural or supernatural sound and continues to tick. Even after its own 'death' it breathes and sighs, like Santi, who the boys call 'the one who sighs'. The bomb also seems gifted with powers sufficient to suggest Santi's location to Carlos by flying a streamer in the direction of where he is hiding. Of the bomb's presence del Toro comments that 'The more absent the war is geographically from that place, the more that bomb in the middle of the patio becomes important because it is a movie that tells you that war doesn't need to be close-by to be important.' The bomb is also exaggerated in size; it looks five feet long whereas the majority of bombs dropped during the civil war were considerably smaller. The bomb becomes the courtyard's central focus and haunts the boys' daily life.[10]

The film's key ghosts, Santi and Casares, are of the traditional variety. I want to offer a reading of the film that suggests that the ghosts of Santi and Casares represent the return of history, that they return from the dead as traces of an immediate past that will not go gently into the night but return to haunt the living, or the present. The two ghosts have clear, if markedly different, reasons for returning; Santi's ghost is motivated by a desire for vengeance for his brutal death at Jacinto's hand. Casares' ghost, however, is a more noble, benevolent being, driven not primarily by personal revenge, but by a desire to salvage a future for the boys. Casares is a man whose career would suggest a scientific rejection of ghosts and the world of the irrational; nevertheless, he seems to have his own doubts. Thus he readily drinks the rum-laced liquid in which he keeps the dead infants who have been born with bifurcated spines and which he sells in the village to raise funds for the orphanage.[11] In *Jokes and Their Relation to the Unconscious*, Freud highlights the story of a man who responds negatively to the question of whether he believes in ghosts: the man proceeds to add that he's not even afraid of them. Similarly, Casares may not believe in the viagric potential of his medical potion but, despite his medical background, he is willing to experiment in an attempt to cure his impotence and develop his sexual relationship with Carmen.

The Devil's Backbone presents two options for how to deal with

7.1 *El espinazo del Diablo/The Devil's Backbone* Carlos faces both his fears and the past when he approaches Santi's ghost.

ghosts/the past. The first is the position taken by another of the boys, Jaime (Íñigo Garcés), who adopts Labanyi's first option and initially refuses to confront the memory of Santi's death. Thus, although a witness to his death, Jaime denies any knowledge of Santi's whereabouts. Despite his best efforts to bury this memory, however, Jaime's repressed traumatic experience surfaces in his comic book drawings which feature images of Santi with blood flowing from his head wound, suggesting that the past will always return in some shape or form, on this occasion through culture. In contrast, Carlos has a contradictory approach towards the past. When Carlos first arrives at the orphanage he has no background knowledge of Santi's existence and is prepared to confront the mysterious presence that first appears in the courtyard doorway. But after hearing about Santi's disappearance, he runs when he sees him and hides in a linen cupboard to seek refuge, or to cut himself off from the past for fear of what his involvement with it will bring. Once he learns more about the past (the circumstances of Santi's death), however, he confronts Santi, despite the dangers that may flow from this. Anne E. Hardcastle draws on Derrida to suggest that the film 'reflects a hauntological approach' and that the 'literal ghost, Santi, leads us to the figurative one, the traumatic history of Civil War'. (2005: 120) She draws a parallel between Carlos's actions and Derrida's call to engage with ghosts. Derrida writes:

> It is necessary to speak of the ghost, indeed to the ghost and with it, from the moment that no ethics, no politics, whether revolutionary or not, seems possible, and thinkable and just that does not recognize in its principle the respect for those others who are no longer or for those others

who are not yet there, presently living, whether they are already dead or not yet born. (2006: xviii)

It is only when Carlos embraces the past that he can begin to move forward, into a future liberated from the dead weight of the past; thus his search can be read as a metaphor for the historical process. Santi's ability to correctly predict the future – he says 'many of you will die', and a number of the boys are later killed in an explosion – further highlights the interconnectedness with past, present and future. A view of history that allows the past to determine the future omits the role of human agency, a key component in understanding the historical process; however, human agency is represented in the film when the boys overcome Jacinto. But they are only successful after the intervention of the past in the shape of the doctor's ghost who releases them from their makeshift prison cell. Similarly the past (Santi's ghost) does not single-handedly destroy Jacinto, but he also needs the actions of those in the present, the boys who force Jacinto into the pool. Ernesto R. Acevedo-Muñoz suggests that 'The fact that the child ghost Santi solves the mystery of his own murder serves to contextualise the film's position on the fatality and inescapability of history.' (2008: 208) Of course, Santi operates to solve the mystery for the audience but he himself is well aware of his murderer from the start; nevertheless, Acevedo-Muñoz correctly alludes to the impossibility of Jacinto's escape from history, reinforcing the sense that past, present and future are woven together dialectically.

The return of cyclical history

The Devil's Backbone posits a view of history as a never-ending repetitive cycle, a view of history discussed in chapter five's exploration of *Vacas*. This is first evident in the opening sequence when, immediately preceding Santi's death in the time of the film's story, a bomb falls into the orphanage courtyard as the narrator says, 'A tragedy condemned to repeat itself time and again?' The bomb may not be human, but the tragedy condemned to repeat itself time and again is of human origin, perhaps suggesting, as del Toro argues, that war continually resurfaces though a constant and never-ending historical cycle. Del Toro states that 'I think that, sadly or not, human life occurs in cycles and there is no possibility of stopping that and that's true for violence and sex and all of that. The more you deny something the more it

comes back, a little late in its cycle, but it comes back and that is true for me in history.' Del Toro suggests that it was inevitable that the Republic was defeated because of the failings of human nature when he comments

> I tried to make the orphanage in the film a microcosm of the war. I wanted to create a situation where the republican figures in the movie allowed for this fascist creature to grow and nurture, and ultimately take over. The Republican government represents the best possible leftist government that has ever taken place on earth – women were emancipated, education was very experimental, culture was booming – and yet it all went to hell.[12]

Del Toro's essentialist beliefs on human nature suggest that the Republic was doomed from the start: it did not, so to speak, have a ghost of a chance. That humanity is never content with its lot and is engaged in an unquenchable search for fulfilment, even through pain and destruction, appears to be a reasonable reading of the film. This is exemplified in the character of Jacinto; he is safe from the war, he has food and he has shelter, he has a young and beautiful fiancé, Conchita (Irene Visedo), and he also has illicit sexual encounters with Carmen. Yet he remains unfulfilled and within him resides the greed of human nature that ensures the inevitability of recurring war. Jacinto, therefore, embarks on a voyage of selfish, violent destruction, which is illustrated in his killing of Santi and in his willingness to blow up the orphanage.[13] It becomes most manifest, however, when he murders Conchita by stabbing her in the stomach with a knife, an action that parallels a Nationalist firing squad execution of a line of International Brigaders earlier in the film. That humanity is selfish, violent and greedy is a bleak reading of the film, one based on pessimistic and essentialist notions of human behaviour; nevertheless it appears to be one that del Toro himself favours and one that the film justifies.

The Devil's Backbone can also be read, however, as representing the idea that it is necessary to face up to the past, not as individuals, but on a collective basis. Within the film, human nature is not simply represented as constant. Jacinto, who Carmen describes as a 'prince without a kingdom', is what Jaime could have become. Like Jacinto, Jaime is a loner who says 'I don't need anyone' and claims that he will not need assistance to fulfil his ambition to produce comics when he is older. His main human interest lies in his sexual infatuation with Conchita, highlighted when he stares longingly at her, and made

apparent when he offers her a cigar wrapper as a pretend ring and as a token of his affection. His animosity towards Jacinto is deepened by violent, adolescent, sexual jealousy about Conchita. Jaime initially exhibits the limitations of an individual response to his individual traumatic experience; however, the explosion forces the boys to act together and both Carlos and Jaime abandon their previous passive stance and prepare to cooperate to kill Jacinto.

In *The Devil's Backbone* the hunting metaphor highlights the fact that individuals acting collectively can achieve far more than if they struggle separately. Thus, when the boys are initially divided and fight among themselves they are useless in the face of a stronger force. In the brutal hunting and killing of Jacinto, however, the boys emulate the collective approach of the primitive mammoth-hunters in a previous classroom scene. As a pack of hunters kill the mammoth in their desperate struggle for food, the boys hunt Jacinto, a metonymic embodiment of fascism, in an organised and collective manner. When they force Jacinto into the pool in which he drowned Santi, his demise comes about at the hands of a combination of those who hunt him and those who haunt him. Fredric Jameson comments that 'history is what hurts' (1986: 102) and it does indeed hurt for Jacinto as the past, Santi's ghost, pulls the janitor down to his ghostly, and ghastly, watery death.[14] In Greek mythology ghosts were appeased and given blood to drink; here Santi is appeased by Jacinto's body (and blood). By rejecting the limitations of individual action and uniting together the boys are victorious and consequently learn about the potential benefits of cooperation and solidarity, thus presenting an alternative model of human nature to that displayed by Jacinto, and that proffered by del Toro.

The surviving boys emerge from the ruined orphanage and into the golden sunlight that is cast across the arid Spanish landscape. The camera slowly pulls back to reveal Casares, who we now know to be the narrator, as he repeats the film's opening words and adds 'A ghost. That's what I am', suggesting that, in this instance, the ghosts are the losers, or the memories of the losers. Earlier Casares comments 'All my life, I've always stopped short, left things unfinished', and it is only now that he sees things through to a conclusion, his life becoming wholly worthy only in death. He watches over the boys as they head off from the darkness of the orphanage into a new world, a sorry assortment of orphans, limping with wooden sticks as they walk into an unknown future. Buse and Stott suggest that 'fictional

7.2 *El espinazo del Diablo/The Devil's Backbone* The ghost of Dr Casares looks out on the boys as they head into an unknown future.

phantoms are usually banished by the imposition of closure at the end of the narrative' (1999: 12); however, at the film's conclusion the narrative remains somewhat open-ended. Thus the ghost of the doctor still stalks the earth, his impotence now channelled into his shotgun, and this suggests that the ghosts of the civil war are very much alive.

Critics have expressed conflicting views on the film's use of history. Hardcastle, for instance, although generally positive about the film, states that 'The distortions of history that we see in the film also correspond to an erasure of the ideological factures in Spanish society during the Civil War.' (2005: 127) She adds 'del Toro is not interested in recounting what is "known" about the Spanish Civil War. Instead he explores current feelings toward the past regardless of historical inaccuracies in its representation.' Here it is worth recounting del Toro's own assertion that he is interested in a spiritual retelling of the event, not a realistic documenting of the event. Labanyi suggests that 'In a country that has emerged from forty years of cultural repression, the task of making reparation to the ghosts of the past – that is, to those relegated to the status of the living dead, denied voice and memory – is considerable.' (2008: 80) Arguably, these reparations will not only be paid through history books or political legislation: cinema can also play an important part in this process. Del Toro states that 'the last image of the movie is, in essence, the new Spain – of the children that are crippled, damaged, bleeding and groping against a plain of nothing with little lances. That, for me is the new Spain, that it has a ghost behind it that is never going to die. I really believe that the civil war is going to haunt Spain for generations to come.'[15] In the

world of cinema the appearance of these ghostly characters mirrors a wider process of excavation and reparation.

The ghost of the Mexican Revolution?

Del Toro points to his use of the war background in the epigraph at the start of this chapter, yet he conjures up the spirits or the memory of the civil war perhaps with one eye on international distribution, as the event still arouses a great degree of interest outside Spain. There are few direct political references to the events in Spain in *The Devil's Backbone*, and there is more than a sense that this is the Spanish Civil War haunted by the ghost of the Mexican Revolution, which was the setting for the first drafts of the screenplay that del Toro developed fifteen years previously.[16] At the 1994 Miami Film Festival, Pedro Almodóvar invited him to make a film in Spain on the back of the success of his art-house vampire movie *Cronos* (del Toro, Mexico, 1993)[17] and del Toro fused his original script with another, *La bomba*, by Antonio Trashorras and David Muñoz, developing it in the style of Carlos Giménez's comic book, *Paracuellos*. (Lázaro-Reboll, 2007: 42) In relation to the civil war itself, the film does not dwell on the conflict's political details: it does reveal Carmen's and the doctor's Republican sympathies, and we know that the boys are orphans of Republican families, but there are few references to the war. Casares says to Carmen that 'England and France might still intervene' and the doctor also witnesses the execution of a group of International Brigade members and Republican fighters. These political references, however, seem somewhat shoehorned into the narrative and it would be easy enough to watch the film without worrying too much about the civil war, certainly for international audiences who are removed both historically and geographically from the events. Indeed, without these direct references we could be in Mexico after all. The connections between Mexico and Spain are considerable. The Spanish filmmaker Luis Buñuel, the leading figure in Surrealist cinema, spent much of his life in exile in Mexico and Buñuel's influence, both aesthetically and thematically, is evident in del Toro's *oeuvre* across both the independent projects under discussion here and in his Hollywood films such as *Mimic* (del Toro, USA, 1997) and *Hellboy*. Moreover, it is notable that, aside from the Soviet Union, Mexico was the only country that supported the Republican government during the conflict and significant numbers of civil war exiles found refuge in Mexico.

Lázaro-Reboll suggests that 'Del Toro's filmic production is clearly an example of the dynamic process of cross-cultural horror exchange, since it borrows from Hollywood and non-Hollywood film-making practices, partaking of diverse international horror traditions, or what could be labelled as transnational horror.' (2007: 46) The film certainly contains numerous cinematic references: Carmen's one-legged lady references *Tristana* (Buñuel, France/Italy/Spain, 1970); Jacinto is dragged down by the weight of the gold as in *The Treasure of the Sierra Madre* (John Huston, USA, 1948); the boys' brutality is reminiscent of the children's violence in the adaptations of William Golding's novel *The Lord of the Flies* (Brook, UK, 1963; Hook, UK, 1990); the doctor guards the boys much as the old woman, Rachel Cooper (Lillian Gish), protects the children from the evangelical preacher, Harry Powell (Robert Mitchum), in *The Night of the Hunter* (Laughton, USA, 1995); parallels can also be drawn with *Les Diaboliques/Diabolique* (Clouzot, France, 1955), which takes place in a boys' school with architectural similarities to the orphanage and, in terms of plot, includes the apparent drowning of a body in a bath-tub, the depositing of the body later in a swimming pool, and the victim's return to haunt one of those responsible; and, finally, the film also has cinematographic similarities to *The Searchers* (Ford, USA, 1956), which also features a civil war veteran, John Wayne's Ethan Edwards, although in this instance one from the American Civil War.[18]

Del Toro states that 'everything in the movie was meant to look, in terms of light and shadow, like a Goya painting. I was very keen to find an aesthetic that was Spanish, but not like any other Spanish movie.'[19] The film's predominant colour is amber, reflecting the fact that, as del Toro puts it, 'the whole movie is supposed to be about ghosts that are supposed to be like insects trapped in amber'.[20] In addition to a palette of 'white, black, and earth', 'green and very, very pale green-blue' feature in the night scenes. The exteriors were shot with a chocolate filter accentuating the amber tones, which gives it, as del Toro puts it, 'the aesthetics of a western; a kind of deranged western instead of a civil war movie feeling'.[21]

This tale of ghosts and greed can travel easily from the Mexican Revolution to the Spanish Civil War precisely because it steers clear of extensive period detail, opting to use allegory in an attempt to generate some form of greater truth about human nature. It is questionable, however, whether this storytelling method has the ability to deal with the specificity of complex political events. When Jaime attempts to get

the boys to rebel against Jacinto he says 'Do you think it will work out if we behave?' To which Galvez replies 'They have the rifle. They're bigger and stronger than us.' Jaime then retorts 'Yes, but there's more of us.' This could be read as an oblique and highly political reference to Republican infighting during the May Days in Barcelona in 1937.[22] Conversely, it is also a common theme of countless Hollywood films, thus highlighting the limitations of allegorical accounts of complex political processes; if there is always a potential polysemy in any text that creates the space for a multitude of responses then allegorisation multiplies this process to an endless degree, thereby potentially weakening the film's political impact.

The allegorical elements are also evident in del Toro's fascination with entomology, an interest shared by Buñuel and Arrabal, which is illustrated by the appearance of insects throughout the film.[23] Of insects, del Toro states that 'I think they are perfect. Humans are imperfect because we have two sides; insects are one-sided . . . They finish their work and die, and then they are eaten by the others. They are almost like the perfect fascist creature.'[24] Read metaphorically, then, a link is suggested between the methodological movement of insects and the cold, rational brutality of fascism. Within the film slugs and insects operate as a motif of death; thus Santi is killed on the night that he secretly goes with Jaime to gather slugs at the pool and witnesses Jacinto attempting to open the orphanage safe. When Jacinto catches sight of him it leads to the young boy's death. Insects also surround the ghostly presence of Santi; moreover, when the doctor dies, the camera follows the flight-path of a fly as it enters a window and joins a small group of flies crawling around his mouth. When the cupboard door opens to release the boys from Jacinto's makeshift prison, we do not see the doctor; rather, the appearance of a number of flies operates to signify his ghostly presence.

In chapter four I highlighted the benefits of allegory and metaphor in the work of Carlos Saura who, as a result of censorship under Franco, was prevented from openly depicting the politics of the civil war and its aftermath. But allegory's political potential seems somewhat limited when open exploration of the past is now possible. Perhaps we expect too much from the cinema. Can it really answer detailed questions about complicated political and historical processes? Can the ghosts of the past be exorcised and laid to rest through cinema screens? Derrida suggests that 'At bottom, the specter is the future, it is always to come, it presents itself only as that which

could come or come back.' (2006: 48) In the cupola of the Church of San Antonio de la Florida, Madrid, is Goya's *Miracle of St Anthony Resurrecting a Dead Man*. The painting depicts Anthony exhuming and resurrecting the corpse of a murdered man so that he can identify his murderer.[25] Similarly, across Spain the Asociación para la Recuperación de la Memoria Histórica (Association for the Recovery of Historical Memory) campaigns for the exhumation of the countless thousands of bodies buried in unmarked graves. Victims of the right-wing dictatorship's policy of *limpieza* or 'cleansing', the dead – denied their voice and their memory for over seventy years – continue to haunt the present, demanding to be heard, demanding reparations. It is worth invoking again the words of Derrida:

> No justice – let us say no law and once again we are not speaking here of laws – seems possible or thinkable without the principle of some responsibility, beyond all living present, within that which disjoins the living present, before the ghosts of those who are not yet born or who are already dead, be they victims of wars, political or other kinds of violence, nationalist, racist, colonialist, sexist, or other kinds of exterminations, victims of the oppressions of capitalist imperialism or any of the other forms of totalitarianism. (2006: xviii)

In 2007 the Spanish government passed the Law of Historical Memory, which allowed for the exhumation of the bodies of those killed by the dictatorship and dumped in unmarked graves in the years following the civil war. The dead from the civil war are alive enough to reappear, to engage in a fight for their own memory, for their own past. Cinema, as is exemplified by *The Devil's Backbone*, is a space where the ghosts of the civil war are emerging in increasing number; a haunting reminder of a traumatic period in Spanish history.

Notes

1 Interview with author during the 2001 Edinburgh International Film Festival, partially published as 'Insects and Violence', *The Guardian*, 28 November 2001.

2 Ghosts are not only present in *The Devil's Backbone*, but surface also in both *Vacas* and *Libertarias* (discussed in chapters five and six respectively). In *Vacas* the presence of the ghosts suggest a never-ending historical cycle of death and rebirth, but they do not have the transformative powers of the ghosts in either *The Devil's Backbone* or *Libertarias*.

3 *El Orfanato/The Orphanage* (Antonio Bayona, Mexico/Spain, 2007) is a

ghost story set in present-day Spain, on which del Toro worked as producer and which was marketed internationally as 'A Guillermo del Toro Film'. The film was also a considerable success picking up seven Goyas in 2008. For audiences outside Spain, *The Orphanage* may simply be a first-class ghost story; however, one crucial aspect of the plot involves the discovery of corpses buried in a secret grave and it is not difficult to see parallels with debates in contemporary Spain over the exhumation of the civil war dead. In previous interviews del Toro has stated that he was working on another ghost story, *3993*, in which ghosts from the civil war returned to haunt Spain in the 1990s; however, it appears to be no longer part of his plans.

4 For more on the exhumations of the civil war dead see Ferrándiz (2006).
5 For an overview of representations of the ghost in culture see Finucane (1984).
6 See 'Introduction: A Future For Haunting' in Buse and Stott (1999). They note that the Reformation and the accompanying, if partial, dismissal of purgatory diminished the idea of the return of the dead. The presence of ghosts in popular culture is now more prevalent in, but not exclusive to, Catholic countries.
7 Notably, the same question is asked by Stephen Dedalus in chapter nine of James Joyce's *Ulysses*.
8 Del Toro states his own personal belief in ghosts: 'I believe in ghosts very firmly.' Del Toro is also clear, however, that he is not trying to answer the question that the film poses. To the question 'What is a ghost?' he responds, somewhat elusively, that 'they can be an event, they can be something else, that's why when the movie asks that question, it tries to give you an answer that gives you clues to other answers. I don't think a movie is a thesis.' Interview with author, Edinburgh, 2001.
9 Interview with author, Edinburgh, 2001.
10 Del Toro states that 'The size of everything is exaggerated, even the unexploded bomb in the centre of the courtyard. The real bombs dropped by the Italian fascists in the civil war were about 18 inches high. Mine is massive, because everything is massive to a child.' Interview with author, Edinburgh, 2001.
11 The devil's backbone of the title refers to what is now termed spina bifida; in the past the condition was often regarded as the curse of the devil.
12 Interview with author, Edinburgh, 2001.
13 Davies (2006: 145) offers an intriguing analysis of the film's representation of masculinity, contrasting Santi's 'menstrual' bleeding with Jacinto's virility and arguing that the film represents masculinity as 'unfixed, in inherent danger of collapsing in on itself and mutating into the feminine abject'.
14 The on-screen violence of the children is unusual in contemporary

cinema; however, the appearance of children in ghost stories is not. Del Toro states that 'It is one of the most ancient conventions in the genre that, for a horror tale to work, it needs the eyes of an innocent; in fact it needs pure eyes. I hate the word innocence – it's so relative. But purity is not. I believe that children are pure and yet I don't believe that they are innocent. Purity is like an amplifier of horror and I have lived the most horrifying chapters of my life being a child, so those are the chapters I can relate to the best.' Interview with author, Edinburgh, 2001.

15 Interview with author, Edinburgh, 2001.

16 In *Fearless Women in the Mexican Revolution and the Spanish Civil War*, Linhard suggests that ghost stories started to circulate about both of these events around thirty years after their respective conclusions. (2005: 229)

17 Information from interview with the author; the film is produced by Pedro Almodóvar and his brother Agustín.

18 Del Toro is undoubtedly a cine-literate filmmaker; *Pan's Labyrinth* is also full of references to other seminal works. For instance, when the fascist officer, Captain Vidal, is shaving in the mirror it brings to mind the figure of Buñuel in the opening sequence of *Un Chien Andalou*.

19 Interview with author, Edinburgh, 2001.

20 Ibid.

21 Ibid.

22 'The May Days' is the name given to the events in Barcelona in May 1937 when the Republican government, acting under the influence of the communists, launched an attack against the institutions that were in the hands of the anarchists, most notably the city's telephone exchange. It led to bitter internal fighting on the Republican side. It is outlined in greater depth when I discuss *Land and Freedom* in the following chapter.

23 Insects feature strongly throughout del Toro's *oeuvre*, most notably in *Mimic*, which might be best described as a giant cockroach movie. In *Cronos* he had wanted to film a scene in which flies surrounded a body, but only with the development of CGI technology did this become possible in *The Devil's Backbone*. For more on Buñuel's entomological interests see Begin (2007).

24 Interview with author, Edinburgh, 2001.

25 The scene from the painting is reconstructed cinematically in *Goya en Burdeos/Goya in Bordeaux* (Saura, Spain/Italy, 1999).

A story from the Spanish Revolution: Land and Freedom/Tierra y Libertad

Barcelona was something startling and overwhelming. It was the first time that I had ever been in a town where the working class was in the saddle. Practically every building of any size had been seized by the workers and was draped with red flags and with the red and black flag of the Anarchists; every wall was scrawled with the hammer and sickle and with the initials of the revolutionary parties.

George Orwell (1989: 8)

The release of *Tierra y Libertad/Land and Freedom* prompted considerable critical praise – the film won the Prize of the Ecumenical Jury and the international critics' FIPRESCI Award prize at the 1995 Cannes Film Festival – and provoked sharp and heated political controversy. In contrast to the dominant view of the civil war as a Manichean conflict between fascism and democracy, *Land and Freedom* excavates the conflict's revolutionary dimension, captured vividly in the quote from Orwell above, and places the complexities of Republican politics centre-stage.[1] This chapter presents an analysis of the film's political content, argues that the social realist film form utilised by the filmmakers is an entirely valid form for representing the past cinematically and considers the political controversy surrounding its release. The chapter also examines some of the pitfalls in representing complex events through the medium of cinema, but concludes that in resurrecting the revolutionary aspects of the fight against fascism, *Land and Freedom* is one of the most important films dealing with the period.

Loach and Allen

Land and Freedom is the final instalment in an impressive list of film, television and theatre productions directed by Ken Loach and scripted by Jim Allen. Their collaborative partnership, which includes *The Rank and File* (BBC, 1971), *Days of Hope* (BBC, 1975), *Hidden Agenda* (UK, 1990) and *Raining Stones* (UK, 1993), seeks to sympathetically represent the struggles of working-class people. Loach and Allen's films weave important political issues around the personal lives of their characters, striving to strike a balance between the dramatic and the didactic.[2] Writing on the nineteenth-century novel, Georg Lukács argues that 'the problem is to find a central figure in whose life all of the important extremes in the world of the novel converge and around whom a complete world with all its vital contradictions can be organised'. (1970: 142) For Lukács, it was important to find a 'typical' figure, who could stand as representative of an entire class and who, as the narrative develops, is thrust into the complexities of a specific period or event. *Land and Freedom* utilises this approach through the focus on the central protagonist, David, a young, unemployed and relatively politically inexperienced Liverpudlian communist who is inspired to travel to fight in Spain. The audience are invited to share in his political journey as he moves from the seemingly straightforward politics of the fight against fascism to become embroiled in the internecine complexities of Republican politics during the civil war.[3]

One central theme running through much of Loach and Allen's work is their contention that working-class struggles are continually betrayed by the leaders of the workers' movement; in *Land and Freedom* this theme is revisited through an analysis of Spain's revolutionary movement and its betrayal at the hands of the communists. Loach and Allen have touched on the Spanish Civil War in previous work: in the British television soap opera *Coronation Street* (Granada TV/ITV 1960–present), on which he worked as a scriptwriter in the 1960s, Allen introduced the character of Stan Ogden, a work-shy window cleaner who had fought with the International Brigades (Newsinger, 1999) and Loach touches on the civil war, albeit briefly, in *Fatherland* (Loach, UK/West Germany/France, 1987), which follows the life of an East German protest singer who defects to the west.[4] *Land and Freedom*, however, places Spanish history centre-stage in its analysis of the Republican side of the civil war or, more accurately, the Spanish Revolution; indeed, an intertitle at the start of the film states: 'A Story

from the Spanish Revolution'. That a revolutionary situation existed, at least in the northern industrial stronghold of Catalonia, was illustrated when Companys, the head of the Catalan government, the Generalitat, declared to a meeting of anarchist leaders: 'Today you are the masters of the city and of Catalonia . . . You have conquered and everything is in your power.' (quoted in Fraser, 1988: 111) It is this revolutionary movement, and its ultimate defeat, that the film strives to both represent and analyse.

A story from the Spanish Revolution

The opening sequence of *Land and Freedom* is set in a Merseyside housing scheme in the 1990s; as the camera follows ambulance workers climbing the stairs to a flat to attend to David, who has suffered a suspected heart-attack, National Front graffiti is seen on the walls, alongside anarchist symbols and anti-racist stickers, thereby highlighting anti-fascism as an ongoing political project. Following David's death (the old man is not mentioned in the credits; the young David is played by Ian Carr) his granddaughter, Kim (Suzanne Maddock), becomes increasingly interested in her grandfather's past as she reads articles he has left behind on a variety of previous struggles, British industrial disputes and national liberation struggles in Ireland and Palestine, among others. Her interest grows when she discovers an old suitcase containing David's mementos from Spain.[5] David's 'history', located via letters and newspaper cuttings, is only accessed after his death; that his granddaughter salvages the documents from an old, battered suitcase hidden above a wardrobe in his bedroom is a symbolic manifestation of the filmmakers' attempt to uncover what they regard as the hidden history of the Spanish revolution. The suitcase contains traces of a factual past (newspaper clippings from the 1930s) with fictional additions: black-and-white photographs of the film's characters, David's letters to his fiancé, Kitty (Angela Clarke), and a handful of earth wrapped in a red handkerchief, which we later learn is collectivised land taken from the graveside of Blanca (Rosana Pastor), an anarchist who David establishes a relationship with in Spain.[6] These traces of times past are then linked to representations of the past itself through a cut to monochrome actuality footage of the revolutionary movement in Catalonia in July 1936, over which the film's introductory bold red credits appear, accompanied by music from the period. This is followed by white

intertitles on a black screen which outline the key political events of the period: the February elections that brought to power the Popular Front government, the generals' coup on 18 July and working-class resistance to the fascist-led coup. The film then cuts to a meeting in Liverpool in August 1936 where a red-and-black-scarved male Spanish anarchist addresses the assembled audience. During this speech, he highlights the extent of working-class organisation and politicisation in Catalonia before a still image of Franco and his entourage is shown. The speaker states 'These are the fascists, the defenders of privilege', as the screen then shows an extreme close-up of Franco. This is followed immediately by a photograph of a row of corpses then a shot of grieving women as the speaker states 'This is what they are doing to us. They are killed and left there, just for being trade unionists.' The footage concludes and the speaker appeals to the crowd for support in the name of international workers' solidarity.

The film form employed in *Land and Freedom* contains a number of elements that attempt to recreate a sense of the everyday experience of real life: jerky movements from the use of a hand-held camera; natural lighting; overlapping dialogue; a rejection of star casting; the use of a number of non-professional actors; and a very limited use of stylisation.[7] The use of improvised acting techniques, combined with linear shooting, enhances the original and authentic effect. Loach goes to great lengths to heighten this sense of authenticity; for instance, pointing to the casting methods he employs, he highlights that 'we tried to find the people who, if it happened now, would go and fight'.[8] Moreover, in the sequence outlined above, the audience was comprised of members of the local labour movement in an attempt to generate a spontaneous and plausible response. The addition of actuality footage of the conflict, contemporary non-diegetic music and explanatory intertitles enhances the naturalistic effect.

Politics and film form

In the 1970s a wide-ranging debate took place within the pages of the film journal *Screen* which was triggered by the formal qualities Loach and Allen employed in *Days of Hope*, a four-part television series that charted the history of the British labour movement from the 1916 Easter Rising in Dublin to the 1926 General Strike.[9] During this debate, Loach's output, which was encapsulated under the title the 'classic realist text', was critiqued on the basis that its reaction-

ary formal qualities outweighed its progressive political content. In relation to this debate, Mike Wayne notes that 'The tension between a necessary attention to form and the dangerous lure of formalism can be traced back to Trotsky's debate with the Russian avant-garde in the 1920s, and it drove much radical film theory and practice in the 1970s into something of an elitist cul-de-sac.' (2001: 10) In his polemic against the Russian Formalists, Trotsky argues that the concentration on form itself is inadequate. (1991: 209) Loach adopts a similar position and has little time for academic arguments concerning the pros and cons of film form. Of academics critical of his methods he comments:

> They are not interested in content; they're interested in form. So when you try and make the content as clear and as complex as it is, to try and unravel something and clarify something and distil something they shy away from confronting it because they don't want to talk about it. They don't feel safe, because then they've got to talk about something other than film. So consequently they kind of hide their eyes from what's in front of them and find some kind of peripheral subject to discuss. If you spend all your time in semiological disputes, then you can't see anything else.[10]

Allen, who worked regularly on popular television programmes such as *Coronation Street* and the courtroom drama *Crown Court* (ITV, 1972–84), also argues for the prioritisation of content over form when he states that 'it is the content that any serious writer should concern himself with'. (Madden, 1981: 51) It is fruitful, however, not to separate the two but to understand their ongoing, interchanging relationship: in highlighting the dangers of falling into a formalist trap that prioritises form at the expense of content Bill Nichols states, 'Form guarantees nothing. Its content, the meaning we make of it, is a dialectical process taking place between us and the screen and between past, present, and future.' (1996: 57) Loach himself argues that his films are 'about a process that is dialectical: that is, the struggle between opposing forces to push events forward. But they're more a description of one side of that process, which is the working class side ... they're films that show or describe that dialectical struggle rather than embody it.' (quoted in Fuller, 1998: 12)[11] While many film theorists have tended to fetishise film form at the expense of analysis of historical detail, it is worthwhile reiterating that Brecht, often cited and celebrated as the proponent of an alternative and revolutionary

political aesthetic, utilised Aristotelian dramatic conventions when he turned his attention to the Spanish Civil War in *Señora Carrar's Rifles*, in an attempt to make a direct political intervention. It is this notion of a practical response that appears to drive the actions of both Brecht in this specific instance and Loach and Allen throughout their work.

Homage to Orwell

There are striking similarities between *Land and Freedom* and Orwell's *Homage to Catalonia*. Indeed, Loach acknowledges that Orwell's auto-biographical account of his time in Spain 'stands as an absolute kind of strength' and was the 'starting point' for the script.[12] Orwell refuses to ignore the conflict's revolutionary nature, suggesting that 'the thing that had happened in Spain was, in fact, not merely a civil war, but the beginning of a revolution. It is this fact that the anti-fascist press outside Spain has made it its special business to obscure. The issue has been narrowed down to "Fascism versus democracy" and the revolutionary aspect concealed as much as possible.' (1989: 192)[13] Orwell highlights the fact that opposition to the military uprising in July 1936 was not organised 'in the name of "democracy" and the status quo; their resistance was accompanied by – one might almost say it consisted of – a definite revolutionary outbreak. Land was seized by the peasants; many factories and most of the transport were seized by the trade unions; churches were wrecked and the priests were driven out or killed.' (1989: 190) *Land and Freedom* brings this revolutionary perspective to the screen, with the following four strands resonating with Orwell's quote. First, the importance of agrarian reform is high-lighted in an extended debate over the collectivisation of land after the militia liberate a village from fascist control. Secondly, the question of workers' ownership and control of industry is raised in the sequence in which David travels through Spain on the collectivised railway network and a train guard welcomes him in the name of solidarity and allows him to travel without a ticket. Thirdly, the continued focus on arms, and in whose control they lie, provokes consideration of control over the state apparatus. Finally, when the priest who has been shooting the militia members from a church tower is captured and executed, he stands as representative of the Church's support for the fascist 'Crusade'.

The main threads of *Homage to Catalonia* run through the film: an

idealistic young Englishman travels to Spain to fight in the civil war and, by chance, enlists in a militia organised by the revolutionary, but anti-Stalinist, POUM.[14] Like Orwell, David witnesses the betrayal of the revolution at the hands of the communists and ends up fleeing Spain, pursued, not by the fascists, but by the communists as part of their suppression of the revolutionary left. Anti-Stalinist politics are expressed throughout, with the character of the Frenchman, Bernard (Frédéric Pierrot), developing the main criticisms of the communists: alluding to Stalin's desire to limit the demands of the Republican movement, Bernard argues that 'Stalin fears us because he wants to sign treaties with the West . . . he needs to be respectable.' An attempt to reappraise the Soviet Union's role was critical in determining the script's contents. Allen outlines why he believes the Soviet Union was keen to limit Republican demands when he suggests that 'They knew that if a democratic revolution had succeeded in Spain then Stalin's days were numbered. It was the last thing he wanted because then the dictatorship in Russia would not have been tolerated.'[15] The fact that the Spanish communists were working under the tutelage of the Soviet Union led them to violently curtail the revolution, justifying their position by arguing that military victory was a prerequisite for societal change. Thus a typical article in the Spanish communist press read:

> at present nothing matters except winning the war; without victory in the war all else is meaningless . . . this is not the moment to talk of pressing forward with the revolution . . . At this stage we are not fighting for the dictatorship of the proletariat, we are fighting for parliamentary democracy. Whoever tries to turn the civil war into a socialist revolution is playing into the hands of the fascists and is in effect, if not intention, a traitor. (quoted in Rogovin, 1998: 350)

The US International Brigader, Lawrence (Tom Gilroy), gives voice to the former part of this position when he states that 'We're here to defeat the fascists. If you want to help you have to moderate your slogans because you're scaring them away.' Showing his naivety, David initially echoes Lawrence, stating 'We need to win the war first . . . ideology is useless.' David's comments also echo Orwell's early thoughts: 'the revolutionary purism of the POUM, although I saw its logic, seemed to me rather futile. After all, the one thing that mattered was to win the war.' (1989: 206) As the political arguments unfold, however, the argument that extending the social programme

8.1 *Land and Freedom/Tierra y Libertad* Spanish peasants, joined by members of the POUM militia, debate the need for agrarian reform.

of the revolution was not an added extra but, given the international context, a necessary prerequisite for a Republican victory is given greater voice.

This is exemplified in the twelve-minute sequence where the villagers meet to debate the collectivisation of land. Shot using two cameras over the course of two days, during the meeting POUM militia members and local villagers, who both support and oppose the collectivisation of land, engage in a protracted debate about agrarian reform. (Hayward, 2004: 229) Patricia Knight points out that the scene parallels a common practice of the time:

> in the Summer and Autumn of 1936 about 2,500 agrarian collectives were set up covering 9 million acres, the process going further in Aragon and Andalusia. The establishment of such a collective was typically preceded by the arrival of an anarchist militia column which would burn the church, drive out any known right-wingers and call an assembly to discuss collectivising the land (a process depicted in a lively scene in the film *Land and Freedom*). (1998: 48)

This sequence is illustrative of the film form utilised by Loach and cinematographer Barry Ackroyd, which is a skilfully crafted illusion of the authentic. Shot in such a way that the camera, often placed at eye-level, appears to follow the action, even on occasion seemingly being caught out by the movement of the characters, the cinematography attempts to create a sense that the audience are witnesses to events as they are unfolding. In the days immediately prior to the shooting of this scene, the film's historical adviser, Andy Durgan, worked with individual actors on the political content of their improvisations, helping to establish the line of argument that each of the characters

might present.[16] Paul Laverty notes, however, that, although the scene's structure was established in advance, 'most of us were not told to say anything. It very much developed according to the personalities of the film.'[17] In its portrayal of the motivation behind the conflicting Republican forces, this scene is perhaps the most detailed analysis of intra-Republican politics in fictional cinema. A space is created for the presentation of conflicting positions that strive to get to the heart of the politics of the conflict. Thus, Bernard argues in relation to land reform that 'private ownership must be given up, cancelled . . . it maintains people in (a) capitalist mentality'. Pointing to the political advantages of collectivisation, Jimmy (Paul Laverty) states, 'We need to look to two million landless peasants . . . need to harness their energy.' The authority of the Spanish peasantry is added to this position when an older peasant, played by an anarchist who had fought during the civil war, interjects, 'We need to collectivise in order to keep the revolution going. The revolution is like a pregnant cow. If we don't help out, the cow and its calf will be gone and the children will be left hungry.'[18] It is a commonplace of politics that if a movement moderates its demands it will increase its support; the position of the majority of the peasants in the film, however, presents an alternative strategy when they contend that guaranteeing social reforms for the majority of workers and peasants was a viable strategy to increase Republican support. Of course, this may not have increased support from capitalist countries elsewhere in Europe, but, arguably, their fear of revolution determined that they were never going to support the Republic, as evidenced by the Non-Intervention Agreement.

Land and Freedom presents a political perspective which is sympathetic to the advocates of social revolution, specifically the POUM; for instance, during the battle scenes the camera is situated alongside the POUM militia, attempting to create narrative identification with the Marxist revolutionaries. David, however, starts out by assuming that all the anti-fascists are fighting a common foe, highlighted when he says, 'I'm not in a communist brigade, but it doesn't matter because we're all fighting the same enemy.' As the narrative develops, however, he is forced to confront the bitter conflicts within the Republican forces that culminated in what historians have termed the 'civil war within the civil war', when opposing factions of the Republican forces came into armed conflict in Barcelona in May 1937.

The nature of Republican division is highlighted by the numerous

references to the presence, or absence, of guns: the anarchist speaker at the Liverpool meeting identifies the lack of guns as a major problem; as David arrives at the POUM training camp the militia members have to train with wooden sticks; at the front Lawrence describes their weapons as 'antiques' and David comments that 'We're holding our own on the Aragon front. If only we had decent arms.' The arm wound that David suffers, the result of a backfiring rifle, is indicative of the inadequate state of the military hardware held by the POUM at the front. This is contrasted, however, with what David experiences in Barcelona, and he notes that 'the Assault Guards have guns sticking out of their arse'. The process of concentrating weaponry in the hands of what they regarded as reliable allies was part of a wider attempt by the communists to circumscribe the revolutionary left, of which Isaac Deutscher comments:

> the contradictions in which Stalin involved himself led him to conduct from the Kremlin a civil war within the Spanish Civil War . . . Stalin undertook the suppression of these unorthodox elements on the left. He made their elimination from the republic's administration a condition of the sale of Soviet munitions to its Government. He dispatched to Spain, together with military instructors, agents of his political police, experts at heresy hunting and purging, who established their own reign of terror in the ranks of the republicans. (1984: 416)

Deutscher's comments can help illuminate the sequence in which the militia discuss their forced reorganisation into the regular army. Reflecting the widespread belief that the communists played a progressive role in the war, David refuses to see the dissolution of the militia as betrayal when he states that 'The Communist Party was set up to inspire revolution – why would it want to suppress the revolution?' Although Bernard argues that 'The new army will destroy the revolutionary spirit of the people', David rejects any criticism of the communists and, in response to Blanca's suggestion that they were arresting and torturing anti-fascists, comments, 'I'll wait till I see it with my own eyes . . . All I can do is believe the party.' After his involvement in the May Day events in Barcelona, however, David has a Damascene conversion and writes to his girlfriend Kitty (Angela Clarke), 'I saw a lot of things with my own eyes . . . the party stinks kid . . . I saw good comrades snatched off the streets and executed.' His break with the communists is dramatically signified when he tears up his Communist Party of Great Britain membership card and

returns to the front to fight with his former POUM comrades, preparing the ground for the film's tragic conclusion. As Lawrence arrives with regular army soldiers to disband the unit and arrest its leaders for collaborating with the enemy, the POUM commander, Major Vidal (Marc Martínez), makes a futile attempt to challenge the nature of the charges when he asks 'What about Sietamo? Alcubierre? Lecinena? Casteas de Quisena? Tierz? Navatez? They are all places liberated by the POUM.' Despite stating the positive, if relatively marginal, role played by the POUM militia, his pleas fall on deaf ears.

Lawrence's involvement in the tragic conclusion fuelled further controversy. Stephen Schwartz argues that 'of all the contested elements in this tapestry, none is more painful and provocative than the point made by Orwell and underlined in Loach's film: that the American and other volunteers ended up as counter-revolutionary mercenaries who were used against the Spanish people'. (2000: 153–4) Writing in *The Volunteer: Journal of the Veterans of the Abraham Lincoln Brigade*, Martha Gellhorn, a reporter during the civil war, also takes issue with what she regards as the negative representation of the American character. (1996: 18) Schwartz's position clearly cannot be applied to the vast majority of International Brigaders whose role in Spain was an overwhelmingly positive one. Jeff Sawtell argues that, for those who died in the war, it is 'an insult to their memory as well as a shameful slur on all those who sacrificed much to provide financial and material support'; he suggests, moreover, that the film 'dismisses the heroic International Brigade as nothing but jack-booted stooges of Stalin'. (Sawtell, 1996) Yet International Brigades involvement was, at least in part, problematic. For instance, when POUM leader Andreu Nin was assassinated, there is evidence to suggest that ten members of the German International Brigades disguised as Nationalist soldiers staged his kidnapping, which allowed the communists to claim that German fascists had rescued him.[19]

Paul Preston, who asserts that the film is 'marginal if not perverse as an explanation of the Spanish Civil War' (2001: 9), also suggests that it 'is probably the only film that most people in the English-speaking world are likely to see on the Spanish Civil War and they have a right to greater accuracy. Ultimately, the problem lies in the fact that Loach's position is virtually identical to that of George Orwell.' (2001: 10) Preston argues that it was the Western powers' refusal to intervene which, given that the Nationalists were supported militarily by Germany and Italy, ensured a Republican

defeat. In highlighting the appeasement policies of France and the United Kingdom, Preston's position is indisputable; one question that perhaps requires an answer, however, is why did the Western powers abandon the Republic? The position of both Preston and the communists appears to flow from a belief that the Western powers had an investment in defeating the military uprising. In practice, however, they demonstrated that they regarded a Nationalist victory as less dangerous than a successful social revolution in Spain – in whatever shape or form. The suppression of the anarchists and the Trotskyists was not a simple sideshow or minor episode within the main event. On the contrary, it was a critical moment that killed off any chance of the war being transformed into a revolutionary war that may have led to a more favourable outcome. Defending the film's specific focus, Durgan suggests that 'It may be true that Loach shows only a small part of the war, but it is this part, symbolized in the suppression of the POUM, which explains exactly who was responsible for dividing the anti-fascist struggle and why the Republic lost.' (1996: 78) The final battle sequence, culminating in the shooting of Blanca, reinforces the sense of betrayal: Blanca's death[20] – a young Spanish revolutionary shot in the back by the communist-led Popular Army – is a metonymical representation of the view that the revolutionaries and the revolution were stabbed in the back by the communists.[21]

John Hill argues that 'by the 1990s, the memory of the Spanish Civil War outside had dimmed so considerably that, for young audiences in particular, the intensity of the film's anti-Stalinist message ran the risk of obscuring the anti-fascist character of the war overall'. (2011: 210) Hill suggests that, although the POUM militia are engaged with the fascist forces in the initial battle and there is a short encounter with a fascist officer, in his words 'the fascists do not appear in front of the camera'. (2011: 210) Yet, as outlined above, the fascists appear on-screen in the opening scene in which the Spanish militiaman addresses the assembled group of Liverpool workers. Indeed, the first half of the film deals mainly with the threat of fascism before moving to address how fascism could have been defeated, which inevitably involves lengthy discussion of the nature of international politics and what Loach and Allen view as the pernicious role of Stalinism.

The closing sequence historicises the action: as Blanca's body is placed in the ground, the film dissolves to David's funeral sixty years later as non-diegetic music from the civil war links the two periods. Although the film rejects the use of Brechtian distancing techniques,

8.2 *Land and Freedom/Tierra y Libertad* Blanca's death stands as representative of the betrayal of the revolutionary spirit of the civil war.

it also avoids sliding into melodrama and refuses to dwell on the emotional impacts of the deaths that occur within its narrative. As Kim, standing alongside David's former comrades, raises a clenched fist, the film suggests that through her journey into the past she has been both inspired and politicised by her grandfather's story. Thus *Land and Freedom* returns to the Spanish revolution with a clear eye on the present as it attempts to weave a red thread between past, present and future struggles. In the changed political landscape of the 1990s, the filmmakers have been accused of looking back at this past nostalgically through their wistful recollections of a long-gone time. It is not the case, however, that nostalgia is inherently conservative. E. P. Thompson argues that 'nostalgic appeals to the past can be progressive under certain circumstances'. (1968: 223) Christie argues that as Kim reads from William Morris's poem, 'Join in the Battle', 'the film's final message is defiantly optimistic. The spirit of Spain's heroic anarchists and Marxists may be dormant in the Britain of 1994, but it isn't dead.' (1995: 37) Despite retelling the story of one of the European labour movement's greatest defeats, the film is far from pessimistic.

There are, however, problems that arise when attempting to cinematically represent the complexities of the civil war. As outlined earlier, Antony Beevor suggests that when the civil war is simplified, it can become more confusing. (1999: 7) Certainly, the condensation of such detailed political processes into less than two hours of screen time leads to simplification of the events. Thus, although sympathetic to the film's politics, Porton suggests that it 'demonstrates that it is extremely difficult to transform an event as intricate and riven with contradictions into a populist epic'. (1999: 33)

Historical detail

There are details in the film that depart from the established historical record. The most substantial of these, which Durgan describes as 'the only major "distortion" of historical reality that occurs in the film', is in the sequence in which the POUM militia take the village. This would have occurred between July and September 1936, not spring 1937 as the film suggests. Moreover, in the film the militia vote to back the POUM leadership in wanting to remain a separate entity, independent of the Popular Army; in fact, Durgan points out that the former POUM militia was transformed into the 129th brigade of the 29th Division of the Popular Army in April 1937. Durgan (1996: 75) suggests, however, that 'Rather than represent a completely accurate picture of what happened, this scene serves to illustrate both the criticisms the POUM had of the new army and the democratic nature of the militia.' Loach, in suggesting that to heighten the drama it is necessary to be flexible with some of the timetable, states:

> Jim Allen and I gradually narrowed it down to what we felt was the crucial issue at the crucial time and then tried to find a way to mirror that in terms of human experience. So that determined the characters that we had. It led us to a character who joined as a member of the Communist Party. But he couldn't join as late as some of the International Brigaders because he would have then missed the moment when the Stalinists attacked the POUM. It meant that he had to join the war really very early in the days before the Communist Party started to organise and then because there wasn't any recognised route set up for him to fight through, by chance, he got involved with the POUM. So in a way it was a quite convoluted story we had to set up in order to have the conflict we wanted.[22]

The film also simplifies the nature of the conflict, even within the revolutionary left, and, by focusing on the POUM, marginalises somewhat the role played by the anarchists. Scriptwriter Jim Allen chose to focus on the POUM rather than the much larger anarchist trade union federation, the CNT, stating that

> The only man in the CNT it would have been worth writing about was Durruti: the rest, no. POUM was a highly politicised organisation. They had the theoretical tools to oppose and destroy the Communist Party. Andreu Nin, who directed POUM, an old pal of Lenin's, he was tortured and killed. Now, I wrote some scenes about that. That had to go out. I went into the political differences between them. That had to go. I

mean Trotsky hated the POUM: Trotsky said, these aren't Trotskyists. I couldn't go into any of that. Had I gone forward with every particular argument it would have been so dense, people would have walked out. I had to simplify it a lot. (quoted in Leigh, 2002: 175)[23]

Although the film simplifies the conflict, the discussion that it generated is testimony to the way that cinema can influence contemporary political debates. One of the most important pieces of political filmmaking of the twentieth century, *Land and Freedom* represents an important step in cinematically representing a neglected part of labour movement history. The problems of interpreting the complex historical detail of the Spanish Civil War does highlight the difficulties of representing complex events cinematically; nevertheless, the film's success is testimony to the way that social realist cinema can be utilised to represent historical events and, in the process, help shape contemporary understandings of the past. It is the most successful of the Loach/Allen collaborations, an undoubted high point in Loach's five-decade-long career in film and television, and a significant milestone in the cinematic portrayal of the Spanish Civil War.

Notes

1 For an account of the civil war's revolutionary dimensions which was first published in 1938 see Morrow (1976).
2 Loach and Allen had conducted initial work on a film about the Irish War of Independence and the subsequent civil war (1919–23). However, it was never realised. Following Allen's death in 1999, Loach and Laverty did bring the project to fruition with the release of *The Wind that Shakes the Barley* in 2006.
3 A similar strategy is employed in *Carla's Song* (Loach, UK/Spain/Germany, 1996), in which George (Robert Carlyle), a Glaswegian bus driver, meets and falls in love with Carla (Oyanka Cabezas), a Nicaraguan refugee. George subsequently travels to Nicaragua with Carla and through his eyes the audience is introduced to the political complexities of the Nicaraguan civil war in the mid-1980s.
4 The influence of an experimental, even modernist, aesthetic is brought to the film by Trevor Griffiths's script.
5 In an extra-textual reference rare in Loach films, scriptwriter Jim Allen is highlighted as the author of one of the articles from a trade union publication, *The Miner*: Allen was a former coal-miner.
6 The film's producer, Rebecca O'Brien, informed the author that story editor Roger Smith (a long-term collaborative partner with Loach)

described the handful of earth as equivalent to the use of the snow globe in *Citizen Kane* (Welles, USA, 1941), although in *Land and Freedom* the 'meaning' of the handful of earth is rather less ambiguous than in *Citizen Kane*.

7 A notable exception, the slow-motion sequence in which Blanca is shot seems almost out of place in a Loach film.

8 Interview with author, partially published as 'Match Made in Heaven', *Sunday Herald*, 29 September 2002.

9 These debates have been well-rehearsed elsewhere: see Caughie (2000: 88–124) for an excellent overview.

10 Interview with author, 2002.

11 Loach's approach can be contrasted with that of Eisenstein who argued that his theory of montage represented a cinematic embodiment of Marxist dialectics.

12 Interview with author, 2002.

13 On his return to England, Orwell initially struggled to find a publisher for his account because of his sharp criticisms of the Republican leaders in general and his scathing criticisms of the communists' role, which no doubt fuelled his idea that the revolution was being concealed. (Coppard and Crick, 1984: 14)

14 For a history of the POUM see Alba and Schwartz (1988).

15 Quoted in *Land and Freedom* production notes, Parallax Pictures, London, 1995.

16 Interview with author, May 2001.

17 Interview with author, April 2000. All subsequent quotes from Laverty are taken from this interview.

18 Although these lines certainly sound like a perfectly scripted simile, Laverty informed me that the old anarchist who spoke them had improvised them on the day.

19 The Catalan-language television documentary *Operació Nikolai/Operation Nikolai*, (TV3, 1992) deals in detail with the kidnapping and murder of Nin.

20 It is notable that the female characters who feature as a central part of the narrative in *¡Ay Carmela!* and *The Devil's Backbone* also die at the end of the films. These individual female characters represent not only themselves, but also stand as metonymical representations of Spain or, in Blanca's case, the revolution.

21 This sequence also illustrates Loach's propensity to withhold information from his actors in an attempt to create a natural response; for instance, the actors were unaware of the planned death of Blanca until the day of the shoot. Paul Laverty states that 'We had no idea what was going to happen at the end so when we saw these people coming down we thought "What the fuck's going on here?" When Blanca was shot none of us knew

and so when it first happened we were all really, really gob-smacked.'
Interview with author, 2000.

22 For background to the development of the finished script see Leigh (2002:
68–9).

23 For a full analysis of Trotsky's position on the POUM and his wider per-
spective on this period see *The Spanish Revolution (1931–39).* (Trotsky,
1998: 306–26)

9

The search for truth in *Soldados de Salamina/Soldiers of Salamina*

Every time you asked about something that happened before that year [1939] the adults would put a finger to their lips and look from side to side. We were a people without a past, without memories. Neither did the present of those days . . . offer much attraction. It was necessary to look to the future. A future that, in the end, never arrived, however much they concealed the past.

Carles Santacana i Torres (quoted in Richards, 2006: 170)

Soldados de Salamina, an adaptation of Javier Cercas's 2001 best-selling novel, calls into question the ability to rediscover and represent the past.[1] Predominantly set in Gerona in the present, Spain's 2004 Academy Awards foreign-language category entry centres on Lola Cercas (Ariadna Gil), a journalist and writer who attempts to uncover the details of the execution of approximately fifty Nationalist prisoners and the escape of one of their group, the real-life writer and fascist ideologue Rafael Sánchez Mazas (Ramón Fontserè).[2] Through an analysis of the film's content and form, this chapter again revisits the theoretical questions concerning problems of historical representation first raised in the introduction. In doing so, I suggest that *Soldados de Salamina* questions the possibility of constructing totalising narratives about the past, promoting in its place a more subjective approach to representations of the past.

The search for the past

Although *Soldados de Salamina* locates its central narrative thread in 2002, extensive employment of flashbacks to 1939 brings the conflict very much into the twenty-first century. The film's opening image is of a tattered Spanish flag lying in the mud. The subsequent

sequence, intercut continually with black-and white credits, consists of a lengthy following shot across a barely colourised mass of mud-splattered male corpses lying motionless in a field. Over Arvo Pärt's melancholic soundtrack can be heard the buzzing sound of flies hovering around the putrescent bodies of what are subsequently revealed to be the executed Nationalists. The film form utilised in the opening sequence signifies a dark, murky past represented through pale, near-monochromatic photography. The film switches to the present and introduces Lola, a young woman suffering writer's block since the success of her debut novel who supports herself by teaching literature and by feature writing. When a newspaper editor commissions her to write an article on the civil war, Lola, after initially expressing little interest, finds herself on an investigative journey to uncover the hidden story behind the mass execution. Her initial focus lies in establishing the nature of Sánchez Mazas' escape, before this switches to the Republican soldier who had discovered Sánchez Mazas hiding in the forest but allowed him to flee. One of the film's central concerns is to explore the extent to which this past can become comprehensible after three imbricating factors: the passage of time (over sixty years), the silence imposed under the Franco dictatorship (*tiempo de silencio*) and the pact of forgetting (*pacto del olvido*) during the transition from dictatorship to democracy.

Lola's initial disregard for this historical period is signified when, as the newspaper editor commissions the feature, she responds 'Not the civil war again'.[3] On a visit to the library to commence her research, however, her interest is piqued when she accidentally discovers a photograph of the Republican-supporting writer Antonio Machado between the pages of a book. By the time that she narrates the finished article, entitled 'An Essential Secret', to her senile father, she appears engrossed. Briefly touching on the theme of *Cainismo*, the article begins by discussing two writers, Antonio Machado and his fascist-sympathising brother, Manuel. Actuality footage of the conflict is then shown as Lola proceeds to recount the experience of another real-life writer, the lesser-known poet and former minister under Franco Rafael Sánchez Mazas. A principal founder and theoretician of Spain's fascist party, Española de las Juntas de Ofensiva Nacional/Spanish Phalanx of the Assemblies of the National Syndicalist Offensive, known popularly as the Falange, Sánchez Mazas was arrested in Barcelona in 1938 and scheduled to be executed along with fifty prominent Nationalists as the Republican-held city was set to fall to

Franco's advancing forces in January 1939. The actuality footage is followed by reconstructed black-and-white footage of Sánchez Mazas, or, more accurately, Fontserè, the actor playing him, accompanied by Pärt's lugubrious, repetitive piano and violin music. A sepia-filtered flashback shows Sánchez Mazas escaping only to be sighted later as he takes refuge in a hollow by a young Republican soldier (Alberto Ferreiro), who refuses either to shoot or capture his prey. It then shows the Friends of the Forest, three Republican deserters, assisting Sánchez Mazas in return for a promise of reciprocal assistance after the conflict's conclusion. The film's central concerns are suggested in the article's closing words: 'Who knows what exactly happened on the day when Rafael Sánchez Mazas was due to be shot – but perhaps there lies the essential secret of the Spanish Civil War.' Lola's newly discovered interest in the past is not, however, shared by her dementia-ridden father (Luis Cuenca). Although she later uncovers a photograph indicating that he was a civil war combatant, when she narrates the article to him he responds blankly, 'What war?' If her father's dementia is symbolic of how previous generations turned their back on the past, either under duress during the *tiempo de silencio* or voluntarily during the *pacto del olvido*, Lola's interest is representative of how subsequent generations have turned their attention to the conflict's history in increasing number.

The article is the starting point for Lola's search and she becomes increasingly focused on establishing the 'essential truth' of this specific episode, hoping that discovering the truth of the particular will illuminate the truth of the general. Her methodological approach is contrasted with that of her friend, Conchi (María Botto), who predicts the future by reading Tarot cards and states 'They always tell the truth. It's knowing how to read them.' Conchi's stage name, Cassandra, invokes the Greek prophetess's abilities, but also the disbelief with which her prophecies were received. Lola attempts a more scientific and objective approach, placing her trust in empirical evidence, perhaps believing that evidence will also tell the truth if one knows how to read it. An investigative journalist on a desperate hunt for the full story, or 'what exactly happened', Lola's actions mirror those of the historian; locating primary and secondary sources from libraries and second-hand bookshops, uncovering old newspapers and, finally, discovering the diary Sánchez Mazas had kept during his escape. The diary enables Lola to reconstruct Sánchez Mazas' journey and, as she retraces his footsteps, temporal shifts between

9.1 *Soldados de Salamina/Soldiers of Salamina* Lola reads her article to her senile father in hospital, his senility being suggestive of the *pacto del olvido*.

past and present create a parallel movement between the fascist's frantic journey and Lola's re-enactment of it. For instance, as Lola visits the Monastery of Santa Maria del Collell, which held the fascist prisoners prior to their execution, a flashback to Sánchez Mazas in the same space occurs. Similarly, as she visits the roof where a priest administers the prisoners' Last Rites, the original event is shown in flashback. Footage of the mass execution, and Sánchez Mazas' subsequent escape through a forest, is followed by hand-held shots of Lola in the same forest, battling foliage and dodging local hunters' stray rifle-fire. As her journey continues, further parallels emerge when she documents her search in a notebook, as the fascist ideologue had done in his diary, second-guessing his movements as he attempted to flee Republican territory and return to the safety of the Nationalist zone. In one scene in the forest, parallel editing even appears to reveal Lola catching sight of a desperate man fleeing for cover, as if to suggest that the gap between past and present is literally closing as she homes in on the truth of the event.[4] Throughout these sequences, narrative identification switches between Lola and the escaping fascist and Arthur J. Hughes suggests that 'Sánchez Mazas, for all that he represents the victorious but currently discredited faction of the Civil War, is transformed into a kind of hero, albeit more of an anti-hero.' (2007: 384)[5] The main focus, however, remains on Lola.

The empirical evidence that she uncovers partially assists Lola's attempts to discover the event's details. The key that seemingly unlocks the door to the past, however, lies in the personal testimonies she receives from old men who were either witnesses to the events or related to those who had been, thereby creating real-life continuity between past and present. She still lacks, however, the central witness

she needs, the young soldier himself. Her friendship with one of her students, a young Mexican called Gastón (Diego Luna), appears to open up a potentially fruitful avenue to pursue. It is noteworthy that Lola's thirst for historical knowledge is matched by Gastón who is also attempting to locate the personal history of his grandfather, a civil war refugee from Alkiza in the Basque country. When Gastón recounts tales of his hero, Miralles (Joan Dalmau), a former Republican soldier who he befriended on holiday, Lola connects the stories and concludes that Miralles is the soldier that she needs to complete her jigsaw – and to complete her book. To help her fulfil her literary ambitions, Gastón suggests that Lola does not require the exact details of the event, commenting that 'Reality always disappoints. What you're looking for is here,' as he softly touches her head. Lola's prioritisation of the real over the fictional is indicated when she responds: 'I will not make him up.' This exchange is indicative of a wider tension in the film between truth and fiction: by advising her that she does not need a real-life Miralles, Gastón is suggesting that her writing has no need to access 'reality', at least in its entirety. Lola, however, refuses to surrender the possibility of producing referential accounts of the past as she pursues her new lead with renewed commitment.

I need a hero

Lola narrativises her search into the past as a search for heroes. In Miralles she thinks she has discovered one of a dying breed; a man who fought for the Republic, for the Free French in North Africa, and then against Nazi Germany in Normandy during the Second World War. Her romanticised narrative does not, however, appear to correlate with the evidence she encounters when she first meets Miralles – an old man, crumpled and scarred, living out his final years in a nursing home watching television, surreptitiously smoking cigarettes and contemplating opportunities to pinch his nurse's backside. In a tight shot–reverse shot sequence, Miralles questions her approach: 'Writers. You're just sentimentalists. What you're looking for is a hero and I'm that hero, aren't I?' Miralles rejects his own heroic status, offering in his place the young men from his village who perished during the civil war, their names and actions obliterated from official history and surviving solely in individual memories. It is a tender and poignant moment which effectively switches the narrative focus from either Sánchez Mazas or the young soldier to embrace the memory of

the countless nameless young men who died fighting in the conflict. By resurrecting their memory, the film juxtaposes Lola's desire – and by extension, mainstream cinema's desire – for heroic figures with war's mundane, deadly, often anonymous reality.[6] This encounter also disrupts Lola's preconceived narrative and her attempt to uncover the truth of the event. In the closing moments, Lola asks Miralles directly 'It was you wasn't it?' The old man responds, 'No'. But his denial is couched in uncertainty and whether he is indeed the hero that she desperately seeks remains unresolved for both Lola and the audience.[7] She, and we, are forced to contend with the fact that her empirical search to uncover both her hero and the event's precise details is unsuccessful. Yet this lack of success will not prevent her from disseminating the information that she has uncovered. In an earlier scene, Lola and Concha are watching the television news in Lola's home when a newsreader says of a young man killed rescuing people from a fire, 'Heroes are only rewarded by the memory of others, of those who admire their courage, their instinct to act at decisive times.' As Lola leaves Miralles' nursing home in a taxi, she indicates a desire to preserve his memory when, in a close-up, she turns to look back on him and says 'I won't forget you. I won't forget you. I won't forget you.' Her following words, 'I won't let them forget you', suggest, moreover, a collective rather than individual approach.

Truth

Lola's inability to uncover all the evidence in the Sánchez Mazas case highlights some of the difficulties in attempting to represent the past. Her decision to start work on a new book in the concluding scenes, however, indicates that although her search does not finish with her accessing the absolute truth of even this one small episode, that does not prevent her from constructing narratives about the past. It does, however, have a significant bearing on the book that she will write. Earlier Concha is critical of Lola's first literary attempt to recount the Sánchez Mazas story, commenting 'It didn't move me', and she offers her the following advice: 'Learn to bare yourself in the novel that you are writing.'[8] In the closing sequence, Lola appears to heed Concha's advice as she commences writing a first-person, subjective account of her experience, one which collapses the gap between past and present. Lola's attempts to write her account invite parallels with the historian's attempt to write objective accounts of the past. Her lack of

empirical evidence, however, imposes limits on the type of book that she can create. Her account suggests that all that can be accessed are subjective truths about the past, reflective of a more generalised approach towards truth, a debate that I touched on in the introduction. Of this debate, Eagleton suggests that the possibility of stating an absolute truth has become increasingly maligned and he notes that 'No idea is more unpopular with contemporary cultural theory than that of absolute truth. The phrase smacks of dogmatism, authoritarianism, a belief in the timeless and universal.' (2003: 103) Eagleton, however, proceeds to reject the notion that absolute truth is what he describes as 'a special kind of truth'. (2003: 103) For Eagleton 'That truth is absolute simply means that if something is established as true – a taxing, messy business, often enough, and one which is always open to revision – then there are no two ways about it. It does not mean that truth can only be discovered from some disinterested viewpoint.' (2003: 106) For Eagleton, therefore, it is possible to assert truths about the past without laying claim to the idea of a totally objective, all-seeing, all-pervasive truth. As I outlined in the introduction, the conflicting accounts of the bombing of Guernica illustrate that debates concerning representations of the past and the possibility of making truth claims about the past are not simply theoretical. As Marx argues in his 'Theses on Feuerbach' (1980: 28), 'The question whether objective truth can be attributed to human thinking is not a question of theory but is a practical question. In practice, man must prove the truth, that is, the reality and power, the this-sidedness of his thinking. The dispute over the reality or non-reality of thinking which is isolated from practice is a purely scholastic question.' Thus the separation between theory and practice is a false one: it is the application of theoretical models to specific historical events that illuminate their validity, or otherwise.

Cercas states of his novel: 'I hope it's contributed with its grain of sand to this facing up to the truth, because my aspiration was to lie anecdotally, in the particulars, in order to tell an essential truth.' (Cercas and Trueba, 2003) Significantly, Cercas never clarifies what he perceives the civil war's essential truth to be. Responding to the question of what he regards as the conflict's essential secret, David Trueba suggests that 'It's something that comes from the novel. For our generation it is very difficult to understand how a country divided in two sides in a so strong and cruel way. So, after the politics, the ideological explanation and the history books, it has to be something

that speaks about the persons in a very private way, something different than the two Spains, the classical dichotomy.'⁹ Like Cercas, Trueba is somewhat elusive in his response and, although both the novel and its adaptation suggest the possibility of an essential history, a history that would close down possible interpretations of the past, by problematising the search for the past *Soldados de Salamina*, both the novel and its cinematic adaptation, work to open up the past to a multitude of interpretations, a feature that is reflected in their distinct formal qualities.

Experimental cinema

As I outlined in the introduction, Rosenstone champions an experimental cinema which, rather than attempting to operate as a window onto the past, encourages audiences to think differently about the past. Hayden White echoes this position in his promoting of a cinematic practice that collapses the distinction between the real and the imaginary. By utilising a variety of film forms, *Soldados de Salamina* veers towards this effect and the line between reality and fiction becomes increasingly difficult to distinguish. In addition to the fictional footage of the present (2002) and the civil war (1936–39), the film includes footage of a real historical event with Franco present on to which images of Fontserè are superimposed, a montage of black-and-white photographs of the civil war, French- and Spanish-language black-and-white actuality footage of the conflict (including excerpts which also feature in *The Spanish Earth*) and colour television footage of Lieutenant-Colonel Antonio Tejero's attempted right-wing *coup d'état* in the Spanish Parliament in February 1981. The film also contains fictional copies of the Spanish newspaper *ABC*, reconstructed black-and-white footage of Sánchez Mazas in captivity, radio reports rendered to sound of the period, Internet video footage of Lola's newspaper editor as he commissions the feature, and reconstructed 8mm colour film footage of Gastón's holidays, which includes shots of Miralles. This collage of film and media forms effectively blurs the line between 'fact' and 'fiction', between the 'real' and the 'reconstructed' or 're-presented'. This process is also evident in the opening credits, which state that the film is based on Cercas's novel, but also on the real-life testimonies of Joaquín Figueras, Daniel Angelats and Jaume Figueras. These real-life witnesses also appear on screen to provide Catalan-language oral testimonies of their recollection of the

events. Sánchez Mazas' real-life son, Chicho Sánchez Ferlosio, is also interviewed, at once developing a higher degree of authenticity for the film and blurring further the line between fact and fiction.[10] However, it is not immediately clear what role these witnesses play. Are they fictional characters performing lines from a script, or fictional characters speaking real testimonies? Or if they are real characters, are they speaking fictional lines or speaking their own testimonies? It is the latter of these four options that appears to be the case, but it is not immediately self-evident. The witnesses' inclusion operates self-reflexively, inviting reflection on the film's constructedness, obfuscating the line between fact and fiction, and between traditional feature film production and documentary cinema.

The film's self-reflexivity is reinforced further by numerous literary references; for example, when Lola hears the details of Sánchez Mazas' escape she says, 'Surviving that and then hiding in the forest, it's like something out of a novel.' As Richard Porton correctly observes in relation to Spanish Civil War literature, while the novels of Hemingway or Malraux are well remembered, 'only a few desultory remarks by Evelyn Waugh and Ezra Pound in support of Franco can be cited as memorable examples of pro-fascist sentiment among distinguished members of the intelligentsia'. (1996: 32) Referring to this process, Lola writes of Sánchez Mazas 'he may have won the war, he lost the history of literature'. Another notable reference to fiction is made when Miralles reveals that his literary tastes lie with the nineteenth-century novel, particularly the work of Honoré de Balzac. Balzac's work was the basis for the development of a strand of realist aesthetics in the latter part of the nineteenth century and, although Balzac stood on the right politically, he was praised highly by Marx and Engels. Marx had planned to write a study of Balzac's works (Marx and Engels, 1984: 439) and Engels stated that he had learned more from Balzac than 'from all the professed historians, economists and statisticians of the period together'. (Marx and Engels, 1984: 91) However, whereas the nineteenth-century realist novel tended to utilise fictional characters within established historical events, thus grounding the fictional within the real, *Soldados de Salamina*, despite the inclusion of real-life material, creates a more fractured, slippery past. This is further evidenced by the focus on numerous written forms including Lola's newspaper article with its specific focus on writers; the books that Lola uncovers in the library and the one she is given by Aguirre, a man who supports her campaign to unearth the

truth and who contacts her via letter; Lola's novel, and her writer's block; Concha's Tarot cards; Sánchez Mazas' diary; and the postcard that Miralles sends from his home to the holiday camp that Lola uncovers.

Trueba suggests that the most significant feature of the film's literary antecedent is that the central character and the novelist are both called Cercas. (Cercas and Trueba, 2003)[11] There is, however, an important formal narrative difference between the novel and its cinematic adaptation. In Cercas's novel, which reads as a true-life account, the author is placed directly in the 'story' and the narrator's search (in the novel the narrator is a journalist called Javier Cercas) through the past becomes an individual quest for the reclamation of historical memory. In the novel, moreover, the narrator is present from the opening page, whereas in the film adaptation, the possibility of a narrator emerging only appears in the final scene as Lola begins to write her book.[12] As with the novel, the film's main focus is on the central protagonist's journey from frustrated writer struggling to find a voice to one able to embark on her next project. Lola's writer's block is cured by her journey into the past, but only when she allows herself the freedom to write a subjective, personalised account, one that reflects both on the past and its literary representation in the present. The opening lines reflect her own stake in the project when she writes, 'The first time I heard of Sánchez Mazas and the firing squad I was just . . .' As she travels back on the bus to Gerona she has put one journey behind her, a journey towards discovering the past, and begins another journey into the future. Thus Hughes notes that, although she fails to uncover the civil war's 'essential secret', 'the process leads her to examine the different forms of memory discourses with regard to the trauma of the Civil War, and to enable the creation of an identity position that bridges the gap between the past and the present'. (2007: 371) Arguably, then, the main event of the film version of *Soldados de Salamina* is Lola's discovery that she need not know everything about the past in order to represent it in literature. This is the point that allows the film an element of narrative closure, but in tandem with this is the assertion that the past is perhaps too distant and complex for us to really comprehend exactly what happened there. The film concludes with a sense of uncertainty as to the exact nature of the events that Lola has been investigating.[13] She has been unable to recover the past but strives, nevertheless, to conjure up the ghosts of the civil war.

Memory

To those who ask the question 'What is the use of history?' Arthur
Marwick writes that 'the crispest and most enlightening reply is to
suggest that they try to imagine what everyday life would be like in a
society in which no one knew any history'. (1970: 13) The enforced
silence and the *pacto del olvido* denied those who opposed Franco
knowledge of their own history and experience. Of this process Cercas
suggests

> The Transition was, effectively, a sort of pact of forgetting, but it wasn't
> a Machiavellian pact. The politicians didn't sit down and agree: 'We're
> going to obliterate this. No talking about the past allowed, no talking
> about the war. There were no victors and no vanquished.' No, it was
> more subtle than that. It was an implicit pact, to which, don't forget, we
> all signed up. Especially the young people; we said to ourselves: 'Let's
> forget all that, it was filthy and repugnant; let's look to the future. We're
> post-modern, we're the Spain of Almodóvar, we're cool. We're not the
> nation of goatherds we used to be.' The price of this isn't exactly obliv-
> ion; it's elusive: it's that fog of mistakes, misunderstandings, half-truths
> and simple lies that floats over the Civil War and the immediate postwar
> period. (Cercas and Trueba, 2003)

The *pacto del olvido* is increasingly breaking down, as exemplified by
the growing number of civil war films and the extent of the debates
taking place in Spain around the Law of Historical Memory. This
process is evident in the scene where Lola calls to speak with Miralles
in his nursing home. When she outlines the nature of her visit, the old
man, now eighty-six, says to her 'And you really think that anybody
will be interested in what happened sixty years ago?' For Miralles, the
civil war is from a dim and distant age; thus he describes the events
surrounding the executions as 'a murder from 1000 years ago'.
Referring to the *pacto del olvido*, he says 'Years ago people decided that
it was best to forget the war. That's fine by me.' As the conversation
continues, however, Miralles contradicts his earlier stated desire to
forget, and speaks movingly of how he remembers his young com-
rades and with bitterness about how they have been forgotten:

> It's the heroes who don't survive. When I left for the front a lot of other
> lads went too, all from Tarrasa like me. Though I didn't know most
> of them. The García Sugués boys, Miquel Cardós, Gabi Baldrich, Pipo
> Canal, Fatty Odena, Santi Brugada, Jordi Gudaayol. All dead. They
> were all so young. Not a day passes without me thinking about them

. . . Sometimes I dream of them. I see them as they were. Young. Time doesn't pass for them. Nobody remembers them. And never . . . not one miserable street of one miserable village in one shitty country will be named after them.

Inspired by their meeting, in the closing scenes, as Lola starts writing her novel, she embarks on a process of actively remembering the past. As Hughes notes: 'Lola filmically becomes the repository of the auto-biographical memory that her father has lost, a symbolic recovery of the collective memory that is never entirely individual in nature.' (2007: 378) Although Lola's novel is a subjective account, the task she lays out is part of a process of collective remembering.

Memory is a crucial part of the process of historical recupera-tion. David Lowenthal suggests that 'Memory and history are pro-cesses of insight; each involves components of the other, and their boundaries are shadowy. Yet memory and history are normally and justifiably distinguished: memory is inescapable and prima-facie indubitable; history is contingent and empirically trustable.' (1985: 187) Lowenthal obviously does not share White's epistemological doubts concerning historiography, but he points to the collective nature of memory when he states that

we need other people's memories both to confirm our own and to give them endurance. Unlike dreams, which are wholly private, memories are continually supplemented by those of others. Sharing and validating memories sharpens them and promotes their recall; events we alone know about are less certainly, less easily evoked. In the process of knit-ting our own discontinuous recollections into narratives, we revise personal components to fit the collectively remembered past, and gradu-ally cease to distinguish between them. (Lowenthal, 1985: 196)

As mentioned previously, Miralles says of his young comrades, 'Sometimes I dream of them.' For Miralles the enforced silence and the *pacto del olvido* have forced his memories into the individual realm of dreams and denied him access to a public space where his memories can be discussed and shared. But his meeting with Lola opens up the possibility of actively remembering the civil war as part of a wider collective process of recuperating historical knowledge from this period. Hughes suggests that 'Given that an objective representation of trauma is almost oxymoronic, the cause–effect structure of history reveals its inadequacy to make sense of such catastrophes; it is left to memory that goes beyond the logical, extracting clues from spaces,

objects, monuments, and people.' (2007: 386) Yet perhaps this establishes a false dichotomy between memory and history. As Joanna Bourke notes: 'History and memory are not detached narrative structures; at no time was history "spontaneous" or "organic"; at no time has history been able to repudiate its debt to memory and its function in moulding that memory.' (2004: 485) The necessity of documenting individual memories to wider Spanish Civil War historiography is evident in Ronald Fraser's landmark oral history of the conflict, *Blood of Spain: The Experience of Civil War 1936–1939*, in which Fraser outlines that his aim

> was not to write another history of the civil war but a book about how people lived that war. It was their truth I wished to record. And what people thought – or what they thought they thought – also constitutes an historical fact. Inevitably memories of thirty-five and forty years past have been 'worked over' in the intervening years; but much less, I am convinced, than might have been the case in other circumstances. This is due, first, to the nature of the war itself; secondly to the political immobilism imposed by the victors in the post-war years and, lastly, to the fact that many of the participants were very young. Memories have 'frozen' as a result . . . because of the need to make a coherent totality, it may seem as though this book is saying: this is 'how it was'. But no. This is how it is remembered as being. (1988: 32)

Jo Labanyi (2008: 112) argues that 'While memory does not give us reliable information about what happened in the past, it does record experiences that are mostly absent from official documents and, above all, it can play a central role in historical understanding by allowing us precisely to see how the past affects the present.'[14] Moreover, for generations growing up with no direct access to memories of the conflict, the increasing representation of the civil war in cinema can help create a turn to history by Spanish audiences. The release of *Soldados de Salamina* coincided with initial moves to uncover the mass graves which held the bodies of the civil war dead, a movement which has grown and developed since. Trueba argues that 'The public debate in Spain continues the ideological patterns that concurred in the war. We don't have a mature democracy because we didn't break with the Franco years.'[15] *Soldados de Salamina* is an important contribution to that debate.

A number of the films that I have discussed in this book, perhaps most notably *For Whom the Bell Tolls*, *Five Cartridges* and *Land and Freedom*, tend to close down possible interpretations of the past,

9.2 *Soldados de Salamina/Soldiers of Salamina* At the film's conclusion the young Republican soldier dances and sings before turning his back to the camera.

narrativising the Spanish Civil War for explicitly political purposes. *Soldados de Salamina*, however, opens up the conflict, presenting the past as a complex space where we do not always find what we expect to find. It represents the civil war as far from black and white or easily accessible, suggesting that the conflict is part of a murky history that is difficult, if not impossible, to recover. It suggests, moreover, that it although it may not be possible, or even desirable, to create totalising narratives about the Spanish Civil War, this should not prevent us from constructing any narratives at all. Lola's attitude in the film's concluding scenes indicates that the partial, subjective truths that can be constructed are of considerable value and that her journey has been worthwhile. Miralles' words have raised the ghosts of the countless anonymous young men from the civil war and, in the process, demands that they be remembered. The closing sequence consists of a slow-motion flashback to the young Republican soldier who saved Sánchez Mazas' life; he dances slowly in the rain to the accompanying melancholic rendering of the *pasadoble* 'Suspiros de España/Sighs of Spain'. The film concludes with a mid-shot of the rain-drenched soldier looking directly at the camera, pausing briefly before he turns his back to the screen: *Soldados de Salamina* invites the audience not to turn away from his memory, but to embrace it.[16]

Notes

1 More information about the film is available at www.soldadosdesala mina.com.

2 In contrast to the way in which the Republican dead have been largely

forgotten, the film highlights that there is a street in Bilbao named after Sánchez Mazas in addition to the memorial to the executed Nationalists.

3 Lola's retort creates an intertextual link with Gil's previous role as the nun-turned-anarchist in *Libertarias*, discussed in chapter five.

4 In relation to the scene where Lola finds herself in the line of fire Hughes argues: 'While much of the synchronicity of past and present is achieved through montage and sound effects, their juxtaposition implies that the past events do get repeated and memory is vital in avoiding and learning from the mistakes of the past.' (2007: 383–4)

5 Hughes notes that his status as an anti-hero is developed by the contrast with the character of Miralles who emerges later in the film. The same point is also made by Mercedes M. Camino (2007: 98), although she stresses that 'far from looking at both sides of the war under the same light, Trueba and Cercas can intimate each side's common humanity'.

6 Near the beginning of the film, Lola watches television footage of what appears to be a mass funeral in Palestine, presumably of a Palestinian fighter or a victim of the Israeli armed forces. It is slightly tenuous, but it appears to connect those who gave their lives fighting fascism with those who died fighting for a Palestinian state.

7 Significantly, in the closing credits the soldier who spared Sánchez Mazas is not named as a young Miralles but as a 'Republican militiaman', thus fuelling further the uncertainty over whether Miralles is indeed the young soldier that Lola searches for.

8 In contrast to Concha's lack of emotional involvement with Lola's book, she becomes noticeably upset when she watches a television news report later in the film, her responses suggesting that images are more likely to engender an emotional response than the written word.

9 Interview with author, 2006.

10 It is noteworthy that Chicho Sánchez Ferlosio rebelled against his rightwing upbringing, and following initial involvement with the Spanish Communist Party he became a supporter of the anarchist CNT.

11 It is, of course, a truism to assert that fiction films are not about any particular historical event, but about how individual characters behave or operate within these events. I have attempted to outline, however, that the setting is far from incidental. In that sense both film and book are very much 'about' the Spanish Civil War.

12 On the decision to alter the gender of the central protagonist Trueba states, 'I think I've seen already enough male writers in crisis, and I wanted a woman alone in the forest and asking questions about a war, usually a thing for the men.' (interview with author, 2006)

13 It is noteworthy that a number of narrative threads which would normally be resolved in mainstream cinema are left untied; for instance,

towards the film's end, Lola has an argument with Conchi, but the pair are not reconciled by the end as one might expect.

14 Labanyi (2008: 122) notes that the term 'historical recuperation' suggests that 'the past lies buried in some kind of time-capsule, waiting to be brought to light like the material remains interred in the mass graves currently being excavated'. In its place she argues for the use of the term 'historical memory', which, she argues, 'has come to be used concretely in relation to those forms of memory work that take place in transitional justice contexts'.

15 Interview with author, 2006.

16 When I commented to Trueba that my experience of teaching this film to students was that they tend to take the view that it is a neutral response to the conflict, he responded: 'I don't want to be a judge when I film. I write an article on politics every Sunday in *El periodico de Catalunya*. I use that to express my ideas, political concerns and expectations. I use my fiction to create fiction. Maybe the film doesn't take sides, but I think it is clear the side you want to be on after seeing the film. At least it is clear for me.' (interview with author, 2006)

Conclusion

In exploring representations of the Spanish Civil War, this book has highlighted the elasticity of cinematic depictions of one historical event. Even though the book has focused on fictional films sympathetic to the Republican side, it has shown the extent to which this historical event accommodates varying political positions in numerous cinematic forms, from Hollywood's attempt to support the US's role in the Second World War through its adaptation of Hemingway's *For Whom the Bell Tolls* to, on the other side of the Iron Curtain, the assistance given to East Germany's communist leaders in their valorisation of the International Brigades' role in the conflict in *Five Cartridges*. While these chapters focused on films that represented the conflict in a manner consistent with their respective dominant national interests, the discussion on Fernando Arrabal's Surrealist-inspired films highlighted cinema's suitability for representing alternative, very personalised responses to traumatic histories, both personal and political. The book also outlines how the civil war has, in more recent years, provided rich material for filmmakers to narrativise the conflict in order both to make more general points about the historical process and to propagate contemporary concerns. This is exemplified by *Vacas*, which posits history as a cyclical process and invites reflection on the Basque country's ongoing conflict, and also by *The Devil's Backbone*, which, while not sharing *Vacas*'s Basque setting, does share its determinist, cyclical view of history. In contrast, *Land and Freedom*, in which the filmmakers revisit revolutionary Spain in an attempt to resurrect socialist ideas, presents a 'history as class struggle' approach to historical thinking in keeping with the Marxist view espoused by the filmmakers. The book has also pointed to the changing nature of representations inside Spain, exploring how filmmakers such as

Carlos Saura attempted to circumnavigate government censors under the dictatorship, producing highly memorable poetic critiques of the civil war's victors, and how Saura and other oppositional filmmakers utilised comic elements in their cinematic depictions of the civil war in the years following the dictatorship's demise. In spite of highlighting this elasticity, however, the book suggests that the past is not as promiscuous as Keith Jenkins and others suggest. This emerges most clearly in the chapter on comedy, which argues that there are referential limits on what histories can be legitimately written or depicted cinematically; thus, at least at the time of writing, there remain no films set during the civil war that conclude happily.

The truth of the past?

Gerard Brenan declined Raymond Carr's invitation to write a volume on Spain in *The Oxford History of Europe*, stating: 'You can't get at the truth by history: you can only get at it through novels.' (cited in Hopkins, 1998: xiii) Is it possible, then, to establish how much truth about the Spanish Civil War can be accessed through cinema? Perhaps we can only say that the films under discussion here contain their own limited, subjective or poetic truths; thus in the analysis of *Soldados de Salamina*, this book suggests that the civil war's labyrinthine complexity can be appropriated to problematise the possibility of accessing the truth of the past in its totality. Although fictional cinema is regarded as being in a privileged position to prioritise the affective experience of the past, it also comes up against historiography's referential yardstick. However, to think primarily in terms of fidelity to the historical referent can be limiting and often results in internecine squabbles about historical detail. As I outlined in the discussion of *Land and Freedom*, it is possible to defend films which depart from the established historical record in order to dramatise what they see as broader political points. The discussion, then, moves from the realm of historiography into the world of politics: whether one regards it as legitimate to criticise *For Whom the Bell Tolls* for appropriating the civil war to suit wartime America will, perhaps, depend on one's attitude to the war itself.

All of the films in the nine case studies presented here provide a way into thinking about the Spanish Civil War. They may not all contain the central political analyses of the Spanish documentaries of the 1970s, nor be the experimental self-reflexive modernist texts that

Rosenstone or White promote; however, in their own way, they each have points to make, both about the civil war and about broader political and historical issues. Although I sympathise with Rosenstone and White when they argue that an experimental film practice is best suited to force reflection on the historical process, I do not accept that realism is, as they postulate, an inadequate form of historical representation, as exemplified by my defence of the film form utilised by the filmmakers in *Land and Freedom*.

That the civil war increasingly attracts cinematic attention suggests unease over a past that has not been settled. In *One Hundred Years of Solitude* the Colombian novelist Gabriel García Márquez describes the deteriorating condition of an amnesiac: 'the recollection of his childhood began to be erased from his memory, then the name and notion of things, and finally the identity of people, and even the awareness of his own being, until he sank into a kind of idiocy that had no past'. (1970: 50) The cinematic depictions of the Spanish Civil War discussed here have helped ensure that the event has continued to provoke discussion and debate inside Spain and beyond its borders, thereby resisting the process of which García Márquez warns. In July 2000 I wrote an article for the *Guardian* on the history of the Spanish Civil War in cinema (Archibald, 2000) to coincide with the UK release of *Butterfly's Tongue*. The newspaper's editors headlined the article 'The war that won't die', alluding to the increased number of films dealing with the period. Over a decade on, this process continues apace, congruent with increased levels of open and public debate as Spain struggles to come to terms with the memory of its bloody past. This book has outlined how the Spanish Civil War, despite attempts to prevent its cinematic depiction within Spain during the latter years of the Franco regime and the *pacto del olvido*, continues to arouse great interest. Writing in 1993, Deveney predicted the death of films about the civil war: 'as time goes on and as the *Cainismo* in Spanish society subsides, the theme may disappear from the Spanish screen'. (1993: 297) To add weight to his thesis, he then quotes Almodóvar: 'I deliberately construct a past that belongs to me. In that past, Franco doesn't exist.' Deveney then suggests that 'In the not too distant future, this will be the case of all Spanish directors, and Cain will at last fade from the screen.' (1993: 297) Yet, despite Deveney's predictions, cinematic representations of the conflict have grown exponentially in recent years, for reasons both political and commercial. Indeed, perhaps responding to the increased level of debate inside Spain, in 2008

Almodóvar himself acquired the film rights to the autobiography of the acclaimed poet Marcos Ana, who was jailed at the end of the civil war for his part in fighting Franco's forces and spent twenty-three years in prison.[1]

The civil war has become a touchstone in the Western political imaginary, which helps to explain the commercial success of del Toro's work outside Spain. Inside Spain, the increased level of debate has provoked wider interest in the conflict. Rather than witnessing the demise of the Spanish Civil War in cinema, then, we may very well see the opposite; indeed, perhaps the ghosts of the civil war will only be laid to rest when the social antagonisms that created it cease to exist. We may have to wait some time yet for that. Meanwhile, the civil war setting will continue to be one to which filmmakers turn as the battle for Spain's future is partially played out in the cinematically recreated battles of the past.

Note

1 Elola, *El Pais*, 17 February 2008.

Filmography

Las 13 Rosas/13 Roses (Martínez Lázaro, Spain, 2007)
¡A mí la legión! (Orduña, Spain, 1942)
L' Âge d'or (Buñuel, France, 1930)
Los Amantes del Círculo Polar/The Lovers of the Arctic Circle (Medem, Spain, 1998)
El amor brujo (Saura, Spain, 1986)
Ana y los lobos/Ana and the Wolves (Saura, Spain, 1972)
The Angel Wore Red (Johnson, Italy/USA, 1960)
Un año de guerra (Castillo, Spain, 1937)
L' arbre de Guernica/The Tree of Guernica (Arrabal, France/Italy, 1975)
Arise, My Love (Leissen, USA, 1940)
Auch zwerge haben klein angefangen/Even Dwarves Started Small (Herzog, West Germany, 1970)
Aurora de esperanza/Dawn of Hope (Sau, Spain, 1937)
¡Ay Carmela! (Saura, Spain, 1990)
El barbero de Sevilla/The Barber of Seville (Perojo, Germany/Spain, 1938)
Behold a Pale Horse (Zinnemann, France/USA, 1964)
Belle Époque (Fernando Trueba, Spain, 1992)
¡Biba la banda! (Palacios, Spain, 1987)
Las bicicletas son para el verano/Bicycles are for Summer (Chávarri, Spain, 1984)
¡Bienvenido Mr Marshall!/Welcome Mr Marshall! (García Berlanga, Spain, 1953)
Birth of a Nation (Griffiths, USA, 1915)
Blockade (Dieterle, USA, 1938)
Bodas de sangre/Blood Wedding (Saura, Spain/France, 1981)
Bronenosets Potyomkin/Battleship Potemkin (Eisenstein, USSR, 1925)
Calle Mayor (Bardem, Spain, 1956)
Caracremada (Galter, Spain, 2010)
Carla's Song (Loach, UK/Spain/Germany, 1996)

Carmen (Saura, Spain, 1983)

Casablanca (Curtiz, USA, 1942)

La caza/The Hunt (Saura, Spain, 1966)

Un Chien Andalou (Buñuel, France, 1929)

Citizen Kane (Welles, USA, 1941)

Confidential Agent (Shumlin, USA, 1945)

Coronation Street (Granada TV/ITV, 1960–present)

Cría cuervos/Raise Ravens (Saura, Spain, 1976)

Cronos (del Toro, Mexico, 1993)

Crown Court (ITV, 1972–84)

Days of Hope (Loach, UK, 1975)

Les Diabolique/The Devils (Clouzot, France, 1955)

Disappearance of García Lorca (Zuringa, Spain/France/USA/Puerto Rico, 1997)

Dragon Rapide (Camino, Spain, 1986)

La escopeta nacional/National Shotgun (García Berlanga, Spain, 1978)

Ernst Thälmann – Führer seiner Klasse/Thälmann – Leader of the Working Class (Maetzig, DDR, 1955)

El espinazo del Diablo/The Devil's Backbone (del Toro, Spain/Mexico, 2001)

El espíritu de la colmena/Spirit of the Beehive (Erice, Spain, 1973)

L'Espoir/Man's Hope (Malraux/Peskin, France/Spain, 1939–45)

The Fallen Sparrow (Wallace, USA, 1943)

Fatherland (Loach, UK/Germany/France, 1987)

La fiel infantería (Lazaga, Spain, 1960)

Fiesta (Boutron, France, 1995)

Fixed Bayonets! (Fuller, USA, 1951)

For Whom the Bell Tolls (Wood, USA, 1943)

Franco ese hombre/That Man Franco (Sáenz de Heredia, Spain, 1964)

Freaks (Browning, US, 1932)

Fünf Patronenhülsen/Five Cartridges (Beyer, GDR, 1960)

Furtivos/Poachers (Boras, Spain, 1975)

The Girl on a Motorcycle (Cardiff, UK/France, 1968)

Los golfos/The Hooligans (Saura, Spain, 1959)

Golpe de mano/Surprise Attack (De la Loma, Spain, 1968)

The Good Fight: The Abraham Lincoln Brigade in the Spanish Civil War (Buckner, Dore and Sills, USA, 1984)

Goya en Burdeos/Goya in Bordeaux (Saura, Spain/Italy, 1999)

Guernica (Resnais, France, 1955)

Guerra en el campo (Castillo, Spain, 1936)

La guerre est finie/War is Over (Resnais, France, 1966)

Head in the Clouds (Duigan, UK/Canada, 2004)

Hellboy (del Toro, USA, 2004)

Hemingway & Gellhorn (HBO, 2012)

Hidden Agenda (Loach, UK, 1990)

Hollywood contra Franco/A War in Hollywood (Porta, Spain, 2008)
The Holy Three (Browning, US, 1925)
La hora de los valientes/A Time for Defiance (Mercero, Spain, 1998)
Las Hurdes/Land Without Bread (Buñuel, Spain, 1932)
Ispaniya/Spain (Shub, USSR, 1939)
Jakob der Lügner/Jacob, the Liar (Beyer, GDR, 1974)
El jardín de las delicias/Garden of Delights (Saura, Spain, 1970)
JFK (Stone, USA/France, 1991)
Katyn (Wajda, Poland, 2007)
Königskinder/And Your Love Too (GDR, 1962)
Land and Freedom/Tierra y Libertad (Loach, UK/Germany/Spain, 1995)
Las largas vacaciones del 36/The Long Vacation of 1936 (Camino, Spain, 1976)
Last Train From Madrid (Hogan, USA, 1937)
Das Leben Der Anderen/The Lives of Others (von Donnersmarck, Germany, 2006)
La lengua de las mariposas/Butterfly's Tongue (Cuerda, Spain, 1999)
Libertarias/Libertarians (Aranda, Spain, 1996)
The Lord of the Flies (Brook, UK, 1963)
The Lord of the Flies (Hook, UK, 1990)
Lucía y el sexo/Sex and Lucia (Medem, Spain/France, 2001)
Mich dürstet/Plagued by Thirst (Paryla, GDR, 1956)
Michael Collins (Jordan, Ireland/UK/USA, 1996)
Mimic (del Toro, US, 1997)
Mission to Moscow (Curtiz, USA, 1943)
La Montaña Sagrada/The Holy Mountain (Jodorovsky, Mexico/USA, 1973)
Mourir à Madrid/To Die in Madrid (Rossif, France, 1963)
Nacional III/National III (García Berlanga, Spain, 1983)
Nackt unter Wölfen/Naked Among Wolves (GDR, 1963)
The Night of the Hunter (Laughton, USA, 1995)
The Night Porter (Cavani, Italy, 1974)
Oktyabr/October (Eisenstein, USSR, 1927)
Operació Nikolai/Operation Nikolai (TV3, 1992)
Osadeni Dushi/ Doomed Souls (Radev, Bulgaria, 1975)
El Orfanato/The Orphanage (Bayona, Mexico/Spain, 2007)
Pascual Duarte (Franco, Spain, 1976)
Patrimonio nacional/National Patrimony (García Berlanga, Spain, 1981)
La pelota Vasca: La piel contra la piedra/The Basque Ball: The Skin Against the Stone (Medem, Spain, 2003)
El perro negro: Stories From the Spanish Civil War (Forgács, Netherlands/France/ Finland/Spain, 2006)
¿Por qué perdimos la guerra?/Why Did We Lose the War? (Santillán, Spain, 1978)
El portero/The Goalkeeper (Suárez, Spain, 2000)

Posición avanzada/Advanced Position (Lazaga, Spain, 1965)
La prima Angélica/Cousin Angelica (Saura, Spain, 1974)
El productor/The Producer (Méndez Leite, Spain, 2006)
Les quatre cents coups/400 Blows (Truffaut, France, 1959)
Raining Stones (Loach, UK, 1993)
The Rank and File (Loach, UK, 1971)
Raza/Race (Sáenz de Heredia, Spain, 1941)
Raza, el espíritu de Franco/Race,The Spirit of Franco (Herralde, Spain, 1977)
Reds (Beatty, USA, 1981)
Le retour de Martin Guerre/The Return of Martin Guerre (Vigne, France, 1982)
Retrato de familia/ Family Portrait (Giménez Rico, Spain, 1976)
Sans Soleil (Marker, France, 1983)
El santuario no se rinde (Ruiz Castillo, Spain, 1949)
The Searchers (Ford, USA, 1956)
Shoah (Lanzmann, France, 1985)
Sin novedad en el Alcázar (Genina, Italy/Spain, 1940)
Die Söhne der großen Bärin/Sons of the Great Mother Bear (Mach, GDR, 1966)
Solange du lebst (Reini, FRG, 1955)
Soldados de Salamina/Soldiers of Salamina (David Trueba, Spain, 2002)
Soldados/Soldiers (Ungría, Spain, 1978)
Song for a Raggy Boy (Walsh, Ireland/Spain, 2003)
Spain in Flames (Prudencio de Pereda, Spain, 1938)
Spain otra vez/Spain Again (Camino, Spain, 1968)
The Spanish Earth (Ivens, USA, 1937)
The Spanish Civil War (Granada TV, 1983)
Spur der Steine/Traces of Stones (GDR, 1966)
Stachka/Strike (Eisenstein, USSR, 1925)
Stagecoach (Ford, USA, 1937)
The Steel Helmet (USA, 1951)
Suspiros de España/Sighs of Spain (Perojo, Germany/Spain, 1939)
There be Dragons (Joffe, USA/Argentina, 2011)
Tierra de todos/Land of All (Isasi Isasmendi, Spain, 1961)
El Topo (Jodorovsky, Mexico, 1970)
The Treasure of the Sierra Madre (Huston, USA, 1948)
Tristana (Buñuel, France/Italy/Spain, 1970)
Unbändiges Spanien/Untameable Spain (Jeanne and Kurt Stern, GDR, 1962)
Vacas/Cows (Medem, Spain, 1992)
La vaquilla (Berlanga, Spain, 1985)
El viaje de Carol/Carol's Journey (Uribe, Spain, 2002)
*La vida de Cristóbal Colón y su descubrimiento de América/The Life of Christopher
 Columbus and his Discovery of America* (Bourgeois, France/Spain, 1916)
La vieja memoria/The Old Memory (Camino, Spain, 1977)
¡Viva la muerte!/Long Live Death! (Arrabal, France/Tunisia, 1970)

Walker (Cox, USA/Mexico/Spain, 1987)
Watch on the Rhine (Shumlin, USA, 1943)
The Wild Bunch (Peckinpah, US, 1969)
The Wind that Shakes the Barley (Loach, Ireland/UK/Germany/Italy/Spain/
 France/Belgium/Switzerland, 2006)
Wo du hingehst/Wherever You Go (Hellberg, GDR, 1957)
Zerkalo/Mirror (Tarkovsky, USSR, 1975)

Bibliography

Acevedo-Muñoz, Ernesto R. (2008), 'Horror of Allegory: *The Others* and its Contexts', in Jay Beck and Vicente Rodríguez Ortega (eds), *Contemporary Spanish Cinema and Genre*, Manchester: Manchester University Press, pp. 202–18.

Aguilar, Paloma (2008 [1996]), *Memory and Amnesia: the Role of the Spanish Civil War in the Transition to Democracy* (trans. Mark Oakley), New York and Oxford: Berghahn.

Alba, Víctor and Schwartz, Stephen (1988), *Spanish Marxism Versus Soviet Communism: A History of the P.O.U.M.*, New Brunswick, NJ, and Oxford: Transaction Books.

Aldgate, Anthony (1979), *Cinema and History: British Newsreels and the Spanish Civil War*, London: Scolar Press.

Alexander, Robert (1999), *The Anarchists in the Spanish Civil War, Vols. 1 and 2*, London: Janus Publishing.

Alexander, William (1981), *Film on the Left: American Documentary Film from 1931 to 1942*, Princeton, NJ: Princeton University Press.

Allan, Seàn (1999), 'DEFA: An Historical Overview', in Seàn Allan and John Sandford (eds), *DEFA: East German Cinema, 1946–1992*, New York: Berghahn, pp. 1–21.

Alpert, Michael (1994), *A New International History of the Spanish Civil War*, London: Palgrave.

Anderson, Perry (1992), 'On Emplotment: Two Kinds of Ruin', in Saul Friedlander (ed.), *Probing the Limits of Representation: Nazism and the 'Final Solution'*, Cambridge, MA, and London: Harvard University Press, pp. 54–65.

Anonymous (1995), '*Land and Freedom* Production Notes', London: Parallax Pictures.

Anonymous (2004), 'La Pelota Vasca: La piel contra la piedra/The Basque Ball: The Skin Against the Stone, British Production Notes', London: Tartan Films.

Anonymous (2010 [1941]), 'Bureau of Motion Pictures Report: *Casablanca*', in Steven Mintz and Randy W. Roberts (eds), *Hollywood's America: Twentieth Century America through Film*, Chichester: Wiley-Blackwell, pp. 142–3.

Archibald, David (2000), 'The War that Won't Die', *The Guardian*, 28 July.

— (2001), 'Insects and Violence', *The Guardian*, 28 November.

— (2002), 'Match Made in Heaven', *Sunday Herald*, 29 September.

— (2004), 'Re-framing the Past: Representations of the Spanish Civil War in Popular Spanish Cinema', in Antonio Lázaro-Reboll and Andrew Willis (eds), *Spanish Popular Cinema*, Manchester: Manchester University Press, pp. 76–91.

— (2006), 'The Closing Image: David Trueba's *Soldados de Salamina*', *The Drouth: Scotland's Literary Quarterly*, 20, pp. 57–9.

— (2011), 'No Laughing Matter? Comedy and the Spanish Civil War', in Hanu Salmi (ed.), *Historical Comedy on Screen: Subverting History with Humour*, Bristol: Intellect, pp. 57–9.

Arrabal, Fernando and Kronik, Eva (1975), 'Interview: Arrabal', *Diacritics*, 5(2), pp. 54–60.

Avisar, Ilan (1988), *Screening the Holocaust: Cinema's Images of the Unimaginable*, Bloomington and Indianapolis: Indiana University Press.

Bailey, Alan (2002), *Sextus Empiricus and Pyrrhonean Scepticism*, Oxford: Oxford University Press.

Bakhtin, Mikhail (1984), *Rabelais and His World* (trans. Helene Iswolsky), Bloomington and Indianapolis: Indiana University Press.

Barthes, Roland (1993), *Barthes: A Reader* (ed. Susan Sontag), London: Vintage.

Bazin, Andre (1967), 'The Myth of Total Cinema', in *What Is Cinema? Vol. 1* (trans. Hugh Gray), London: University of California Press, pp. 17–22.

Beevor, Antony (1999), *The Spanish Civil War*, London: Cassell.

Begin, Paul (2007), 'Entomology as Anthropology in the Films of Luis Buñuel', *Screen*, 48(4), pp. 425–44.

Benjamin, Walter (2003), *Walter Benjamin: 1938–1940 Vol. 4: Selected Writings*, Cambridge, MA: Harvard University Press.

Besas, Peter (1985), *Behind the Spanish Lens: Spanish Cinema under Fascism and Democracy*, Denver, CO: Arden Press.

Bordwell, David (1985), *Narration in the Fiction Film*, Madison, WI: University of Wisconsin Press.

Bordwell, David and Thompson, Kristin (1992), *Film Art: An Introduction*, New York: McGraw-Hill, 1992.

Bourke, Joanna (2004), 'Remembering War', *Journal of Contemporary History*, 39(4), pp. 473–85.

Brecht, Bertolt (1986), *Brecht on Theatre: The Development of an Aesthetic* (ed. and trans. John Willett), London: Methuen.

Brenan, Gerard (1990), *The Spanish Labyrinth: An Account of the Social and Political Background to the Spanish Civil War*, Cambridge: Cambridge University Press.

Breton, André (1982), *Manifestos of Surrealism* (trans. Richard Seaver and Helen R. Lane), Ann Arbor, MI: University of Michigan Press.

Broer, Lawrence (1973), *Hemingway's Spanish Tragedy*, Tuscaloosa, AL: University of Alabama Press.

Bürger, Peter (2002), *Theory of the Avant-Garde: Theory and History of Literature, Volume 4* (trans. Michael Shaw), Minneapolis, MN: University of Minnesota Press.

Buse, Peter and Stott, Andrew (1999), 'Introduction: A Future for Haunting', in Peter Buse and Andrew Stott (eds), *Ghosts: Deconstruction, Psychoanalysis, History*, Basingstoke: Macmillan, pp. 1–20.

Byg, Barton (1999), 'DEFA and the Traditions of International Cinema', in Seàn Allan and John Sandford (eds), *DEFA: East German Cinema, 1946–1992*, New York: Berghahn, pp. 22–41.

Callinicos, Alex (1997), *Theories and Narratives: Reflections on the Philosophy of History*, Cambridge: Polity Press.

Cameron, Marina (2000), 'Viva la revolucion! Viva la mujeras!', www.green-left.org.au, last accessed 12 February 2000.

Camino, Mercedes M. (2007), 'War, Wounds and Women: The Spanish Civil War in Victor Erice's *El espíritu de la colmena* and David Trueba's *Soldados de Salamina*', *Journal of Iberian Studies*, 20(2), pp. 91–104.

Campbell, Russell (1982), *Cinema Strikes Back: Radical Filmmaking in the United States 1930–1942*, Ann Arbor, MI: UMI Research Press.

Capellan, Angel (1985), *Hemingway and the Hispanic World*, Ann Arbor, MI: UMI Research Press.

Carr, Gary (1984), *The Left Side of Paradise: The Screenwriting of John Howard Lawson*, Ann Arbor, MI: UMI Research Press.

Caughie, John (2000), *Television Drama: Realism, Modernism, and British Culture*, Oxford: Oxford University Press.

Cercas, Javier (2003), *Soldiers of Salamis* (trans. Anne McLean), London: Bloomsbury.

Cercas, Javier and Trueba, David (2003), *Diálogos de Salamina: un paseo por el cine y la literatura*, Barcelona: Tusquets, extract trans. Anne McLean at http://wordswithoutborders.org/article/from-conversations-about-sol diers-of-salamis/, last accessed 26 July 2010.

Christie, Ian (1995), 'Film for a Spanish Republic', *Sight & Sound*, 5(10), pp. 36–7.

Christie, Stuart (2000), *We, the Anarchists! A Study of the Iberian Anarchist Federation (FAI) 1927–1937*, Hastings: Meltzer Press/Jura Media.

Collins, Jacky and Perriam, Chris (2000), 'Representations of Alternative Sexualities in Contemporary Spanish Writing and Film', in Barry Jordan

and Rikki Morgan-Tamosunas (eds), *Contemporary Spanish Cultural Studies*, London: Arnold, pp. 214–22.

Colmiero, José F (1997), 'Paradise Found? Ana/chronic Nostalgia in *Belle Epoque*', *Film-Historia*, VII(2), pp. 131–40.

Cooper, Stephen (1987), *The Politics of Ernest Hemingway*, Ann Arbor, MI: UMI Research Press.

Coppard, Audrey and Crick, Bernard (1984), *Orwell Remembered*, London: BBC.

Cunningham, Valentine (ed.) (1980), *The Penguin Book of Spanish Civil War Verse*, Harmondsworth: Penguin.

Davies, Alan (1999), 'The First Radio War: Broadcasting in the Spanish Civil War, 1936–1939', *Historical Journal of Film, Radio and Television*, 19(4), pp. 473–513.

Davies, Anna (2006), 'The Beautiful and the Monstrous Masculine: The Male Body and Horror in *El espinazo del diablo* (Guillermo del Toro)', *Studies in Hispanic Cinemas*, 3(3), pp. 135–47.

De España, Rafael (1986), 'Images of the Spanish Civil War in Spanish Feature Films, 1939–1985', *Historical Journal of Film, Radio and Television*, 6(2), pp. 223–36.

Del Amo García, Alfonso (1996), *Catálogo general del cine de la guerra civil*, Madrid: Cátedra/Filmoteca Española.

Derrida, Jacques (2006), *Specters of Marx: The State of the Debt, the Work of Mourning and the New International* (trans. Peggy Kamuf), New York and London: Routledge.

Deutscher, Isaac (1984), *Stalin: A Political Biography*, Harmondsworth: Penguin.

Deveny, Thomas G. (1993), *Cain on Screen: Contemporary Spanish Cinema*, Metuchen, NJ, and London: Scarecrow Press.

Diez, Emeterio (2009), 'Anarchist Cinema During the Spanish Civil War' (trans. Paul Sharkey), in Richard Porton (ed.), *Arena One: On Anarchist Cinema*, Oakland, CA, and Hastings: PM/Christie Books, pp. 33–96.

Dika, Vera (2008), 'An East German *Indianerfilm*: The Bear in Sheep's Clothing', *Jump Cut: A Review of Contemporary Media*, 50, www.ejumpcut. org/archive/jc50.2008/Dika-indianer/index.html, last accessed 23 April 2012.

D'Lugo, Marvin (1991), *The Films of Carlos Saura: The Practice of Seeing*, Princeton, NJ: Princeton University Press.

Durgan, Andy (1996), 'The Hidden Story of the Revolution', *New Politics*, 21, pp. 74–8.

— (2007), *The Spanish Civil War*, Basingstoke and New York: Palgrave Macmillan.

Eagleton, Terry (1981), *Walter Benjamin or Towards a Revolutionary Criticism*, London: New Left Books.

— (1996), *The Illusions of Postmodernism*, Oxford: Blackwell.

— (2003), *After Theory*, London: Penguin.

Edwards, Gwynne (1995), *Indecent Exposures: Bunuel, Saura, Erice & Almodovar*, London: Marion Boyars.

— (1997), 'The Persistence of Memory: Carlos Saura's *La caza* and *La prima Angélica*', *Journal of Iberian and American Studies*, 3(2), pp. 191–203.

Eisenstein, Sergei (1988), 'The Dramaturgy of Film Form (The Dialectical Approach to Film Form)', in S. M. *Eisenstein Selected Works, Volume 1, Writings, 1922–34* (ed and trans. Richard Taylor), London: BFI.

Ellwood, Sheelagh (1995), 'The Moving Image of the Franco Regime: Noticiarios y Documentales 1943–1975', in Helen Graham and Jo Labanyi (eds), *Spanish Cultural Studies: An Introduction: The Struggle for Modernity*, Oxford: Oxford University Press, pp. 201–3.

Elola, Joseba (2008), 'Almodóvar rodará la vida de Marcos Ana', *El Pais*, 17 February.

Elton, Geoffrey (1991), *Return to Essentials*, Cambridge: Cambridge University Press.

Evans, Jo (2007), *Julio Medem*, London: Grant and Cutler.

Evans, Richard J. (2000), *In Defence of History*, London: Granta.

Evans, Peter William (ed.) (1999), *Spanish Cinema: The Auteurist Tradition*, Oxford: Oxford University Press.

Farmer, R. L. (1971), 'Fernando Arrabal's Guerrilla Theatre', *Yale French Studies*, 46, pp. 154–66.

Faulkner, Sally (2006), *A Cinema of Contradiction: Spanish Film in the 1960s*, Edinburgh: Edinburgh University Press.

Feinstein, Joshua (2002), *The Triumph of the Ordinary: Depictions of Ordinary Life in the East German Cinema 1949–1989*, Chapel Hill, NC. and London: University of North Carolina Press, pp. 176–93.

Ferrándiz, Francisco (2006), 'The Return of Civil War Ghosts: The Ethnography of Exhumations in Contemporary Spain', *Anthropology Today*, 22(3), pp. 7–12.

Finucane, R. C. (1984), *A Cultural History of Ghosts*, New York: Prometheus Books.

Fraser, Ronald (1988), *Blood of Spain: The Experience of Civil War 1936–1939*, London: Penguin.

Friedlander, Saul (ed.) (1992), *Probing the Limits of Representation: Nazism and the 'Final Solution'*, Cambridge, MA, and London: Harvard University Press.

Fuller, Graham (ed.) (1988), *Loach on Loach*, London: Faber and Faber.

García Márquez, Gabriel (1970), *One Hundred Years of Solitude*, New York: Avon.

Gellhorn, Martha (1996), 'This is Not the War That I Knew', *The Volunteer: Journal of the Veterans of the Abraham Lincoln Brigade*, XVIII(1), p. 18.

Gibson, Ian (1987), *The Assassination of Federico García Lorca*, Harmondsworth: Penguin.

Glaister, Dan (2000), 'Julio Medem: All About My Father', *The Guardian*, 5 January.

Gordon, Avery (2008), *Ghostly Matters: Haunting and the Sociological Imagination*, Minneapolis, MN: University of Minnesota Press.

Graham, Helen (1991), *Socialism and War: The Spanish Socialist Party in Power and Crisis 1936–1939*, Cambridge: Cambridge University Press.

— (2002), *The Spanish Republic at War 1936–1939*, Cambridge: Cambridge University Press.

— (2005), *The Spanish Civil War: A Very Short Introduction*, Oxford: Oxford University Press.

Graham, Helen and Labanyi, Jo (eds) (1995), *Spanish Cultural Studies: An Introduction: The Struggle for Modernity*, Oxford: Oxford University Press.

Greeley, Robin Adèle (2006), *Surrealism and the Spanish Civil War*, New Haven, CT, and London: Yale University Press.

Gubern, Román (1991), 'The Civil War: Inquest or Exorcism?', *Quarterly Review of Film and Video*, 13(4), pp. 103–12.

Hardcastle, Anne E. (2005), 'Ghosts of the Past and Present: Hauntology and the Spanish Civil War in Guillermo del Toro's *The Devil's Backbone*', *Journal of the Fantastic in the Arts*, 15(2), pp. 119–31.

Harper, Graeme and Stone, Rob (2007), 'Introduction', in Graeme Harper and Rob Stone, (eds), *The Unsilvered Screen: Surrealism on Film*, London: Wallflower, pp. 1–8.

Hayward, Anthony (2004), *Which Side Are You On? Ken Loach and his Films*, London: Bloomsbury.

Hemingway, Ernest (1969), *The Fifth Column and Four Stories of the Spanish Civil War*, New York: Scribner.

— (1976), *For Whom The Bell Tolls*, London: Harper Collins.

Herodotus (1996), *The Histories* (trans. Aubrey de Sélincourt), London: Penguin.

Higginbotham, Virginia (1988), *Spanish Film Under Franco*, Austin, TX: Austin University Press.

Hill, John (2011), *Ken Loach: The Politics of Film and Television*, London: BFI/Palgrave Macmillan.

Hobsbawm, Eric (1984), 'Marx and History', *New Left Review*, 143, pp. 39–50.

— (2002), *Interesting Times: A Twentieth Century Life*, London: Penguin.

— (2007), 'War of Ideas', *The Guardian*, 17 February, pp. 4–8.

Hopewell, John (1986), *Out of the Past: Spanish Cinema after Franco*, London: BFI.

Hopkins, James K. (1998), *Into the Heart of the Fire: The British in the Spanish Civil War*, Stanford, CA: Stanford University Press.

Horne, Gerald (2002), *Class Struggle in Hollywood, 1930–1950: Moguls, Mobsters, Stars, Reds, and Trade Unionists*, Austin, TX: University of Texas Press.

Howson, Gerald (1998), *Arms For Spain: The Untold Story of the Spanish Civil War*, London: John Murray.

Hughes, Arthur J. (2007), 'Between History and Memory: Creating a New Subjectivity in David Trueba's Film *Soldados de Salamina*', *Bulletin of Spanish Studies*, 84(3), pp. 369–86.

Hughes-Warrington, Marnie (ed.) (2009), *The History on Film Reader*, New York and London: Routledge.

Hutcheon, Linda (1988), *A Poetics of Postmodernism: History, Theory, Fiction*, New York and London: Routledge.

Jameson, Frederic (1979), 'Marxism and Historicism', *New Literary History*, 11(1), pp. 41–74.

— (1986), *The Political Unconscious: Narrative as a Socially Symbolic Act*, London and New York: Routledge.

Jenkins, Keith (1991), *Re-thinking History*, London and New York: Routledge.

— (1995), *On 'What is History?': From Carr and Elton to Rorty and White*, London and New York: Routledge.

— (1999), *Why History? Ethics and Postmodernity*, London and New York: Routledge.

Jordan, Barry and Morgan-Tamosunas, Rikki (1998), *Contemporary Spanish Cinema*, Manchester: Manchester University Press.

— (eds) (2000), *Contemporary Spanish Cultural Studies*, London: Arnold.

Josephs, Allen (1996), 'Hemingway's Spanish Sensibility', in Scott Donaldson (ed.), *The Cambridge Companion to Hemingway*, Cambridge: Cambridge University Press.

Keller, Julia (2008), 'Why McCain and Obama Reading Hemingway is Good', *Chicago Tribune*, 23 August.

Kinder, Marsha (1993), *Blood Cinema: The Reconstruction of National Identity in Spain*, Berkeley, CA: University of California Press.

— (1997), *Refiguring Spain: Cinema/Media/Representation*, Durham, NC: Duke University Press, 1997.

Kinnamon, Kenneth (1996), 'Hemingway and Politics', in Scott Donaldson (ed.), *The Cambridge Companion to Hemingway*, Cambridge: Cambridge University Press, pp. 149–65.

Knight, Patricia (1998), *The Spanish Civil War: Access To History in Depth*, London: Hodder and Stoughton.

Koppes, Clayton R. and Black, Gregory D. (2000), *Hollywood Goes to War: Patriotism, Movies and the Second World War from 'Ninotchka' to 'Mrs Miniver'*, London and New York: Tauris Parke.

Kovács, Katherine (1981), 'Loss and Recuperation in *The Garden of Delights*', *Cine-Tracts* (Montreal), IV(2/3), pp. 45–54.

Kowalsky, Daniel (2007), 'The Soviet Cinematic Offensive in the Spanish Civil War', *Film History: An International Journal*, 19(1), pp. 7–19.

Krammer, Arnold (2004), 'The Cult of the Spanish Civil War in East Germany', *Journal of Contemporary History*, 39(4), pp. 531–60.

Kurlansky, Mark (1999), *The Basque History of the World*, London: Jonathan Cape.

Labanyi, Jo (2000), 'History and Hauntology; or, What Does One Do with the Ghosts of the Past? Reflections on Spanish Film and Fiction of the Post-Franco Period', in Joan Ramon Rasina (ed.), *Disremembering the Dictatorship: The Politics of Memory in the Spanish Transition to Democracy*, Amsterdam and Atlanta: Rodopi, pp. 65–82.

— (2008), 'The Politics of Memory in Contemporary Spain', *Journal of Spanish Cultural Studies*, 9(2), 119–25.

Landy, Marcia (2001), *The Historical Film: History and Memory in Media*, New Brunswick, NJ: Rutgers University Press.

Laurence, Frank (1981), *Hemingway and the Movies*, Ann Arbor, MI: University of Michigan Press.

Lawson, John Howard (1985), 'Organizing the Screen Writers Guild', in Dan Georgakas and Lenny Rubenstein (eds), *Art, Politcs, Cinema: The Cineaste Interviews*, London and Sydney: Pluto Press, pp. 188–204.

Lázaro-Reboll, Antonio and Willis, Andrew (eds) (2004), *Spanish Popular Cinema*, Manchester, Manchester University Press.

Lázaro-Reboll, Antonio (2007), 'The Transnational Reception of *El espinazo del diablo* (Guillermo del Toro 2001)', *Hispanic Research Journal*, 8(1), pp. 39–51.

Leigh, Jacob (2002), *The Cinema of Ken Loach: Art in the Service of the People*, London: Wallflower.

Linhard, Tabea Alexa (2005), *Fearless Women in the Mexican Revolution and the Spanish Civil War*, Columbia, MO, and London: University of Missouri Press.

Lowenthal, David (1985), *The Past is a Foreign Country*, Cambridge: Cambridge University Press.

Löwy, Michael and LaCoss, Donald (2009), *Morning Star: Surrealism, Marxism, Anarchism, Situationism, Utopia*, Austin, TX: University of Texas Press.

Lukács, Georg (1969), *The Historical Novel*, Harmondsworth: Penguin.

— (1970), *Writer and Critic*, London: Merlin Press.

— (1971), *History and Class Consciousness*, London: MIT Press.

McKnight, George (ed.) (1997), *Agent of Challenge and Defiance: The Films of Ken Loach*, Trowbridge: Flicks Books.

McLellan, José (2004), *Antifascism and Memory in East Germany: Remembering the International Brigades 1945–1989*, Oxford: Clarendon Press.

— (2006), '"I Wanted to be a Little Lenin": Ideology and the German

International Brigade Volunteers', *Journal of Contemporary History*, 41(2), pp. 287–304.

Madden, Paul (1981), 'Jim Allen', in G. W. Brandt (ed.), *British Television Drama*, Cambridge: Cambridge University Press, pp. 36–55.

Mangini, Shirley (1995), *Memories of Resistance: Women's Voices from the Spanish Civil War*, New Haven, CT, and London: Yale University Press.

Marsh, Steven (2006), *Popular Spanish Film under Franco: Comedy and the Weakening of the State*, Basingstoke and New York: Palgrave Macmillan.

Marwick, Arthur (1970), *The Nature of History*, London: Macmillan.

Marx, Karl and Engels, Friedrich (1956), *The Holy Family or Critique of Critical Critique*, London: Lawrence and Wishart.

— (1980), *Marx/Engels: Selected Works in One Volume*, London: Lawrence and Wishart.

— (1984), *Marx and Engels on Literature and Art*, Moscow: Progress Publishers.

Marx, Karl (1992), 'A Contribution to the Critique of Hegel's Philosophy of Right', in Karl Marx, *Early Writings*, Harmondsworth: Penguin, pp. 243–57.

Michalczyk, John J. (1977), *Andre Malraux's Espoir: The Propaganda/Art Film and the Spanish Civil War*, University of Mississippi: Romance Monographs.

Michalczyk, John J. and Villani, Sergio (eds) (1992), 'Malraux, Hemingway and Embattled Spain', special issue of *North Dakota Quarterly*, 60(2).

Mintz, Steven and Roberts, Randy W. (eds) (2010), *Hollywood's America: Twentieth Century America through Film*, Chichester: Wiley-Blackwell.

Molina, Juan, M. (1958), *Noche sobre España*, Mexico: Ediciones de la CNT de España.

Monegal, Antonio (1998), 'Images of War: Hunting the Metaphor', in Jenaro Talens and Santos Zunzunegui (eds), *Modes of Representation in Spanish Cinema*, Minneapolis, MN: University of Minnesota Press, pp. 203–15.

Monteath, Peter (1994a), *The Spanish Civil War in Literature, Film and Art: An International Bibliography of Secondary Literature*, Westport, CT, and London: Greenwood Press.

— (1994b), *Writing the Good Fight: Political Commitment in the International Literature of the Spanish Civil War*, Westport, CT, and London: Greenwood Press.

Morrow, Felix (1976), *Revolution and Counter-Revolution in Spain*, London: New Park.

Mückenberger, Christiane (1999), 'The Anti-Fascist Past in DEFA Films', in Seán Allan and John Sandford (eds), *DEFA: East German Cinema, 1946–1992*, New York and Oxford: Berghahn, pp. 58–76.

Nash, Mary (1995), *Defying Civilization: Women in the Spanish Civil War*, Denver, CO: Arden Press.

Neale, Steve and Krutnik, Frank (1990), *Popular Film and Television Comedy*, London and New York: Routledge.

Newsinger, John (1999), 'Scenes From the Class War: Ken Loach and Socialist Cinema', *International Socialism Journal*, 83, available at http://pubs.social-istreviewindex.org.uk /isj83/newsinger.htm, last accessed 23 April 2012.

Nichols, Bill (1994), *Blurred Boundaries: Questions of Meaning in Contemporary Culture*, Bloomington: Indiana University Press.

— (1996), 'Historical Consciousness and the Viewer: Who Killed Vincent Chin?', in Vivian Sobchack (ed.), *The Persistence of History: Cinema, Television and the Modern Event*, London and New York: Routledge, pp. 55–68.

Orwell, George (1968), 'Looking Back on the Spanish Civil War', in *The Collected Essays, Journalism and Letters of George Orwell: Volume II My Country Left or Right, 1940–1943* (ed. Sonia Orwell and Ian Angus), London: Secker and Warburg, pp. 249–67.

— (1989), *Homage to Catalonia*, Harmondsworth: Penguin.

Payne, Stanley G. (1970), *The Spanish Revolution*, London: Weidenfeld and Nicolson.

Paz, Abel (1997), *The Spanish Civil War*, Paris: Hazan.

Paz, María Antonia (2003), 'The Spanish Remember: Movie Attendance During the Franco Dictatorship, 1943–1975', *Historical Journal of Film, Radio and Television*, 23(4), pp. 357–72.

Peirats, José (2001), *The CNT in the Spanish Revolution* (ed. and rev. Chris Ealham), Hastings: Meltzer Press.

Pérez González (Peridis), José María (2000), 'Resisting the Dictatorship through Humour', in Monica Threlfall (ed.), *Consensus Politics in Spain: Insider Perspectives*, Bristol: Intellect, pp. 16–26.

Phillips, Gene, D. (1980), *Hemingway & Film*, New York: Frederick Ungar.

Podol, Peter, L. (1985) 'The Grotesque Mode in Contemporary Spanish Theater and Film', *Modern Language Studies*, 15(4), pp. 194–207.

Porton, Richard (1996), 'Revolution Betrayed: An Interview with Ken Loach', *Cineaste*, 22(1), pp. 30–1.

— (1999), *Film and the Anarchist Imagination*, London and New York: Verso.

Preston, Paul (1990), *The Politics of Revenge. Fascism and the Military in Twentieth-Century Spain*, London: Unwin Hyman.

— (1993), *Franco: A Biography*, London: Harper Collins.

— (1994), *The Coming of the Spanish Civil War. Reform, Reaction and Revolution in the Second Republic*, London: Routledge.

— (1996a), *The Triumph of Democracy in Spain*, London and New York: Methuen.

— (1996b), *A Concise History of The Spanish Civil War*, London: Fontana.

— (1996c), 'Introduction', in Paul Preston and Ann L. Mackenzie (eds), *The Republic Besieged: Civil War in Spain 1936–1939*, Edinburgh: Edinburgh University Press, pp. v–xiv.

— (2000), *¡Comrades! Portraits from the Spanish Civil War*, London: HarperCollins.

— (2001), 'The Civil War in the Civil War', *The Volunteer: Journal of the Veterans of the Abraham Lincoln Brigade*, XXIII(3), pp. 6–10.

Preston, Paul and Mackenzie, Ann L. (eds) (1996), *The Republic Besieged: Civil War in Spain 1936–1939*, Edinburgh: Edinburgh University Press.

Radosh, Ronald, Habeck, Mary R. and Sevostianov, Grigory (eds) (2001), *Spain Betrayed: The Soviet Union in the Spanish Civil War*, New Haven, CT, and London: Yale University Press.

Richards, Michael (1996), 'Civil War, Violence and the Construction of Francoism', in Paul Preston and Ann L. Mackenzie (eds), *The Republic Besieged: Civil War in Spain 1936–1939*, Edinburgh: Edinburgh University Press, pp. 197–239.

— (2006), *A Time of Silence: Civil War and the Culture of Repression in Franco's Spain, 1936–1945*, Cambridge: Cambridge University Press.

Richardson, Michael (2006), *Surrealism and Cinema*, Oxford and New York: Berg.

Roberts, Stephen (1999), 'In Search of a New Republic: Bardem's *Calle Mayor*', in Peter William Evans (ed.), *Spanish Cinema: The Auteurist Tradition*, Oxford: Oxford University Press, pp. 19–37.

Rollins, Peter C. (ed.) (1983), *Hollywood as Historian: American Film in a Cultural Context*, Lexington, KY: University Press of Kentucky.

Rogovin, Vadim (1998), *1937: Stalin's Year of Terror*, Sheffield: Mehring Books.

Rosenstone, Robert A. (1995), *Visions of the Past: The Challenge of Film to our Idea of History*, Cambridge, MA: Harvard University Press.

— (2006), *History on Film/Film on History*, Harlow: Pearson Longman.

Santoalalla, Isabel C. (1999), 'Julio Medem's *Vacas* (1991): Historicizing the Forest', in Peter William Evans (ed.), *Spanish Cinema: The Auteurist Tradition*, Oxford: Oxford University Press, pp. 310–24.

Sawtell, Jeff (1996), '*Land and Freedom*: Ken Loach's Distortion of the Spanish Civil War', *Communist Review*, Summer, available at www.communist-party.org.uk/index.php?option=com_content&view=article&id=66:land-and-freedom-ken-loachs-distortion-of-the-spanish-civil-war&catid=113:features-history&Itemid=22, last accessed 20 July 2010.

Schwartz, Stephen (2000), 'The Spanish Civil War in Historical Context', *Critique: A Journal of Socialist Theory*, 32–33, pp. 147–65.

Shindler, Colin (1996), *Hollywood in Crisis: Cinema and American Society, 1929–1939*, London: Routledge.

Smith, Greg M. (1996), 'Blocking *Blockade*: Partisan Protest, Popular Debate, and Encapsulated Texts', *Cinema Journal* 36(1), pp. 18–38.

Smith, Michael E. (1996), *The Aztecs*, Oxford and Cambridge: Blackwell.

Smith, Paul Julian (1994), '*Belle Epoque*', *Sight and Sound*, 4(4), p. 38.

— (2000), *The Moderns: Time, Space and Subjectivity in Contemporary Spanish Culture*, Oxford: Oxford University Press.

— (2007), 'Pan's Labyrinth (El laberinto del fauno)', Film Quarterly, 60(4), pp 4–9.

Sobchack, Vivian (ed.) (1996), The Persistence of History: Cinema, Television and the Modern Event, London and New York: Routledge.

Soldovieri, Stefan (2007), 'Germans Suffering in Spain: Cold War Visions of the Spanish Civil War in Fünf Patronenhülsen (1960) and Solange du lebst (1955)', Cinémas: revue d'études cinématographiques/Cinémas: Journal of Film Studies, 18(1), pp. 53–69.

Sorlin, Piere (1980), The Film in History, Restaging the Past, Oxford: Blackwell.

Stone, Rob (2002), Spanish Cinema, Harlow: Longman.

— (2004), 'Animals were Harmed during the Making of this Film: A Cruel Reality in Hispanic Cinema', Studies in Hispanic Cinemas, 1(2), pp. 75–84.

— (2007), 'Eye to Eye: The Persistence of Surrealism in Spanish Cinema', in Graeme Harper and Rob Stone (eds), The Unsilvered Screen: Surrealism on Film, London: Wallflower, pp. 23–37.

Talens, Jenaro and Zunzunegui, Santos (eds) (1998), Modes of Representation in Spanish Cinema, Minneapolis, MN: University of Minnesota Press.

Thomas, Hugh (2003), The Spanish Civil War, Harmondsworth: Penguin.

Thompson, E. P. (1968), The Making of the English Working Class, Harmondsworth: Penguin.

Triana-Toribio, Núria (2003), Spanish National Cinema, London: Routledge.

Trotsky, Leon (1991), Literature and Revolution, London: RedWords.

— (1998), The Spanish Revolution (1931–39), New York: Pathfinder.

Trumpener, Katie (2001), 'La Guerre est finie: New Waves, Historical Contingency, and the GDR "Rabbit Films"', in Michael Geyer (ed), The Power of Intellectuals in Contemporary Germany, Chicago and London: University of Chicago Press, pp. 113–37.

Valleau, Marjorie (1982), The Spanish Civil War in American and European Films, Ann Arbor, MI: UMI Research Press.

Walinksi-Kiehl, Robert (2006), 'History, Politics, and East German Film: The Thomas Müntzer (1956) Socialist Epic', Central European History, 39, pp. 30–55.

Waugh, Thomas (1998), 'Men Cannot Act Before the Camera in the Presence of Death', in Barry Keith Grant and Jeanette Sloniowski (eds), Documenting the Documentary: Close Readings of Documentary Film and Video, Detroit, MI: Wayne State University Press, pp. 136–53.

Wayne, Mike (2001), Political Film: The Dialectics of Third Cinema, London and Sterling, VA: Pluto Press.

Weintraub, Stanley (1968), The Last Great Cause: Intellectuals and the Spanish Civil War, London: W.H. Allen.

Westwell, Guy (2006), War Cinema: Hollywood on the Front Line, London: Wallflower.

White, Anne M. (1999), 'Manchas Negras, Manchas Blanca: Looking Again

at Julio Medem's *Vacas*, in Rob Rix and Roberto Rodríguez-Soana (eds), *Spanish Cinema: Calling the Shots*, Leeds: Leeds Iberian Papers, Trinity and All Saints, pp. 1–14.

White, Hayden (1973), 'Interpretation in History', *New Literary History*, 4(2), pp. 281–314.

— (1978), *Tropics of Discourse: Essays in Cultural Criticism*, Baltimore, MD: Johns Hopkins University Press.

— (1987), *The Content of the Form: Narrative Discourse and Historical Representation*, Baltimore, MD: Johns Hopkins University Press.

— (1992), 'Historical Emplotment and the Problem of Truth', in Saul Friedlander (ed.), *Probing the Limits of Representation: Nazism and the 'Final Solution'*, Cambridge, MA, and London: Harvard University Press, pp. 37–53.

— (1996), 'The Modernist Event', in Vivian Sobchack (ed.), *The Persistence of History: Cinema, Television and the Modern Event*, London and New York: Routledge, pp. 17–38.

— (2007), 'Against Historical Realism: A Reading of "War and Peace"', *New Left Review*, 46, pp. 89–110.

Whittaker, Thomas A. (2010), 'Producing Resistance: Elías Querejeta's Political Landscapes', *Jump Cut: A Review of Contemporary Media*, 52, www.ejumpcut.org/currentissue/whittakerQuerejeta/index.html, last accessed 14 June 2011.

Wollen, Peter (1969), *Signs and Meaning in the Cinema*, London: Secker and Warburg in association with the BFI.

Index